```
A B R A C A D A B R A
 A B R A C A D A B R
  A B R A C A D A B
   A B R A C A D A
    A B R A C A D
     A B R A C A
      A B R A C
       A B R A
        A B R
         A B
          A
```

Harriet Bart: Abracadabra and Other Forms of Protection

```
A B R A C A D A B R A
 A B R A C A D A B R
  A B R A C A D A B
   A B R A C A D A
    A B R A C A D
     A B R A C A
      A B R A C
       A B R A
        A B R
         A B
          A
```

Laura Wertheim Joseph, Editor
Hopkins/Baumann, Design

Weisman Art Museum

Published by Weisman Art Museum
University of Minnesota
333 East River Road
Minneapolis, MN 55455
www.weisman.umn.edu

 Distributed by the University of Minnesota Press
111 Third Avenue South, Suite 290
Minneapolis, MN 55401
www.upress.umn.edu

We have endeavored to credit the photographers of all illustrations
in this book, as well as the collections to which artworks now belong,
but occasionally this information was not available. Unless otherwise
indicated, personal photographs are courtesy of Harriet Bart. Image on full
title page by Heather Everhart and Yu-Wen Wu. Please contact
the Weisman Art Museum about any unintentionally omitted credits.

BOOK AND JACKET DESIGN
Hopkins/Baumann
Mary K. Baumann, Will Hopkins
Mackenzie Huckstorf, Genevieve Kettleson

EDITOR
Laura J. Westlund

PHOTOGRAPHY
Rik Sferra (unless otherwise noted)

PRODUCTION MANAGEMENT
Jim Bindas, Books & Projects LLC

PRINTER
Asia Pacific Offset

Printed in China

 The Andy Warhol Foundation for the Visual Arts

Library of Congress Cataloging-in-Publication Data

Joseph, Laura Wertheim, editor. | Frederick R. Weisman Art
 Museum, organizer, host institution.
Harriet Bart : abracadabra and other forms of protection /
 Laura Wertheim Joseph, editor.
Minneapolis, MN : Weisman Art Museum, [2020] | Summary:
 "Harriet Bart: Abracadabra and Other Forms of Protection is a
 comprehensive look at the prolific and dynamic career of
 this international feminist conceptual artist. The book, which
 accompanies the first retrospective exhibition of her work
 at the Weisman Art Museum in 2020, features poetry and prose
 contributions by significant writers, artists, and curators who
 have been influenced by her art."
Identifiers: LCCN 2019027084 | ISBN 978-1-5179-0861-4 (hc)
Subjects: LCSH: Bart, Harriet—Exhibitions.
Classification: LCC N6537.B2257 A4 2020 | DDC 700.92–dc23
LC record available at https://lccn.loc.gov/2019027084

CONTENTS

6 **Director's Foreword** Lyndel King

8 **this is indeed the place / with many layers**
introduction by Laura Wertheim Joseph

33 **The Geniza as a Process of Thought**
Studio Photographs by John Schott

GENIZA

43 **Vessels** (containing)
Autobiography
 essay by Stephen Brown
Reliquary
 "Reliquiae," Nor Hall
Museum
Lustral Bowl
Essential Kabbalah
The Book of Sand
Homage

67 **Amulets** (shielding)
Abracadabra Universe
 essay by Joanna Inglot
Shards
 "Talisman," Susan Stewart
Without Words
The Words
Uninscribed Book
In the Presence of Absence
Strata: Tales of Power, The Invisible World

93 **Garments** (shrouding)
Processional
 essay by Robert Cozzolino
Penumbra
 "Penumbra," Jim Moore
Ascension
Strong Silent Type I
The Collar
Effigy
Double Ode

113 **Mirrors** (reflecting)
Reflexions
 essay by Joan Rothfuss
Silhouette I–III
 "The Peace Work of Piecework,
 Matthea Harvey
The Gaze
Remains of the Day
Genii Loci
Cento
Strong Silent Type II

131 **Memorials** (remembering)
Drawn in Smoke
 essay by Samantha Rippner
Drawn in Smoke
 "Edges Burned," Eric Lorberer
Re-Marks (Memorial)
Requiem
 (Inscribing the Names:
 American Soldiers Killed in Iraq)
Caged History
Enduring Afghanistan
Garment Registry
Crossings

161 **Tools** (navigating)
Plumb Bob
 essay by Betty Bright
Elements
 "This Burnt Space," Sun Yung Shin
Pendulum
Gutenberg Galaxy
Geography
Cultural Structures
Invisible Cities

181 **Found Objects** (transforming)
Forms of Recollection (Storied)
 essay by Diane Mullin
Remembrance: Florence
 "Travel," Elizabeth Erickson
Notion
Concrete Poem
Ledger Domain
Altered Classics III: Tales from Shakespeare
Campaign Chest

198 **Chronology** Heather Everhart

224 **Acknowledgments**

226 **Contributors**

230 **Gratitude**

DIRECTOR'S FOREWORD

Lyndel King

I can't remember when I first met Harriet Bart. She has been an artist of importance for more than forty years, and I may have known her nearly that long. She continues to make artwork that is as strikingly beautiful as it is full of meaning and inspiration. Harriet was a founding member of WARM, the Women's Art Registry of Minnesota, in 1976. WARM was among the first women's cooperative galleries established in the United States and gave women artists in our region a critical public stage at a time when mainstream art venues paid little attention to their work. Harriet has remained a feminist artist, but she has also become "a recorder of cultural memory," as Dr. Joanna Inglot described her in *WARM: A Feminist Art Collective in Minnesota,* WAM's book on the history of WARM.

Harriet started her career as a fiber artist. Though she has not used traditional weaving techniques for many years, a deeply felt reverence for texture and materials is still quite evident in her art, and she privileges work whose concepts embrace "women's work." Her *Strong Silent Type,* an installation and book created in 2016, in her own words, "honors generations of anonymous women, an unsung core of modern America." The abstract shapes gradually come into focus as dress pattern pieces; the strength and weight of black steel cutouts mounted on the wall contradict the tissue-paper sewing patterns from which the shapes are taken.

Harriet's work is spare and quiet. It attracts not by shouting but by whispering quietly, yet so persistently that one must pay attention. Stepping into Harriet's studio evokes a mystical world, full of beauty and also unspoken strength. She has long been compelled by the aesthetics and the power of incantations and the magic of words and letters. The exhibition and book that the Weisman Art Museum at the University of Minnesota presents are appropriately titled *Harriet Bart: Abracadabra and Other Forms of Protection.* Abracadabra is a word familiar to many from childhood as the magic word of transformation in magic shows. The true origin of the word remains a mystery, but it has been ascribed power since at least the third century AD, and probably earlier. Some believe it is from Hebrew or Aramaic, meaning "I will create as I speak." That is most fitting for Harriet's work: she creates magic and healing with words, letters, symbols, forms – art.

Harriet's travels through Israel in the

early years of the twenty-first century inspired several projects about the pome-granate, a fruit imbued with symbolism and myths in many cultures since ancient times. I am personally very attracted to legends of the pomegranate, so I am particularly drawn to Harriet's pomegranates. The pomegranate is thought to be the apple of Eve's temptation of Adam in Judeo-Christian tradition, thereby casting humanity from paradise into the mortal world of suffering and sin. It played an essential role in the myth of Persephone, the Greek goddess of vegetation who was abducted by the god Hades and, because she ate a pomegranate seed, was required to return to his dark underworld for some time every year, thus causing the world to endure winter. Harriet explored the pomegranate allegories in a series of beautiful cast bronzes and a book, *Punica Granatum*, in which embossed images of pure white pomegranates are mixed with excerpts from contemporary and classical sources. This poetic exploration sets Harriet's work in its own world and makes it so seductive.

WAM is proud to include many women artists in our collection – a higher percentage than at most art museums –

and we are honored that Harriet Bart has chosen our museum as the place where her artistic archive will reside. *Harriet Bart: Abracadabra and Other Forms of Protection* is the result of the work of many women, starting with Laura Wertheim Joseph, the curator of the exhibit and editor of this book. Laura received a Lisa and Gerald O'Brien Curatorial Fellowship at WAM, and we are proud that her curatorial expertise has now been applied to Harriet's art. Diane Mullin, senior curator, was essential to the guidance and direction of the project among WAM staff and also contributed her writing to this publication. Our registrars, Annette Van Aken and Rosa Corral, organized the archive of Harriet's work. I especially want to thank Karen Desnick and Dianne Fenyk, longtime supporters of the arts, who led a fundraising campaign for this exhibit and publication. I thank the many donors who stepped forward in support and are listed in this book: they are a testament to Harriet's deep-rooted presence in our arts community and to her influence as an artist here and internationally. Thank you, friends and supporters. Thank you, Harriet, for your contributions to our lives.

this is indeed the place / with many layers
Laura Wertheim Joseph

when you are in trouble
and turn from death
this is what to do
find the meeting place:
intersectionality
under stars
way to gnosis
saying this is the place
this is indeed the place
with many layers
lie down here

ANNE WALDMAN
"TRICK O'DEATH"
TRICKSTER FEMINISM

In 1978, art historian Kathryn Johnson described encountering a body of work that made her feel as if she were "descending into the core of the earth, through layers of meaning and texture." Johnson writes that this environment, filled with a series of commanding, totemic, black fiber objects, was "unlike . . . the ordinary world." By her account, these objects performed an act of magic: they granted access to a space not unreal but buried and unseen.[1]

This was Harriet Bart's first solo exhibition. It transformed the second floor of the downtown Minneapolis gallery operated by the Women's Art Registry of Minnesota (WARM), an important women's art collective of which Bart was a cofounding member. Here, Bart *passed through* fiber on her way to developing an artistic practice across media, including bronze and stone in her large-scale conceptual installations; everyday and found objects in her sculptures; and in the paper and words of her artist's books.[2] *Harriet Bart: Abracadabra and Other Forms of Protection* sets out to explore the many layers of this practice.

Organized during a time of political trouble, *Abracadabra* looks to Bart's work to consider the possibility of magic as recourse for the marginalized against "failing cultural systems and ancestral abuses."[3] In so doing, it embraces complexity. The concept of magic is very difficult to pin down across time and vast cultural variations, and it must dodge a few bullets: not only is magic undecidable, it is also associated with the primitive and antiscientific, the dangerous and heretical, and it is easy to capitalize and commodify. "when you are in trouble / and turn from death," Anne Waldman tells us in her cunning and incantatory anthology of poems, "this is what to do / find the meeting place . . ."[4]

Taking cues from Bart, this book's approach (to finding the meeting place) is subterranean but not archaeological. As Carol Mavor warns, to take an

Installation view
of **Bart/Belvo,**
WARM Gallery,
Minneapolis, 1978

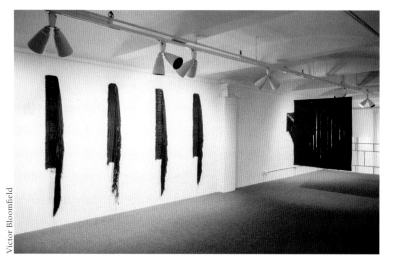

Victor Bloomfield

"archaeological view of the past" is to expect to unearth buried things and to find them unchanged – shards waiting to be made whole.[5] Fragments that resist our desire to project them into a fully knowable state are a defining feature of this artist's significant oeuvre across time and media.[6]

Bart's early fiber works provide a compelling entryway because they suggest her deep artistic commitment to the unseen. Made up of intersections where the visible weft and invisible warp touch, the very structure of weaving meditates on the relationship between the worlds we see and the ones we don't. In traditional weaving, the vertically oriented warp provides tension and structure for the horizontally oriented weft that passes through it. But as a support, the warp becomes invisible as the textile materializes. Like the warp and the weft, the invisible and the visible are not opposites; rather, one provides the tension that gives the other form.

In 1979, Bart shared intentions for this body of work: "I want my weavings to have a quality of mystery and strength about them, . . . to have some power of their own as they confront you."[7] Her interest in staging her viewer's encounter with objects that refuse to fully reveal themselves and that are possessed of their own power is related, I argue, to her ongoing explorations of art as a form of protection. While surveying her career of more than forty-five years and counting, this catalogue and the exhibition pay particularly close attention to the artist's work as it takes protective form.

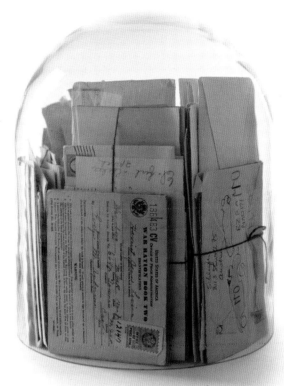

Harriet Bart
The Letters, 2001
found letters
and bell jar
15 x 10 inches

Abracadabra identifies Bart's two primary, interrelated methods of channeling art's protective abilities; at the core of both is her belief in the individual and combined power of objects and words.

The first method is a *practice* of preservation: she saves things others would not (found stereoscopic slides and letters); she places objects in protective vessels (boxes and test tubes sealed with wax); she inscribes the names of those otherwise forgotten (soldiers killed in Afghanistan and Iraq) on scrolls of paper and in ledgers. In her efforts to preserve, Bart refers often to the Jewish American poet Muriel Rukeyser and a line from one of her poems: "pay attention to what they tell you to forget."[8]

The second method is the more elusive process of transformation. Recognizing that many of her pieces are made of materials transformed or transforming (text turned to globe, or books turned to stones, for example) does not reveal why the process

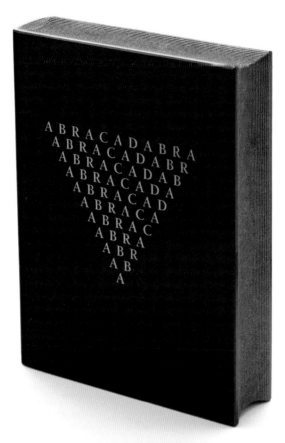

Harriet Bart
Abracadabra
1994/2018
granite
9 x 12 x 2 ¾ inches

antiquity and the Middle Ages was driven by their promise to offer "safe passage through a precarious world."[10]

As it appears in her prints, sculptural objects, and installations, Abracadabra signals the presence of a similar pursuit in Harriet Bart's practice. But what does her work seek to protect and what does it seek to avert? To explore these questions, this introduction uses Abracadabra as an organizational device; divided into sections marked by diminishing, written incantations of the word, it draws on the amuletic effects of Bart's art across time to offer safe passage. Counterintuitively, as the word disappears, its magical efficacy increases. This essay does not end with magic's disappearance, as it might appear.

As it transforms from visible to invisible, Abracadabra suggests a kind of descent, from an extended, horizontally oriented surface above to a core, unseen, below. After this essay, readers encounter Bart's art in this book within a conceptual space inspired by geniza, an ancient Jewish tradition of storing documents in a safe place to protect or conceal their words. The origins, development, and precise nature of this practice have remained mysterious, but we know that it initially involved the physical act of concealing, storing away, and in many cases physically burying heretical religious texts.[11]

At some point, geniza "evolved from indicating a *process* to also . . . a *place*,"[12] eventually referring to the receptacle that protected words as well as to the practice of preserving them. Hovering between parts of speech, geniza as a form of concealment of the heretical was gradually eclipsed by geniza as a means of guarding fragile and obsolete texts, both religious and nonreligious.[13] Geniza evades full understanding, represents the Jewish cultural investment in the power of words, and serves as a reminder that concealment

is significant to her. By its very nature, transformation cannot be subject to classification: it signals things in between states, with the capacity to become something different from what they were. For insight, I looked to the frequent appearance of the word Abracadabra, an emblem of transformation, across her art.

The word is of ancient and uncertain origin. Since its earliest known use in the seventh century BCE, Abracadabra has most often appeared in the form of a textual amulet, an apotropaic text handwritten or mechanically printed on a flexible writing support, such as parchment, and worn on the body to protect the wearer from harm. "[A]rranged as an inverted triangle, with the magical word diminished one letter per line until only an A remained," each written incantation represents the abatement of threat until it disappears.[9] The widespread dissemination of such amulets in late

can "[make] future revelation possible."[14]

In this context, geniza suggests the preservation of Bart's art, both through this publication and through the Weisman Art Museum's acquisition of her archive. In the spirit of the cultural practice from which it takes inspiration, the geniza that follows this introduction contains a significant cross-section of the artist's work but not her entire oeuvre. Its division into seven sections reflects Bart's interest in numerology. In the ancient and medieval worlds, it was thought that folding amulets into patterns that were numerologically meaningful could increase their magical power.[15]

Seven works of art by Bart are placed in each of seven sections, grouped together based on their shared protective powers: vessels that contain, amulets that shield, garments that shroud, mirrors that reflect, memorials that remember, tools that navigate, and found objects that transform. Each begins with an essay and poem written in response to particular artworks in that section. Although they take different forms and methods of approach, the written responses held within these sections share a recognition of the power of Bart's art to give presence to what cannot be seen. They examine empty vials (Nor Hall) and move along "forking paths" (Sun Yung Shin). They find the artist reluctant to give (fallen and forgotten) bodies figuration; instead, they discover that she "evokes bodies" through their traces – tears, teeth, ashes (Robert Cozzolino).

"I wanted to put it in a box," begins Eric Lorberer's poem "Edges Burned," written in response to Bart's *Drawn in Smoke*. Composed of 160 works on paper arranged in a rectangular grid, this installation registers the loss of women who died in the Triangle Shirtwaist Factory fire of 1911. At the center of each sheet of paper is a square "box" that gives

the viewer a window into a smoke-like formation of amorphous shapes. Beneath each "smoke drawing" is the name of one woman killed, written in ink.

The page confronts us with the loss of this woman – we can read her name only if we get close to it. But the work also keeps us at a distance, insisting on our inability to occupy or ascertain the space of that loss. The smoky veil, contained within a visual box at the center of the page, signals the presence of things we cannot fully see or comprehend. "I wanted to put it in a box. / And then the dawn came, and I realized / it might require a bell jar, a filmstrip, / a cup of lava, a motion detector, a cartoon tsunami," Lorberer continues.

These writings seek to understand the alchemical nature of Bart's work, "matted of our need / both to hide and to reveal" (Jim Moore). They consider the sources of its power to protect: "What magic hovered nearby to shield you?" asks Susan Stewart. Inspired by Bart's haunting silhouettes of sewing patterns stitched to paper with thread, Matthea Harvey wonders if a garment, with an epaulette weighted to simulate the feeling "of a hand lingering on a [soldier's] shoulder," could even put an end to war. Tracing how the wars of the

twentieth and twenty-first centuries have influenced the artist gives insight into her interest in geniza, which preceded and informed this project's development. To do this, I look to formative moments in her history.

Born in Duluth, Minnesota, in 1941, Harriet Bart grew up in a first-generation Jewish immigrant home during World War II. Her father, Mort, was religiously nonobservant, but her mother, Natalie, remained devout until familial losses from the war attenuated her faith. When Mort was drafted into military service in 1945, Bart and her mother returned to Duluth from Portal, North Dakota, where the family had moved for Mort's job as hearing examiner for the United States Border Patrol. They lived with the artist's Orthodox maternal grandparents, who had immigrated to the United States from Eastern Europe. Like many other Jews at that time, Bart's grandmother emigrated to escape the pogroms, a wave of collective anti-Jewish violence that swept the Russian Empire in the late nineteenth century.[16]

Although reluctant to make definitive claims about her experience of being from a Jewish family at this time, Bart often turns to books to consider war's transgenerational effects. Ann Michaels's novel *Fugitive Pieces* is of particular interest because it offers deeper understanding of geniza as a ritual practice of burying in order to conceal and preserve. Opening in the Polish archaeological site of Biskupin during Nazi occupation, this book tells the story of many burials, first of a boy who covers himself in mud to hide from the soldiers who murdered his family. In her book, Bart underlined a passage in which the reader also bears witness to the burial of objects:

In the zudeccha, the Spanish silver siddur with hinges in the spine, the tallith and the candlesticks are being buried in the earth under the kitchen floor. Letters to absent children, photos are buried. While the men and women who have placed these valuables in the ground have never done so before, they go through the motions with centuries of practice guiding their hands, a ritual as familiar as the Sabbath. [. . .]

After burying the books and dishes, the silverware and photos, the Jews of the Zakynthos ghetto vanish.

They slip into the hills, where they wait like coral; half flesh and half stone.[17]

This passage gives some indication why Bart believes in the power of objects: they are vessels of memory, even (or perhaps especially) when those who care about them and invested them with meaning are gone. Rather than arising from spiritual devotion, Bart's interest in ritual stems from its ability to draw out memory held within objects. She is particularly compelled by books as vessels of memory. During her childhood, she recalls being surrounded by Hebrew texts that she was never taught to read but that nevertheless exerted a strong presence. The Hebrew word *nignaz* (engraved on gravestones to mark the presence of a body "hidden" below) shares the same etymological root, *g–n–z*, with geniza, suggesting a relationship in the Hebrew language between body and text that Bart seems to have felt.[18]

She would go on to explore this relationship in *Forms of Recollection (Storied)*, a spiral wall installation Bart created with books that she made to appear like weathered stones by covering their surfaces with gesso, sand, and acrylic paint. Although the titles scratched into the surfaces of the spines intimate the presence of content within, this content cannot

be seen or accessed. Testaments to the presence of the unseen and the unknown, these objects nevertheless provide tangible structure and passage.

When this work was first exhibited in 1989, as part of the Minnesota Artists Exhibition Program at the Minneapolis Institute of Arts, Bart noted that the stone-like books aimed to evoke the cross-cultural symbolism of stones as "enduring containers for ancestral souls."[19] Laying down the book objects one by one to create a formation suggestive of ancient walls and shrines, Bart approached art-making as kin to ritual, channeling the ability of both practices to heighten our awareness of the invisible, the inaccessible, and the absent. As *Forms of Recollection* alludes, it was the ritualistic aspect of Judaism that imprinted itself most strongly on her – "centuries of practice guiding their hands."

In 1947, Bart moved with her family from Portal, North Dakota, to San Francisco, where her dad had accepted a job as a Chinese immigration officer for the United States Immigration and Naturalization Services. It was there that she had her first memorable encounter with an art object. On bike rides through Golden Gate Park, Bart would sometimes stop to visit the de Young Museum. Her time spent looking at the museum's collection of artifacts from Ancient Egypt sparked what would be an ongoing interest in Egyptian burial customs, but one experience in particular had a transformational effect on her.[20]

She remembers finding a room of all black paintings that struck her as powerful. These works could not have been the well-known series of black paintings by color field abstract expressionist Ad Reinhardt; he didn't create this series until 1963. As American poet and scholar Fred Moten discusses at length, Reinhardt insisted

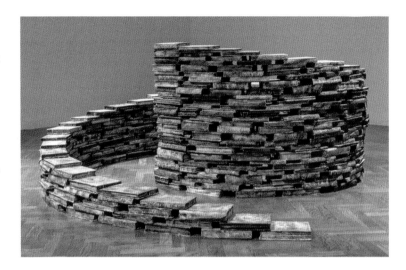

these paintings were purely aesthetic, formalist, and apolitical *negations* of color, refusing their relationship with the social and political world.[21]

I have not been able to determine definitively whose work Bart saw that day in the mid-1950s. But Rebecca Solnit's book *Secret Exhibition: Six California Artists,* which chronicles the lesser known avant-garde scene in San Francisco in the 1950s, gave me an idea and provides context about the cultural environment in which Bart grew up.[22]

The countercultural network of artists that thrived in San Francisco at this time was deeply committed to anticommercialism and antiformalism. Korean War veteran Wally Hedrick was in this group; he was a cofounder of Six Gallery, an art exhibition space and node of Beat Generation activity, where Allen Ginsberg read his incendiary poem *Howl* for the first time in 1955.[23] Also in 1955, Hedrick had eleven works on display as part of a group show at the de Young.[24]

In the early fifties, Hedrick's paintings included intentionally crude representations of the American flag on which he had written words like "Peace" and "Burn Me." Such paintings predated the famous flag paintings of Jasper Johns but were very different in spirit. Johns's

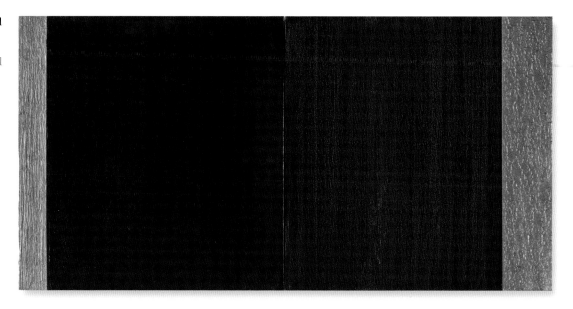

flags were rejections of illusionism, whereas Hedrick's were explicit condemnations of American military actions. His work from the early and midfifties is not well documented, and the de Young does not have records of which of his artworks were on display.[25] It's difficult to know if any of the paintings on view in 1955 anticipated the type of work he took up systematically in 1957, when he painted his older flag canvases black as a sign of mourning and protest against the Vietnam War. Hedrick continued to work in this way until his death in 2003, adding layers of black to correspond with subsequent wars, including the Gulf War (1990–91) and the Iraq War (2003–11).[26] This was not an act of negation but rather an act of covering, of refusing to allow his art to remain visible.[27]

I don't know if it was Hedrick's work that impressed Bart so strongly. Proximity to San Francisco's counterculture and antiwar activism did inform her creative consciousness, even if she did not know exactly what it was at the time. Bart would go on to make her own interventions into formalist visual rhetoric, as well as into the warmongering symbolism of the American flag.

In the late 1970s, when she was moving away from fiber, she created a series of transitional "woven" canvases that represent both aspects of her practice. Small strips of the American flag cover the surface of *Intersect I* (1979), a six-foot-square wall hanging made of interlacing horizontal and vertical strips of canvas. The darkly painted strips, with red undertones and black glazing, are visually suggestive of Minimalist art of the previous decade.

While such grids appear often in her art, they represent the ongoing influence of the feminized, and handmade, practice of weaving rather than the Minimalist project of simple forms and industrial means of manufacture to evacuate signs of the artist's hand. Although it bears visual resemblance, *Intersect I* cannot be understood through the impersonal lens of Minimalism. Created several years after the end of the Vietnam War, the grid of intersecting vertical and horizontal lines suggests the place where the upright and the recumbent (or fallen) meet, and the tally-like bits of American flag (visually muted under a thin veil of black-tinted gel medium) call to attention bodies and histories on the verge of being forgotten.[28]

Bart grapples with the complexities of memorialization more explicitly in subsequent works. Although she remains reluctant to give bodies figuration, she considers this approach most seriously in a series of stitched canvases from 1984. Among these works was *Elegy*, a visual response to Robert Bly's poem "Counting the Small-Boned Bodies."

The poem satirically reflects on the dehumanizing effect of counting the bodies of enemy dead: "If we could only make the bodies smaller / Maybe we could get / A whole year's kill in front of us on a desk!" Bart wrestles with this problem of death become abstract by setting figural forms – resembling mummies and painted red – against a green canvas covered with rows of white tally marks. The anthropomorphic shapes make the significance of the tallies concrete and unmistakable among the more established elements of Bart's visual vocabulary at the time.

Bly's poem was written in 1967 in response to the Vietnam War, and it was reprinted in 1984 in a critical overview of the poet's work.[29] This second publication was two years after the construction of Maya Lin's Vietnam War memorial on the National Mall in Washington, D.C., had reanimated debates about the war and how to remember it. Lin's design is made of two 248-foot stretches of highly polished, reflective black granite slabs that reach a height of more than ten feet at the apex, where the two flat surfaces come together at a 125-degree angle.[30] Breaking with monumental tradition, the slabs sink into the earth's surface rather than rise above it. At the apex, on the right-hand side, begins a chronological list of the names of the more than 58,000 American soldiers killed in the war, cut into the stone.[31] In a description she wrote later, Lin explains she "never looked at the memorial as a wall or an object, but as an edge to the earth."

She recalls imagining "taking a knife and cutting into the earth, opening it up and the initial violence that in time would heal." This cut would create "an interface between our world, and the quieter, darker, more peaceful world beyond."[32]

The design incited controversy for what detractors considered its antiheroic effect. It is horizontal (recumbent) rather than vertical, and it descends into the earth rather than rising above it. It remembers not through figuration but rather through

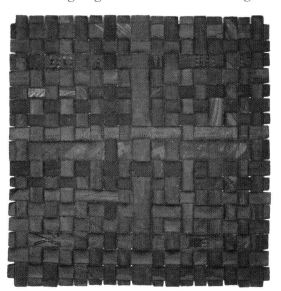

Harriet Bart
Intersect I, 1979
acrylic and mixed media on canvas
6 x 6 feet

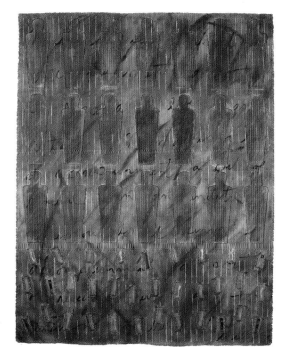

Harriet Bart
Elegy, 1984
acrylic and mixed media on canvas
48 x 38 ¼ inches

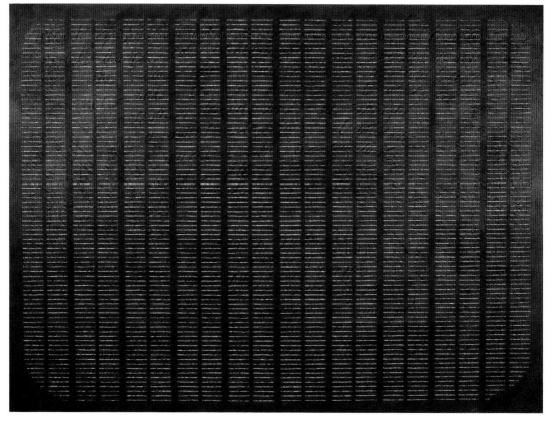

Harriet Bart, **Re-Marks (Memorial),** 1986
mixed media on canvas
62 x 91 inches

names that require proximity and intimacy to be read. Lin's design changed the trajectory of public memorialization in ways that would be generative for Bart, who would go on to design large-scale public sculptures around the world.[33] At this point she was still working on a human scale, in part because of the ongoing influence of textiles and their integral relationship to the human body and also because of the technical obstacles involved with scaling up.

Despite a difference in scale, Bart's orientation (looking to what is beneath the surface rather than above) and aptitude for distilling complex ideas and histories into powerfully minimal forms were in kinship with Lin. So too was Bart's interest in the potential of mark-making to express what she described at the time as "the continuing and insistent human need to record, to remember, and to connect with the past."[34]

Ultimately, Bart was not satisfied with figuration as a response to the challenges of memorializing death and war.[35] In visual conversation with Lin, Bart tests the limits of representation in *Re-Marks (Memorial),* completed in 1986. She first covered a large canvas with gesso and handwritten spiraling text, drawn from Marie Cardinal's autobiography *The Words to Say It.*[36] She then stitched neatly ordered rows of lines across the surface. She painted over the text and stitch marks with red acrylic, framing the composition with curved corners meant to recall the television screen through which she experienced the war. Finally, she went back with a sable brush and painted each stitched line (meant to recall an empty ledger and the *unknown* names of people who died in the Vietnam War) white.

A full sense of how Bart metabolized Lin's approach to memorialization was revealed in the early 2000s, when she

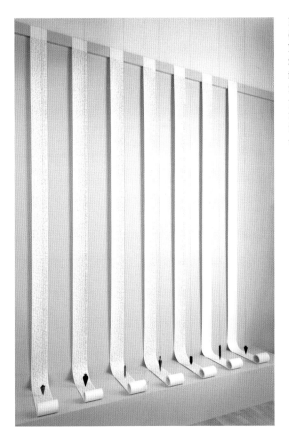

Harriet Bart, **Requiem (Inscribing the Names: American Soldiers Killed in Iraq)**, 2003–11 ink on paper, plumb bobs, and mixed media installation dimensions variable

sought to process the mounting death toll from the war in Iraq. By this time, Bart had developed her own feminist-informed strategy for working on an architectural scale, incorporating smaller elements additively to create something larger. In *Requiem (Inscribing the Names: American Soldiers Killed in Iraq)*, seven scrolls can each be held by hand but also can be rolled out to extend approximately twelve feet. Bart began with Lin's simple premise: naming is powerful, both as a singular act and as a process of accumulation. But Bart writes the names by hand – a repetitive, durational, embodied, and solitary practice that required that she intimately commune with each letter, "centuries of practice guiding [her] hands."

The installation is displayed with each scroll cascading vertically, at even intervals, down a wall, with the ends of each spilling onto the floor and out toward the viewer. Names, written in Bart's neatly

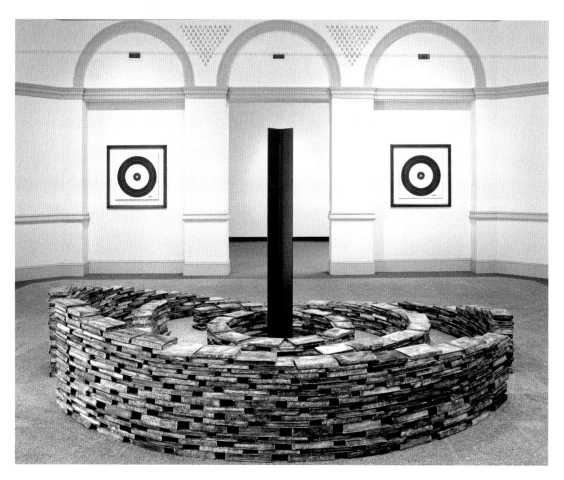

ABRACADABRA

angled cursive script, fill the entire space on six of the seven scrolls; the seventh is left empty. This void gestures toward the uncounted and the unfathomable. Hung in front of each scroll is a line weighted with a leaden plumb bob, an everyday instrument "of precise calculation and mystical divination."[37] Pulled by the earth's gravity and pointing toward the earth's core, the plumb bob marks the spot where the vertical and the horizontal, the upright and the recumbent, the world above and the world below, the visible and the invisible, meet.

At the meeting place, one wonders: "What magic hovered nearby to shield you?"

Harriet Bart first channeled the protective powers of Abracadabra in *Dialogue: Alchemy of the Word,* an exhibition at Dolly Fiterman Fine Arts in Minneapolis in 1993. The gallery was housed in a Beaux Arts–style building, once a branch of the Minneapolis Public Library.[38] As the title suggests, *Dialogue* featured the artist's explorations of letters and words across media in conversation with Helmut Löhr, a Düsseldorf-based artist and frequent collaborator with Bart from 1990, when they met, until his death in 2010. In her words, the exhibition explored "the alchemy of the word, the iconography of text, the labyrinth of the book, the book as poetic object."[39]

In one of the galleries, inverted triangles of diminishing Abracadabra text

filled the abutments between the room's arched doorways. This text surrounded *Building Discourse,* an installation of stone-like books similar to *Forms of Recollection.* Three concentric arched walls of diminishing height enclose an x-shaped steel pillar, which signals the significance of the place where the two surfaces meet. Does this x represent the interface between vertically and horizontally oriented worlds? Does it mark the presence of something buried and hidden below?

Bart introduced Abracadabra into this particular work because of the suitability of the architecture.[40] Her earlier projects give insight into this approach to architecture as a visual language. She established the symbolic importance of the arch in her work in 1988 at *Visions of Fate,* a group show at the Minneapolis College of Art and Design organized around themes of death and transformation. As part of an installation of stone-like books arranged in spiral pathways, she included an archway made of wood and treated with acrylic to mimic stone. This arch made reference to the seventh gate through which the Sumerian goddess Inanna had to pass in her journey through the Underworld.[41]

ABRACADABR

The myth, reconstructed by modern historians from Uruk-Sumerian artifacts, tells the story of Inanna, the goddess of fertility, descending to the Underworld in pursuit of self-discovery. Encountering seven gates, she must give up something of value at each, beginning with her crown. After passing through the seventh gate, "she is left 'naked and bowed low,'" and then dies.[42] But beyond the seventh gate, Inanna also gains knowledge and possession of her sexuality and is reborn. Medical historian John Riddle draws understanding of the myth from its

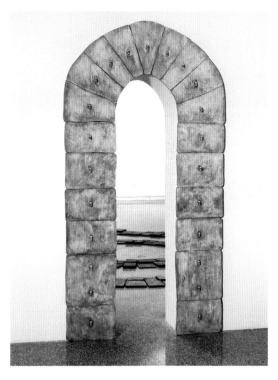

Installation view of **The Arch** from **Mnemonic Site: Place of Recollection,** part of the group show **Visions of Fate,** Minneapolis College of Art and Design, Minneapolis, 1988

retelling by Sumerian poets in the third millennium BCE:

> Inanna sought fulfillment in her feminine powers by a descent into the underworld, first as an innocent virgin, returning as a mature woman who knew sorrow and had met death.[43]

Although she must pay a price, in the Underworld Inanna meets the God of Wisdom and also gains power by acquiring a *Huluppu* tree, which Riddle identifies as a pomegranate tree.[44] Understanding pomegranate seeds as antifertility agents is much more explicit in Greek myth and medical records, but Riddle claims that this knowledge was also held within the Sumerian myth, in part by looking to the meaning of the name Inanna, which does not mean fertility but rather "one who can be fertile or nonfertile."[45] Inanna's power is derived not from her ability to give birth but rather from her ability to *control* her own fertility through knowledge of the power of the *Huluppu* tree.

ABRACADAB

Bart's reference to the myth in *Visions of Fate* was not a one-off. Although its form changed, her engagement was consistent over the course of several decades. Ten years earlier, she made abstract reference to the Greek version in *Seasons of Sorrow,* a dense black rectangular fiber work. A barely discernible Greek cross woven in the center, again, marks a place of intersection. At the bottom, three curved and nested swaths of woven linen, silk, wool, and cotton extend down and away from the object to suggest layers giving way to layers beneath. Tendrils of warp, reminiscent of tears or rain, hang from each and claim interconnectedness between emotional and physical depth.

The black, mournful weaving represents the sorrow manifested on the earth by Demeter, the goddess of fertility and life, when her daughter Persephone is abducted to the Underworld by Hades. Signs of life retreat underground and the earth becomes barren. Her father, Zeus, instructs Persephone not to eat while she is gone, but before she returns she eats pomegranate seeds – seven, by many accounts – resulting in a corresponding number of seven winter months in the world above.[46]

Harriet Bart
Seasons of Sorrow, 1978
linen, silk, wool, and cotton
62 x 62 x 3 inches

Harriet Bart
Pomegranate, 2002
bronze
4 x 4 x 4 inches

Harriet Bart
Punica Granatum
(detail), 2005
letterpress and
embossing on paper
14 ¼ x 10 ½ x 1 ¼
inches (closed)

ABRACADA

Pomegranates and their seeds are symbols of the knowledge hidden within such myths: since ancient times women have known how to use herbs to control fertility and have passed the information from generation to generation.[47] Both the pomegranate and its seeds appear in Bart's art regularly since her trip to Israel in 2000, where she encountered the fruit often in nature and depicted on ancient monuments.

In 2002, she memorialized the pomegranate by casting it in bronze. She extolled its mythic powers in 2005 in *Punica Granatum,* an artist's book that juxtaposes embossed images of the pomegranate and related goddesses with written reflections on the fruit across time. Bart effectively creates a new poem by weaving together the words of others. The last text to be featured (next to an embossed figure of an ancient goddess with her back to the reader and her face turned away) is a poem by Eleanor Rand Wilner. It envisions the mythic woman who eats the pomegranate seed as a powerful seer, both of what is to come and what has passed:

> When she ate the pomegranate,
> it was as if every seed
> with its wet red shining coat
> of sweet flesh clinging to the dark core
> was one of nature's eyes. Afterward,
> it was nature that was blind,
> and she who was wild
> with vision, condemned
> to see what was before her, and
> behind.[48]

In 2011, Bart safeguarded glass pomegranate seeds in the forty-seventh of the seventy test tubes that make up *Autobiography.* Arranged evenly in a

horizontal line, each glass tube contains a distillation of the artist's memories and experiences in material form – small stones, a lock of hair, fragments of printed text from Helmut Löhr's memorial, and glass pomegranate seeds. Each small vessel signifies a year of the artist's life up until she made the work, and each material held within it expresses a relationship to the passage of time and the process of transformation.

ABRACAD

Translucent ruby flesh that clings to a dark core; black fibrous tendrils that reach, longingly, for the buried and unseen; a stone arch that marks the final stage of a rite of passage: these are signs of Bart's deep and abiding interest in cultural mythology. Her curiosity was initially sparked by engagement with feminist artists, critics, and activists she met through WARM, the newly established feminist art cooperative she joined in 1976.[49] Like many of her contemporaries, she was compelled by feminist reinterpretations of myths and Jungian archetypes as part of broader critiques of patriarchal culture.

Estella Lauter's *Women as Mythmakers*, published in 1984, was one of the books that influenced Bart's understanding of mythmaking as an ongoing process – not just a practice of ancient cultures. Lauter argues that mythmaking is "a kind of collective memory" that is transmitted but also negotiated and altered across time; as a mode of knowing with potential to be remade, it plays an important role in the articulation of a feminist worldview. To achieve mythic status, the stories and symbols that give shape to myths through repetition must be potent and widely dispersed. As a result, cultural myths are not made by individuals, but Lauter

Harriet Bart
Autobiography (detail)
2011
mixed media
6 ¼ x 70 ½ x 2 inches
(ledge with vials)

points to several twentieth-century artists and writers as barometers for measuring the increasing pressure exerted against Western cultural mythology that solidified within the Western feminist community in the seventies. When it materialized, Lauter tells us, this pressure often took the form of new myths – "sometimes in collision with other myths, sometimes within them, and sometimes with only tangential reference to them."[50] The examples she cites are evidence, she claims, of "the richness and variety" but also of the combined power of feminist interventions into patriarchy's dominion over mythmaking.[51]

ABRACA

Bart can't remember when exactly she read *The Moon and the Virgin: Reflections on the Archetypal Feminine* except that it was "a long time ago."[52] Written by Minneapolis-based Nor Hall several years before *Woman as Mythmakers*, the book revisits ancient myths to recover female archetypes suppressed under patriarchy. Bart and Hall became friends and collaborators around 2004, but they had already been in the same places at the same times for many years. In 1982, Bart participated in a collaborative project on mythmaking at Macalester College inspired by Hall's recently published book. Hall claims that Demeter's search for Persephone represents a search for the "dark terrain of an unknown self,"[53] and the project at Macalester, which included theater and dance performances, poetry readings, and an art exhibition, was titled *The Dark Core*.[54]

At the center of Bart's section of the exhibition were two sculptural installations. Composed of small objects that visitors were invited to take with them, Bart made these offerings with

fellow WARM member Elizabeth Erickson. One set of these offerings was contained within a larger object, an isosceles triangle with solid rectangular sides and an open triangular front. To the darkly painted exterior surface of the wooden structure Bart applied small, mysterious, rectangular packets – signatures of her work at the time. Within the structure, stacked along the rectangular base, she and Erickson placed stick-like prisms, painted white with red ends and wrapped in black cloth bound with red string. Tied to the end of the red string were small metal disks, "amulets," signaling the protection of the anthropomorphic objects from harm.

Amulets take many forms here, and the small pouches (suggestive of tally marks in their small rectangular shape) keep their unknown contents held safely within. The triangular structure provides shelter for the objects it holds. These objects are protected not only by the small metal disk but also by the black cloth in which they are wrapped. Here and elsewhere, Bart claims cloth as a source of protection. She often reminds people that we are swaddled at birth and shrouded at death in cloth: it is central to many rites of passage.

Bart and Erickson's offerings to the visitor also included an installation of small cloth bags, arranged in a circular pile on the floor. Painted black with a red spiral and white line on the front, each bag contained a stone from the North Shore of Lake Superior in Minnesota, an agate gem revered since ancient times for its ability to harmonize positive and negative energies, and a scroll of text in honor of Inanna. The text praised, among other things, the courage required to "descend to the depth of self-knowledge," to experience "essential transformation," and to "exist powerfully" in the world.[55] These offerings imply the art object itself can be a quietly subversive method of transmitting memory and knowledge – and even, perhaps, a means of initiating transformation and empowerment.

ABRAC

A series of stitched canvases also hung on the surrounding walls as part of Bart's contribution to *The Dark Core*. Among these was *Sampler II*, which includes many of the elements present in the collaborative offerings but more explicitly emphasizes their function of protection. Bart had been working primarily on canvas for several years at this point. She found that it allowed more spontaneity and intuition than the "analytical and physically taxing" practice of weaving did.[56] But as a stitched canvas, *Sampler II* indicates that she approached the medium as fiber rather than as a support.

Bart created most of the compositional elements (including seven mysterious rectangular pouches situated along the top two sides of a pyramidal form) by stitching them to the surface. Although she also applied paint to the background, she rubbed the earthen reds, browns, and mauves into the surface, using rags and sponges, to give it the appearance of an ancient wall of stone or clay. In addition to tally marks painted in a curving row above the pouches, and a series of ancient pagan symbols stitched in a line along the top edge, she featured tally-like bits of the American flag along the bottom edge of the piece. Along the three sides of the central triangle, she stitched text from a poem by William Carlos Williams: "Memory is a kind / of accomplishment / a sort of renewal / even / an initiation."

Harriet Bart
Sampler II, 1981
mixed media on canvas
48 x 37 inches

Memory is a hint of accomplishment

a sort of renewal
even
an imitation

With this text, Bart calls on viewers to participate in a quiet project of remembering and transmission. The title and the techniques she used to make *Sampler II* alert our attention to women's domestic labor, specifically the creation of samplers, pieces of embroidery or cross-stitching that, historically, served to demonstrate a woman's skill. Bart's interest was facilitated by Mirra Banks's book *Anonymous Was a Woman,* which was published in 1979 and popular within feminist circles in the early 1980s.[57] The book brings together a collection of samplers, quilts, needlework, and other craft objects created by American women in the eighteenth and nineteenth centuries, alongside excerpts from their diaries and letters, to reveal that these objects often bore traces of important events in their makers' lives, sometimes even delivering messages.[58]

What message does Bart's "sampler" hope to convey? Combined with amuletic offerings and reference to Inanna, it suggests the transmission of women's knowledge and stories to be a source of power and protection. As she explained in an interview in 1979, Bart's tally marks represent her attempt to keep "records of forgotten lives" and "story-less names," and to keep track of "quiet comings and goings."[59]

ABRA

Although we do not know when exactly it came and went, women's knowledge of pomegranate seeds and herbs to control fertility was ultimately suppressed and forgotten. John Riddle cites many sources to support that women's use of herbal abortifacients and contraceptives was widely assumed in the ancient world. Passages from Hippocrates, Plato, and Socrates, for example, indicate that Greeks believed women to be "inferior beings"

but also accepted that "they determined reproduction and did so deliberately" by means of "drugs [*pharmakia*] and incantations."[60]

Some demographers cite population increases that began at the end of the fifteenth century as evidence that the witch trials successfully disrupted the transmission of women's reproductive knowledge and power.[61] According to Riddle, demographic data do not conclusively indicate that the witch trials directly had this effect, although this was one of their intended consequences.[62] After offering several arguments about why women were more prone to witchcraft than men, a Dominican treatise from 1484 listed seven of witchcraft's fundamental practices, all of which related to "misusing" sexuality or obstructing reproduction.[63] Riddle is reluctant to argue that the broken chain of knowledge was a direct result of the witch trials, but the feminist Marxist scholar Silvia Frederici is not. She claims the witch hunts to be a hidden history of femicide that "aimed at destroying the control women had exercised over their reproductive function," at "[forcing] them to submit to patriarchal control of the nuclear family," and at "confining [them] to reproductive work."[64]

Seven heretical practices, seven pomegranate seeds, seven gates, seven mysterious pouches, seven days a week. In the fall of 2018, Bart emailed to tell me about a reading she attended. "I went to hear Anne Waldman and Nor [Hall] read last night at Moon Palace Books. What a treat! Anne read from her new [anthology of poems] *Trickster Feminism.* I came away with this wonderful line: 'Make the day an amulet.'"[65] In response to Waldman's call, *Harriet Bart: Abracadabra and Other Forms of Protection* offers a different type of protective object for each day, each gate, and each threshold of transformation.

The question of magic remains. How can we say it relates to Bart's art if we can't say exactly what it means? The word evades. It is tricky, in part because it has meant different things to different people across time. In our moment, even the post-truth philosopher Bruno Latour, who argued to influential effect that scientific fact is a product of ideology, is coming to the defense of science. Risks are involved with embracing a concept that suggests there are forces that cannot be seen by the eye or apprehended by logic.[66] But here again Frederici is helpful. She tells us that what is most revealing about the concept of magic is the forces that have attempted to suppress it:

> The battle against magic has always accompanied the development of capitalism, to this very day. Magic is premised on the belief that the word is animated, unpredictable, and there is force in all things: "water, trees, substances, *words* . . ."[67]

She explains that for the seventeenth-century ruling class that attempted to dispel magical beliefs in an effort to discipline an obedient workforce,

> it hardly mattered whether the powers people claimed to have were real or not, for the very existence of magical beliefs was a source of insubordination. [. . .] It would hardly be fruitful to investigate whether these powers were real or imaginary. It can [just] be said that all precapitalist societies have believed in them . . .[68]

Circling back to the room where Bart first used Abracadabra, we can now see the arched doorway as an invitation: to step into a place of power, achieved through accumulation and transmission of knowledge. At face value, the myth of Inanna, signaled by the arch, is about the empowerment of a single woman realized by descending underground. But understanding mythology as a mode of communicating about structures of power, and taking a broader view of Bart's work, we find that the artist's view of transformation is transgenerational.

The amuletic text of Abracadabra fills the space that supports the lateral pressure of the arches. Which is to say that Bart visually connects it to the forces that hold up the arch and thereby create the opening. Meanwhile, the diminishing text signals the abatement of harmful forces but also performs its own act of disappearance. It is a visualization of the space *between* the visible and the invisible. Just as it dispels the injurious, it reaches a point of convergence, a dark core where the vertical and horizontal meet, and then it vanishes.

When explaining her interest in the arched "gate" in the 1988 exhibition *Visions of Fate,* Bart said that she "chose the form, in part, after reading that keystone in an arch 'never sleeps.'"[69] The keystone tells us that objects are powerful, in part, because they remember the presence of the unseen and hold within them the possibility of communicating that presence across time and space.

A

"When you are sitting / with the corpse of your friend / this is what to do," begins Waldman's *Trickster Feminism.*[70] In the face of so much violence (felt on a personal

and global scale), this trickster feminist poetry moves quickly, telling readers to "open words like talismans / that shake the cosmos."

We are told to meet at "the crossroads," at "the edge of town," to "find the meeting place: intersectionality / under stars / way to gnosis / saying this is the place / this is indeed the place / with many layers / lie down here."[71] Waldman's trickster feminist poetry rises to the need to be shape-shifting and mercurial to take on the conman, patriarchy, and their myths. It invokes women deities, suffragettes, and feminists for help. Bart's form of address is often quieter; it whispers, but it works similarly, showing us that art can avert evil and avenge death.

The concept of "trickster feminism" also suggests playfulness and humor, qualities indeed present in Bart's art. I haven't captured them here. But you will find them elsewhere in this book . . .

Notes

[1] Kathryn C. Johnson, "Lights and Shadow," *Bart/Belvo* exhibition catalogue (Minneapolis: Women's Art Registry of Minnesota, 1978), n.p.

[2] Bart's mother, a skilled seamstress, taught Bart to sew when she was young. The artist began to think of this practice in artistic terms when she saw the landmark UCLA Art Galleries exhibition *Deliberate Entanglements* during a visit to Los Angeles in 1971. Shortly thereafter, she started classes at the Weaver's Guild of Minnesota, where she learned weaving techniques and gained technical proficiency. Endeavoring to bring more critical traction to her work, she applied and was accepted to the University of Minnesota's University Without Walls (UWW) program in 1974. Because there was not a fiber arts program in the art department at the university, Bart chose to study in the College of Design and found herself under the mentorship of Charlene Burningham, who modeled an instinctual and embodied process of making.

[3] Female Background, "Secure the Bagua," *Ultracultural Others* (blog), November 30, 2018. ultraculturalothers.wordpress.com.

[4] Anne Waldman, "Trick O'Death," *Trickster Feminism* (New York: Penguin Books, 2018), 8.

[5] Carol Mavor, *Reading Boyishly: Roland Barthes, J. M. Barrie, Jacques Henri Lartigue, Marcel Proust, and D. W. Winnicott* (Durham, N.C.: Duke University Press, 2007), 125. See also Jane Blocker, *Becoming Past: History in Contemporary Art* (Minneapolis: University of Minnesota Press, 2016), 165.

[6] Laura Wertheim Joseph, *Strong Silent Type* (New York: Driscoll Babcock Gallery, 2016), n.p.

[7] Quoted in Mary Abbe, "Here come the artists, there goes the neighborhood," *Twin Cities Magazine* 1 (1979): 10.

[8] Muriel Rukeyser, "Double Ode," *The Collected Poems of Muriel Rukeyser,* ed. Janet Kaufman and Anne Herzog (Pittsburgh: University of Pittsburgh Press, 2006).

[9] Don C. Skemer, *Binding Words: Textual Amulets in the Middle Ages* (University Park, Penn.: The Pennsylvania State University Press, 2006), 1, 25.

[10] Ibid., 1.

[11] In their account of the discovery of the Cairo Geniza, essayist Adina Hoffman and poet Peter Cole speak to the elusive nature of geniza, both as word and Jewish practice. Adina Hoffman and Peter Cole, *Sacred Trash: The Lost and Found World of the Cairo Geniza* (New York: Schocken, Nextbook, 2011), 13.

[12] Ibid.

[13] For more than nine hundred years, the Palestinian Jews of Old Cairo stashed hundreds of thousands of documents in a hidden room of the city's synagogue complex, including not just religious texts but also detritus from everyday life. Their reasons for saving both religious and nonreligious texts are unknown, but some scholars have speculated that the comprehensive collection was a matter of efficiency: they simply did not take the time to distinguish the items. Others have suggested that the wide-ranging documents found in the Cairo Geniza (all written in Hebrew letters but in many different languages) indicate that reverence for the word had accumulated significance and extended beyond its religious origins. See Hoffman and Cole, *Sacred Trash.*

[14] Ibid., 19.

[15] Skemer, *Binding Words*, 141–42.

[16] Natalie Davis Levine, interview by Eden Bart, 2002; transcript from Eden Bart.

[17] Ann Michaels, *Fugitive Pieces* (New York: Vintage International, 1996), 39.

[18] Hoffman and Cole, *Sacred Trash*, 13.

[19] Adelheid Fischer, "Volumes," *The Magazine for Members of the Minneapolis Institute of Arts* (April 1989): 14.

[20] Bart, interview with the author, October 17, 2017.

[21] See Fred Moten, "The Case of Blackness," *Criticism* 50, no. 2 (2008): 177–218.

[22] Rebecca Solnit, *Secret Exhibition: Six California Artists* (San Francisco: City of Lights Publishers, 1991), 29.

[23] Ibid., 43.

[24] Lauren Palmer (assistant curator, Fine Arts Museums of San Francisco), email to the author, January 25, 2019.

[25] Ibid.

[26] Air de Paris, "Wally Hedrick," news release, 2017.

[27] Hedrick is quoted as giving this explanation of the act: "Since there is no way for me to affect any political decision, what I'll do is I'll deny Western Culture my contribution." See Greil Marcus, "The Incredible Disappearing Act," in *San Francisco Focus* (October 1991).

[28] Bart first used fragments of flags in *Processional* (1978), an installation of five fibrous torsos representing five stages of womanhood: the innocent, the siren, the matriarch, the mourner, and the ancestor. The torso for the ancestor is lined with amuletic black leather pouches filled with different materials, including strips of American flags.

[29] The poem was first published in Robert Bly, *The Light around the Body* (New York: Harper and Row, 1967). It was reprinted in Howard Nelson, *Robert Bly: An Introduction to the Poetry* (New York: Columbia University Press, 1984), 63.

[30] Technical information about the memorial can be found on the Vietnam Veterans Memorial Fund's website, www.vvmf.org/About-The-Wall.

[31] Ibid.

[32] Maya Lin, *Boundaries* (New York: Simon and Schuster, 2006), n.p.

[33] The first of these public sculptures was a spiral made of individually cast bronze books for a public library in Ibaraki, Japan, in 1991. For information about all of Bart's public art commissions, see the Chronology at the end of this book.

[34] The quotation is from an undated artist statement (held in the archives of the artist) that Bart wrote in the 1980s about her collaborative series of paintings titled *Re-Marks.*

[35] Bart, interview with the author, January 17, 2019.

[36] The autobiography *The Words to Say It* (1984) chronicles the mental illness and seven-year psychoanalytic treatment of Algerian-born French writer Marie Cardinal.

[37] Christina Schmid, *Locus* (New York: Driscoll Babcock Gallery, 2013), n.p.

[38] Dolly Fiterman, "Foreword," *Dialogue: Alchemy of the Word* (Minneapolis: Dolly Fiterman Fine Arts, 1993), n.p.

[39] Ibid.

[40] Bart, email to the author, March 18, 2019.

[41] See Adelheid Fischer, "Memento Mori," *The Magazine for Members of the Society of Fine Arts* (February 1988): 16–20.

[42] John M. Riddle, *Goddesses, Elixirs, and Witches: Plants and Sexuality throughout Human History* (New York: Palgrave Macmillan, 2010), 12.

[43] Ibid.

[44] Ibid., 17.

[45] Ibid.

[46] Ibid., 44.

[47] See Riddle, *Goddesses, Elixirs, and Witches.*

[48] Eleanor Rand Wilner, "The Apple Was a Northern Invention," in *The Girl with Bees in Her Hair* (Port Townsend, Wash.: Copper Canyon Press, 2004), 33.

[49] For a full history of WARM, see Joanna Inglot, *WARM: A Feminist Art Collective in Minnesota* (Minneapolis: Weisman Art Museum and University of Minnesota Press, 2007).

[50] Estella Lauter, *Women as Mythmakers: Poetry and Visual Art by Twentieth-Century Women* (Bloomington: Indiana University Press, 1984), 18.

[51] Ibid., 17.

[52] Bart, email exchange with the author, April 13, 2019.

[53] Nor Hall, *The Moon and the Virgin: Reflections on the Archetypal Feminine* (New York: Harper and Row, 1980).

[54] *The Dark Core: A Collaboration in Poetry and Prose, Visual Art, Theatre, Dance, and Myth* (St. Paul: Macalester College, 1982), archive of the artist. Macalester dance instructor Becky Heist and the Macalester Dance Ensemble created a new choreographic work inspired by *The Moon and the Virgin*; the Illusion Theater Company performed a one-act play based on Charlotte Perkins Gilman's early feminist story "The Yellow Wallpaper"; and poets Jonis Agee, Elizabeth Erickson, Alvin Greenberg, and Patricia Hampl read works reflecting on the dual self and darkness.

55 Bart, email to the author, April 12, 2019.

56Abbe, "Here come the artists, there goes the neighborhood."

57 Bart, interview with the author, August 6, 2018.

58 Mirra Banks, *Anonymous Was a Woman* (New York: St. Martin's Press, 1979). Included in the book is Marguerite Ickis's retelling of her great-grandmother's secret: a quilt she made over the course of twenty years bore evidence of the joy but also the sorrow and anger she experienced in her roles as mother and wife. Ickis quotes her great-grandmother as saying, "I tremble sometimes when I remember what that quilt knows about me." In other words, these objects transmit memories, coded forms of expression, and even subversive messages of forgotten women.

59 Abbe, "Here come the artists, there goes the neighborhood."

60 John M. Riddle, *Eve's Herbs: A History of Contraception and Abortion in the West* (Cambridge, Mass.: Harvard University Press), 65.

61 Ibid., 167.

62 Ibid., 205.

63 Ibid., 111.

64 Silvia Frederici, *Caliban and the Witch: Women, the Body, and the Primitive* (Brooklyn, N.Y.: Autonomedia, 2004), 14; and Silvia Frederici, *Witches, Witch-Hunting, and Women* (Oakland: PM Press), n.p.

65 Waldman, *Trickster Feminism,* 18.

66 Ava Kofman, "Bruno Latour, the Post-Truth Philosopher Mounts a Defense of Science," *New York Times* (October 18, 2018).

67 Frederici, *Caliban and the Witch,* 173 (emphasis added).

68 Ibid., 142–43.

69 Fischer, "Memento Mori," 17.

70 Waldman, *Trickster Feminism,* 1.

71 Ibid., 8.

THE GENIZA AS A PROCESS OF THOUGHT

Studio Photographs by John Schott

On first visit, Harriet Bart's studio looks like an exhibition space rather than a working studio: an obsessive geometry of exquisitely considered placements, vistas, juxtapositions, taxonomies, and alignments, all washed in sheets of golden northern light.

On second visit, a surprise: so many things have decamped and relocated, as though objects had awakened at night, cavorted promiscuously in the bluing light, and, after discovering congenial new friends, decided to hang out together to prolong the conversation.

Harriet's studio is a geniza, yes, since here her legacy is safe and assured. Yet it is also a model of her mind, a machine for discovery, always on the march, and something of a party.

Looking at these photographs, imagine this studio itself as an uber-composition in which Harriet assembles, edits, and reedits a ready-at-hand history of her work, along with newly introduced, frequently uncertain provocations. Think of this studio as the material externalization of a restless, curious mind: a space-based, object-centered assemblage of novel potentialities, which, under persistent interrogation, strike sparks and offer startling affinities.

This geniza is not a reliquary; it is a propeller.

Make no mistake: work gets made here. Although you do not see her in most of these photographs, imagine Harriet here — always fastidiously turned out — perhaps on hands and knees, wrestling something into perfection.

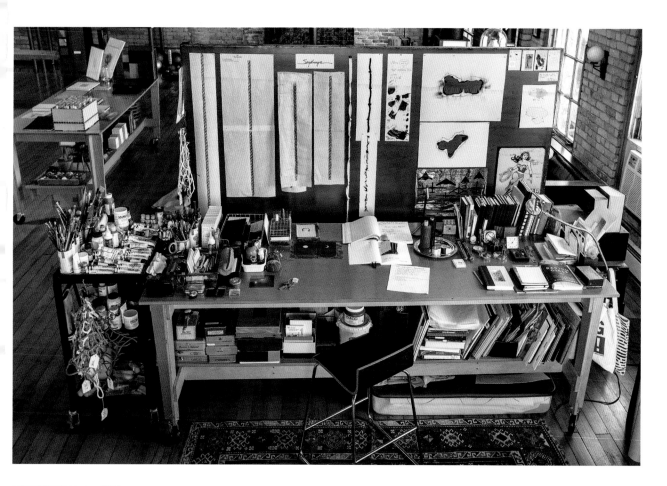

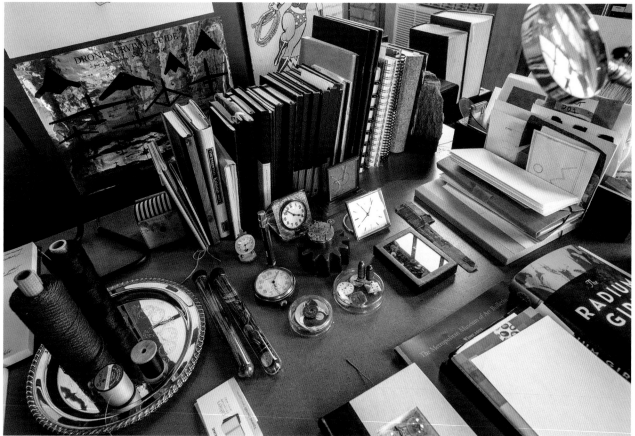

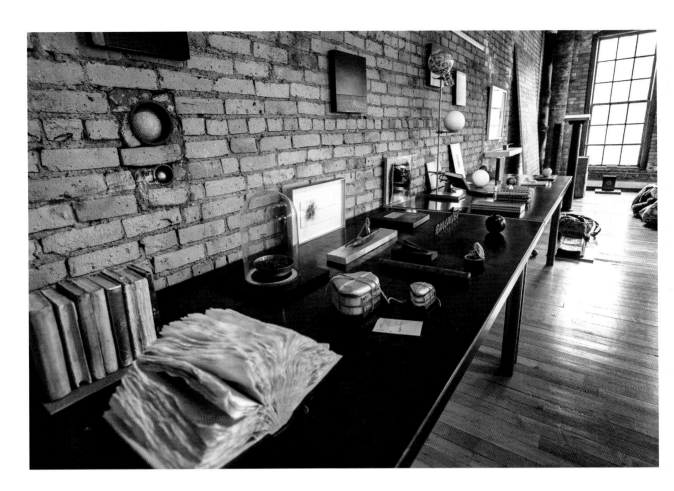

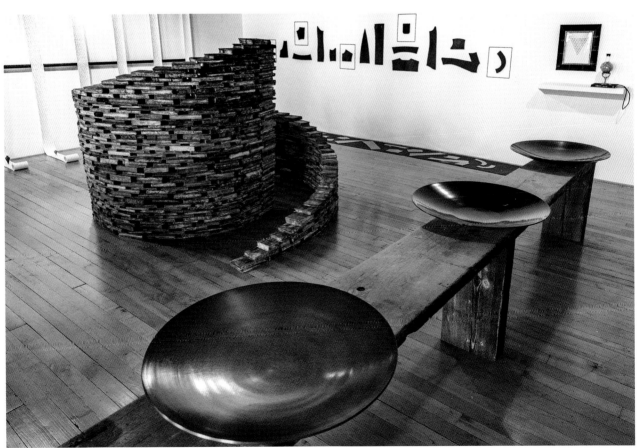

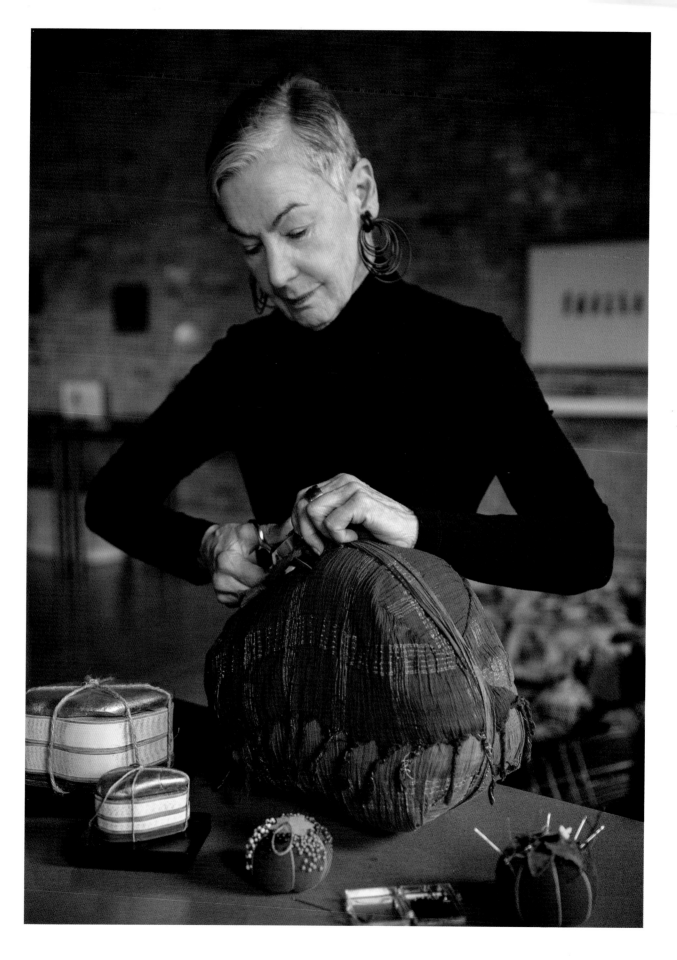

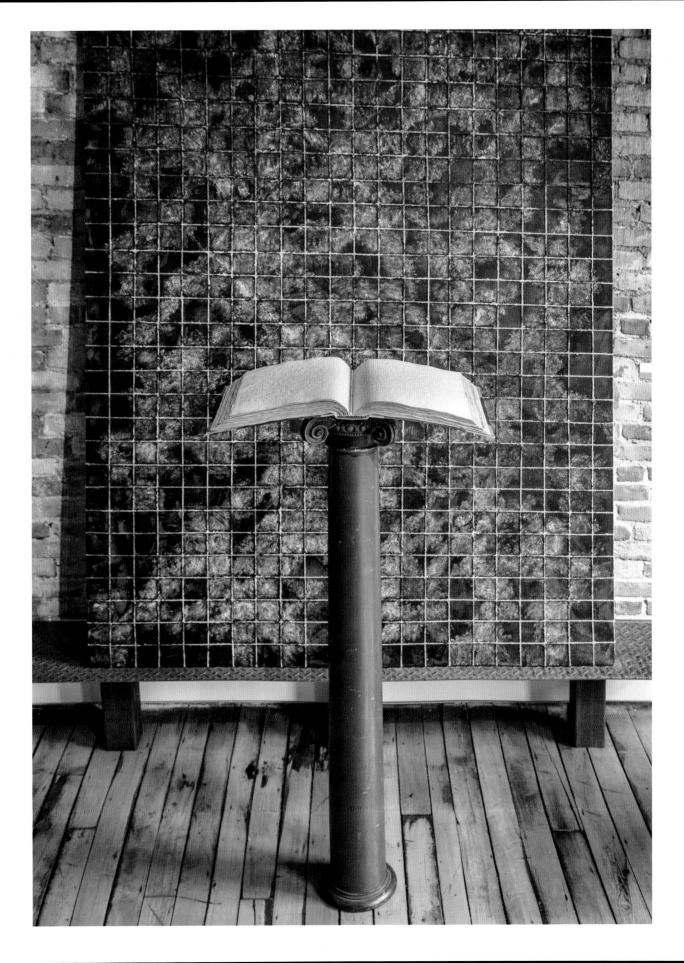

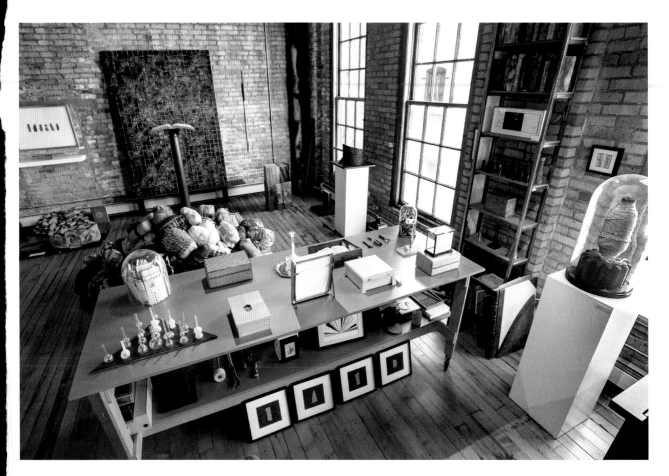
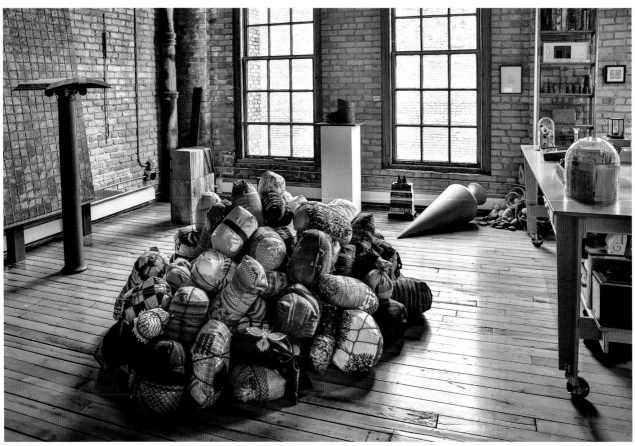

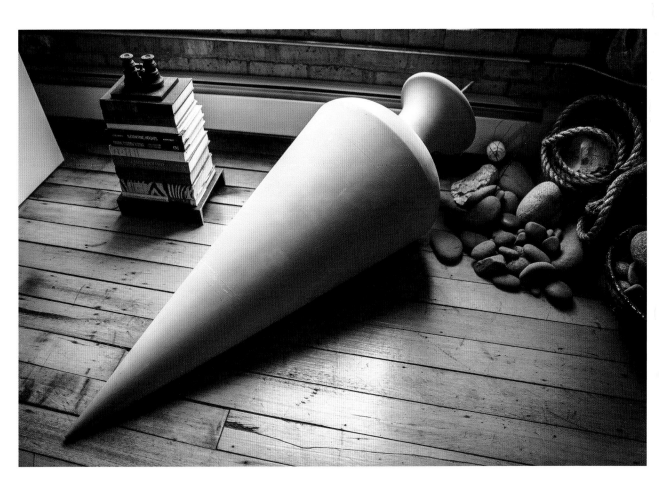
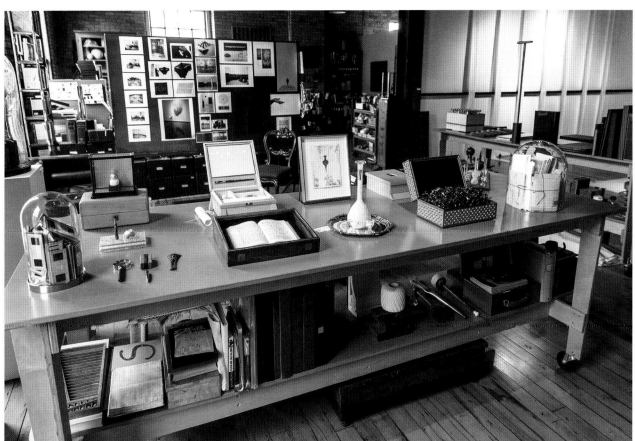

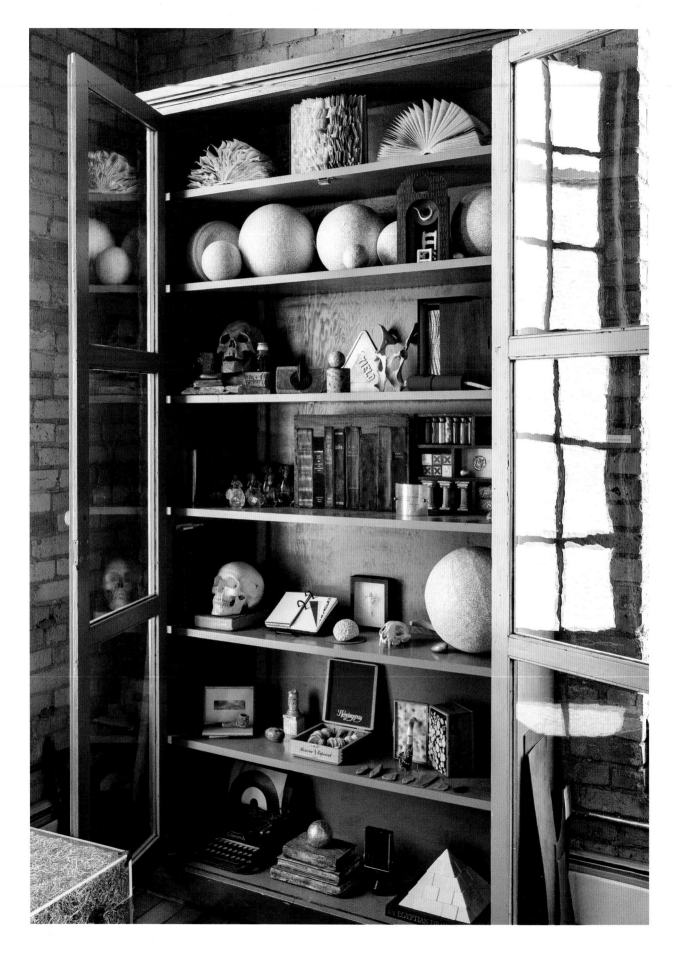

VESSELS
(containing)

AUTOBIOGRAPHY

Stephen Brown

The genre of self-portraiture concerns the artist's creative self-representation driven by her own perceptions of identity. Self-portrayal requires reflection, but Harriet Bart's *Autobiography* suggests that the naturalistic depiction of the face is not essential. Instead, the work seeks to evoke the self and its significance through the inscription of letters, words, forms, and colors.

In an artist statement from 2011, Bart describes *Autobiography* as "a self portrait of sorts . . . a personal year-by-year history of time and transformation." The sculpture approaches the traditional understanding of portraiture as narrative: the belief that from an image, biographical knowledge can be gained about the subject in a manner comparable with literary description. But *Autobiography* departs from the privilege traditionally accorded the human face. The viewer is introduced obliquely to the artist's life through an array of vessels, a series of test tubes containing evidence, gathered across the years through 2011, the year of the work's creation. With a minimalist's reserve and an elegance entirely characteristic of her oeuvre, Bart developed a calendrical system of reflecting on the seventy years of her life that had passed at that time. Representing the self through discrete materials and documents chosen for each year, *Autobiography* provokes a reconsideration of the genre. Unlike a representational image, it confronts the artistic and philosophical problem of representing a person over time.

A thin metal shelf is attached to the wall and extends horizontally, supporting seventy tubes with their cork stoppers. The linear presentation is arranged in containers that connote preciosity and the systematic methods of the laboratory, reflecting personal intimacy and characteristics of the scientific document. It is as though the transformations of a life were presented as registered by chemistry, pharmacy, or medicine. Yet although this appearance suggests objectivity, the elements exceed exact designation, and the viewer is left to decrypt them for their further significance. Set orthogonally below the tubes is a white shelf that supports an open ledger. The pages of this book offer a simple chart with two columns: on the left side is the imprint of a cork stopper in black ink, and on the right is a word describing the contents of each tube. This documentation forces the viewer to evolve from spectator to investigator.

Certain elements suggest an interest in science and alchemy: a feather of a blackbird (6), pebbles (11), bee pollen (29), iron dust (55), and Hawaiian black sand (68). The attention to the physical body recalls the medieval study of nature, horticulture, and medicine, as well as the recording of knowledge in manuscripts.[1] The definition of the humors in the Middle Ages developed from a desire to understand creation and how bodies functioned in relation to the world. Following this pattern, Bart might here be interpreted as inserting herself into the canon of women in the sciences through the exploration of her own body. The ledger is organized to correspond with the order of the tubes, from left to right,

chronologically advancing through Bart's life, and its contents partake of the sense of the memento; each piece incorporates its own materiality, its extraction from the flow of time, and its repositioning within the matrix established by the work of art.

Examination of the traces within each tube produces sensual associations, thoughts, and feelings that are experienced directly, without the mediation of a representational image. The categories are wide-ranging: organic substances; visual and literary descriptions; references to individuality and social experience; the body and sexuality; fauna; letters, journals, poetry, literature, and manuals; music; knowledges (ancient, modern, and contemporary); gifts; and base metal. The second tube contains a child's signet ring, suggestive of beginnings and belonging. Others contain texts evocative of war and memory, recurring themes throughout Bart's oeuvre. Bart also incorporates elements of her own creative work, reflexively establishing the relationship between art and her identity.

The artist is here both the author and subject of an ensemble that comprises the memories of her being. Under the guise of scientific objectivity, the observer is invited to "read" the traces, although these are susceptible to variable meanings. The viewer is challenged to question the objectivizing assumptions of the genre of portraiture. Through *Autobiography's* focus on concepts, associations, and time, the enigma resides in the work's appeal to an ekphrasis that is divided from the experience of a unified narration or image.

Contrary to the immanence of a formalist materialism in the minimalist movement in art, the relations of visual presence and referential experience are key to the heightened awareness of the sculptural objects of Harriet Bart. Their poetry is one of connection and transcendence, which, to the artist's mind, "draw attention to imprints of the past as they live in the present."[2] Not by chance, *Autobiography* includes references to archaic Greek poetry (4: "Someone will remember us . . . in another time" [Sappho]) and to Marcel Proust (41). Through this scientific framework of accumulations (the laboratory, the archive, the geniza) emerges a philosophical sense of the dichotomy between knowledge and feeling. This polarity is bridged through the experience of the work of art. The autobiography, deliberated and recapitulated as a synthesis of the artist's passage through time, is transmuted into collective remembrance from the fragments of her own subjectivity.

Notes
The author is grateful for assistance from Emily Knapp in writing this essay.

[1] See Victoria Sweet, "Hildegard of Bingen and the Greening of Medieval Medicine," *Bulletin of the History of Medicine* 73 (Fall 1999): 381–403.

[2] Harriet Bart, quoted in Joanna Inglot, "*Between Echo and Silence*: Harriet Bart," exhibition catalogue, Law Warschaw Gallery, Janet Wallace Fine Arts Center, Macalester College, St. Paul, Minnesota, 2012.

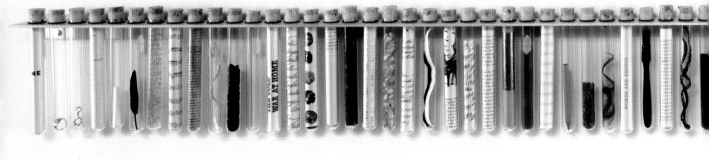

Autobiography, 2011
mixed media
6 ¼ x 70 ½ x 2 inches
(ledge with vials)
3 x 36 x 12 inches (shelf)
9 ½ x 29 ½ x 1 ½ inches
(open ledger)

Each of the seventy test tubes in
Autobiography contains a material
that represents each year of the
artist's life up to the year she creat-
ed the work. The title connotes a
literary rather than a visual portrait
of the self and attests to the influ-
ence of the written word on Bart's
art. Bart considers the open ledger
in the installation as both an inven-
tory and a list poem; the pages of
the open ledger feature imprints
of each of the seventy corks in one
column and a one-word descrip-
tion of the content of that tube in
another.

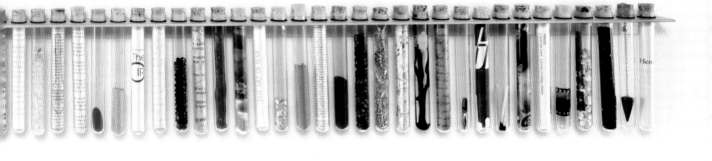

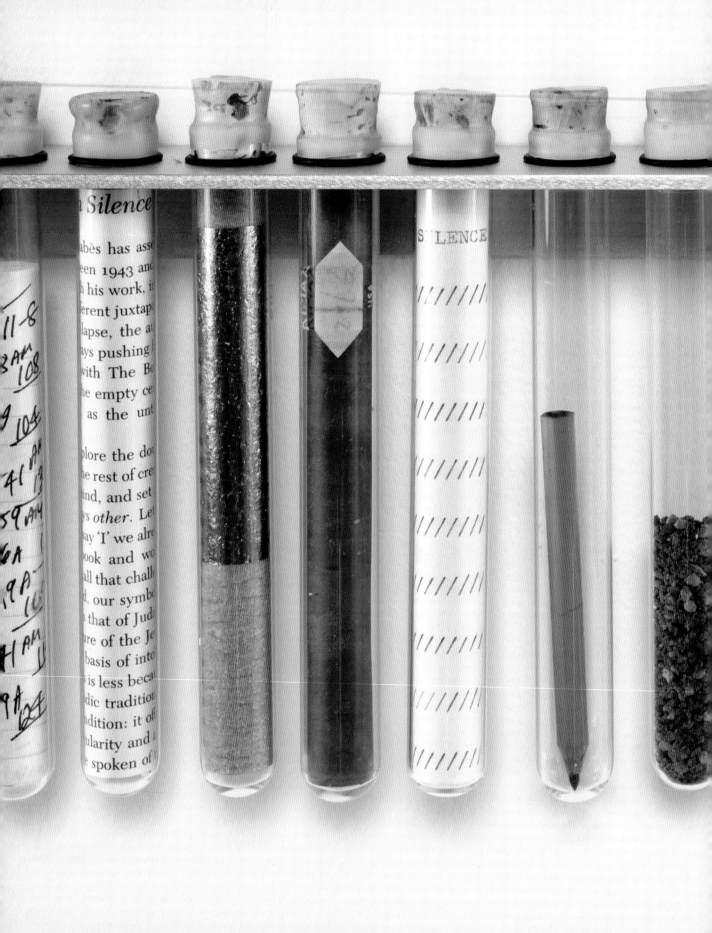

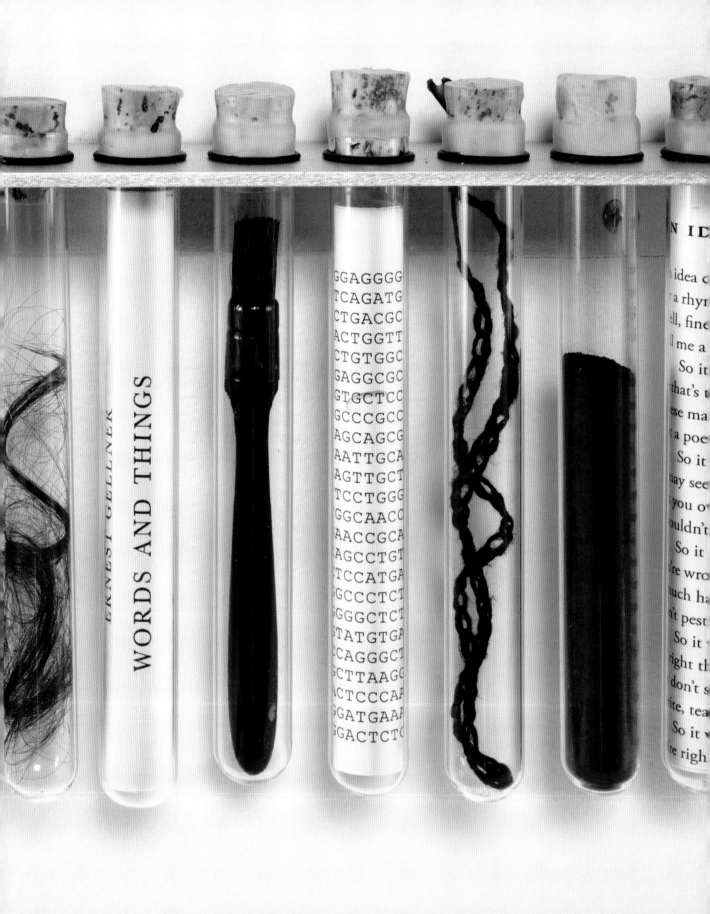

RELIQUIAE
Nor Hall

Reliquiae is from the graphic essay in Nor Hall, *Ancestry of Friendship* (forthcoming).

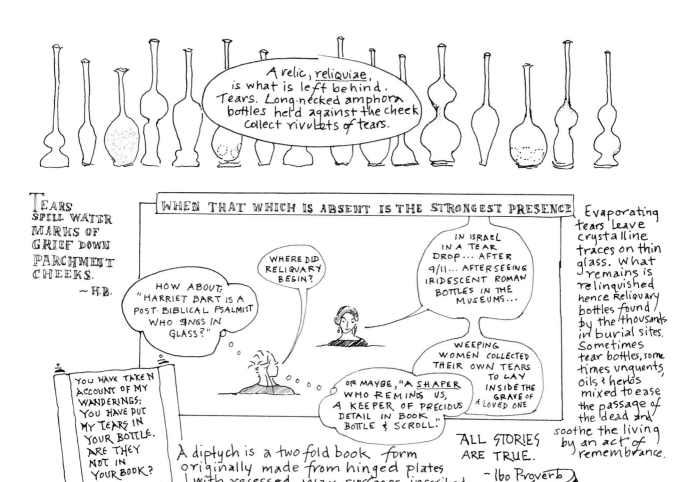

A relic, reliquiae, is what is left behind. Tears. Long-necked amphora bottles held against the cheek collect rivulets of tears.

Tears spill water marks of grief down parchment cheeks. ~H.B.

WHEN THAT WHICH IS ABSENT IS THE STRONGEST PRESENCE

HOW ABOUT: "HARRIET BART IS A POST-BIBLICAL PSALMIST WHO SINGS IN GLASS?"

WHERE DID RELIQUARY BEGIN?

IN ISRAEL IN A TEAR DROP... AFTER 9/11... AFTER SEEING IRIDESCENT ROMAN BOTTLES IN THE MUSEUMS...

WEEPING WOMEN COLLECTED THEIR OWN TEARS TO LAY INSIDE THE GRAVE OF A LOVED ONE

OR MAYBE, "A SHAPER WHO REMINDS US, A KEEPER OF PRECIOUS DETAIL IN BOOK, BOTTLE & SCROLL."

Evaporating tears leave crystalline traces on thin glass. What remains is relinquished hence Reliquary bottles found by the thousands in burial sites. Sometimes tear bottles, sometimes unguents, oils & herbs mixed to ease the passage of the dead and soothe the living by an act of remembrance.

YOU HAVE TAKEN ACCOUNT OF MY WANDERINGS; YOU HAVE PUT MY TEARS IN YOUR BOTTLE. ARE THEY NOT IN YOUR BOOK?

PSALM 56:8

ALL STORIES ARE TRUE.

~Ibo Proverb

A diptych is a two-fold book form originally made from hinged plates with recessed wax surfaces inscribed, erased, reinscribed. When made of anodized aluminum the shelves subtly recede foregrounding the shapes of translucent bottles that appear suspended. They hold our imagination of grief, contain memories of love & loss, making that which is impossible to grasp graspable. Each bottle is shaped to the palm of the hand as if to deliver the message of the poet Valéry, that "products of the fire are molded to be caressed."

DID WE READ THIS ONE ALOUD IN PUBLIC SCHOOL? H.B.'S ANCESTRAL STRAIN RUNS RIGHT THROUGH THE GENIUS GAON OF VILNA WHO ORDAINED (18thc) THE DAILY READING OF PSALMS FOR EDUCATIONAL PURPOSES.

CHAGALL 1935

GAON'S STUDY - KLOYZ BURNT WWII

Who shall write the history of tears? -R. Barthes

ON THE SHAPES OF TEARS

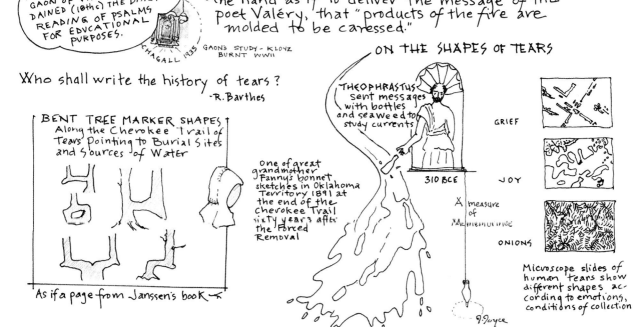

THEOPHRASTUS sent messages with bottles and seaweed to study currents

310 BCE

A measure of melancholia

GRIEF

JOY

ONIONS

Microscope slides of human tears show different shapes according to emotions, conditions of collection

BENT TREE MARKER SHAPES
Along the Cherokee Trail of Tears Pointing to Burial Sites and Sources of Water

One of great grandmother Fanny's bonnet sketches in Oklahoma Territory 1891 at the end of the Cherokee Trail sixty years after the Forced Removal

As if a page from Janssen's book

Reliquary, 2003
blown glass,
anodized aluminum
30 × 30 × 4 ¼ inches
Aluminum fabricated
by Tom Oliphant
Glass by Tom Rine
at Island Glass Studio

These vessels are inspired by the small teardrop-shaped bottles that have been found on graves throughout the ancient Mediterranean world. Their function in Hellenistic and early Roman funerary rituals has not been established, but some early scholars believed they were lachrymatories to collect the tears of mourners. This interpretation has been largely dismissed by contemporary scholars, but it remains of interest to Bart for suggesting the complexities of memory.

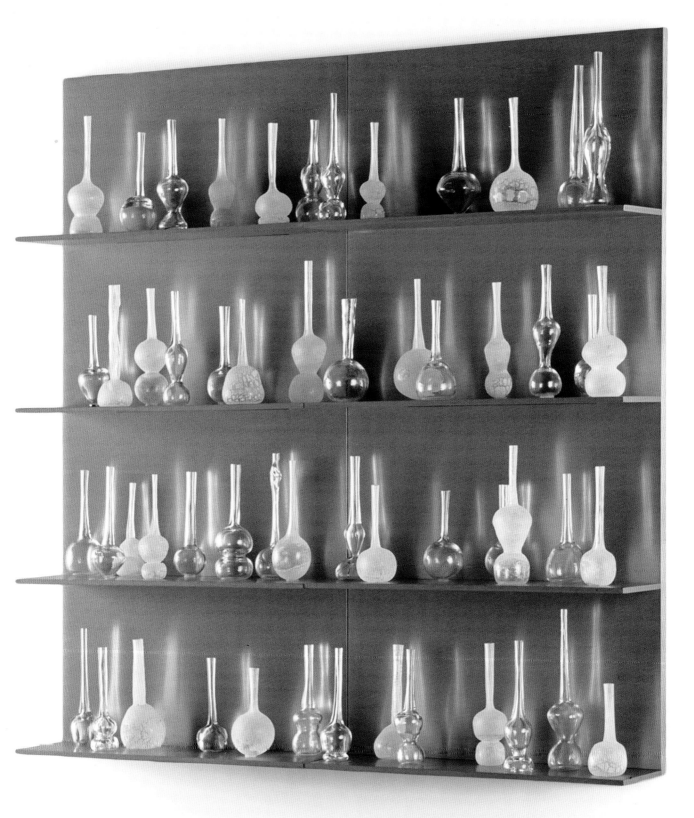

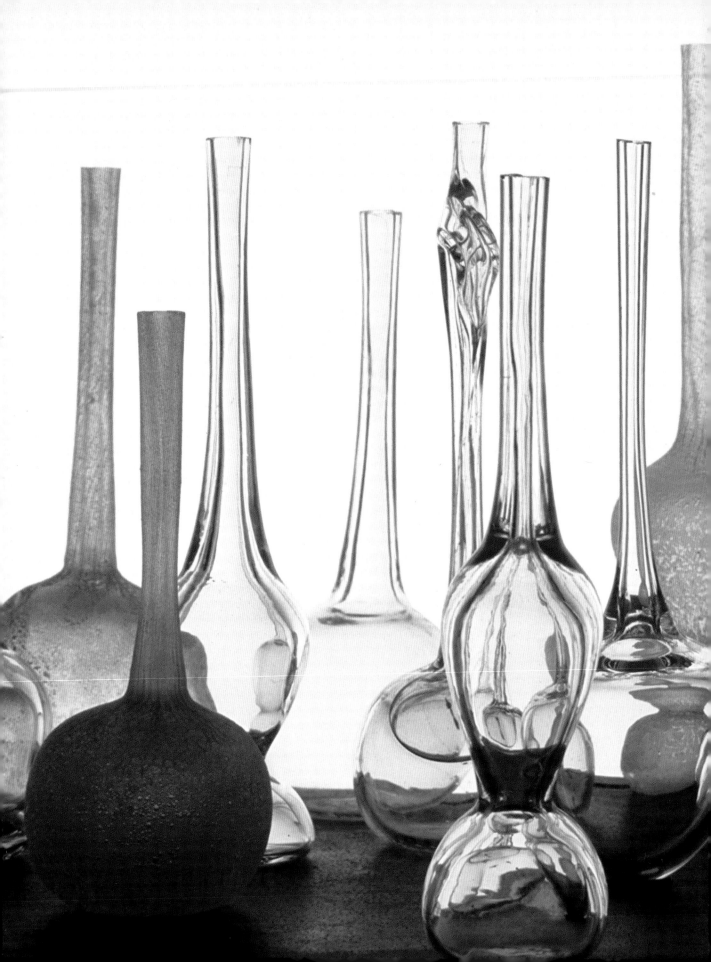

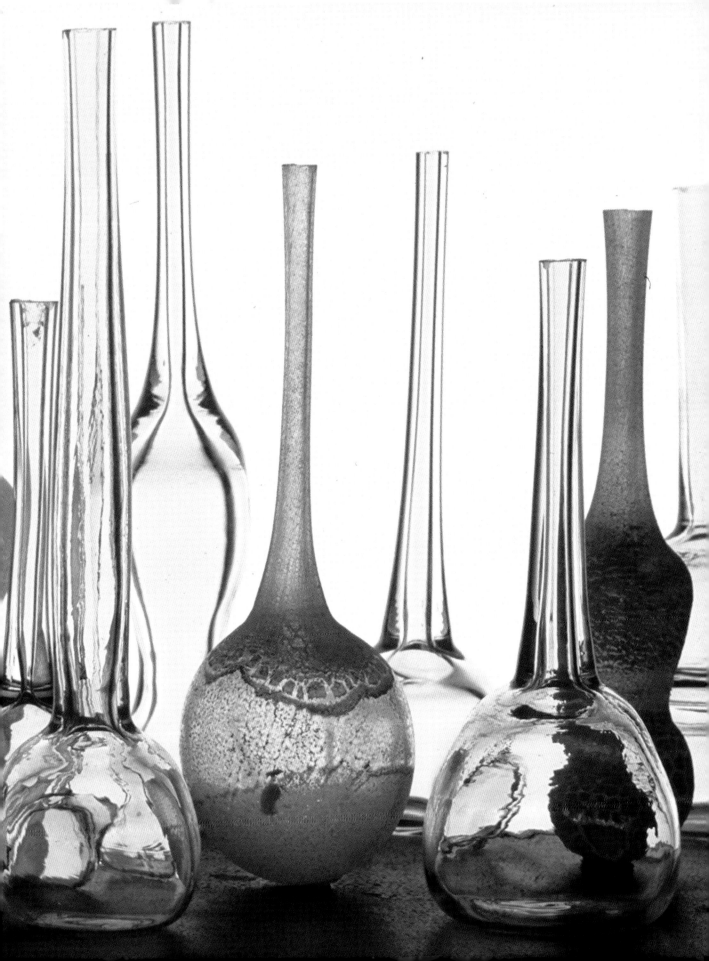

Museum, 2007
mixed media
9 ¼ x 11 ½ x 12 inches (open)
5 ⅛ x 11 ½ x 7 ¼ inches (closed)

This work was made in response to
the poem "Museum" by Minneapolis-
based poet Eric Lorberer, which Bart
interpreted to be a reflection on the
relationship between beauty and danger.
A gold box, which recalls the medieval
reliquary, contains swarf from the
lathing of Bart's bronze bowls. Buried
with the sharp metal are strips of
paper on which lines of the poem have
been printed in gold ink. Bart chose
the paper for its jewel-toned color,
similar to the heat-exposed swarf.
Those enticed by the beauty of the box
will reach for a line from the poem
and find its contents sharp.

Lustral Bowl, 2008
carbon steel, glass
45 x 6 inches

Made of spun carbon steel and
often arranged on the floor in a
series of three, this object suggests
both emptiness and the potential
of being filled. Occasionally it is
displayed holding materials such
as small shards of glass.

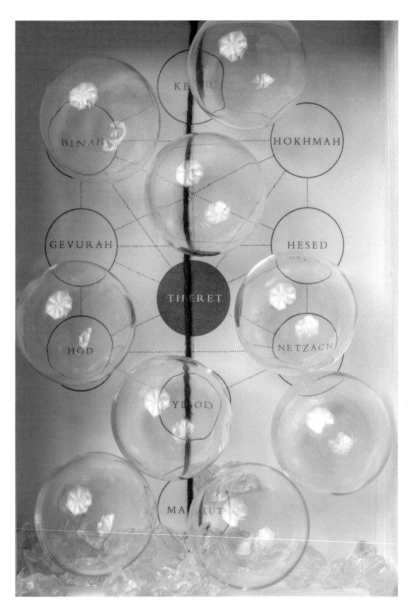

Essential Kabbalah, 2019
mixed media
7 ⅞ x 5 ⅞ x 1 ¼ inches
Edition of 3

Bart was inspired by the Ten Sefirot, the ten spheres of light understood within the Kabbalah to hold God's light. Unable to withstand the pressure of the emanative process, some spheres shattered, causing divine sparks to disperse throughout the world. Within a cutaway space at the center of the book-like object are ten glass spheres; one is broken.

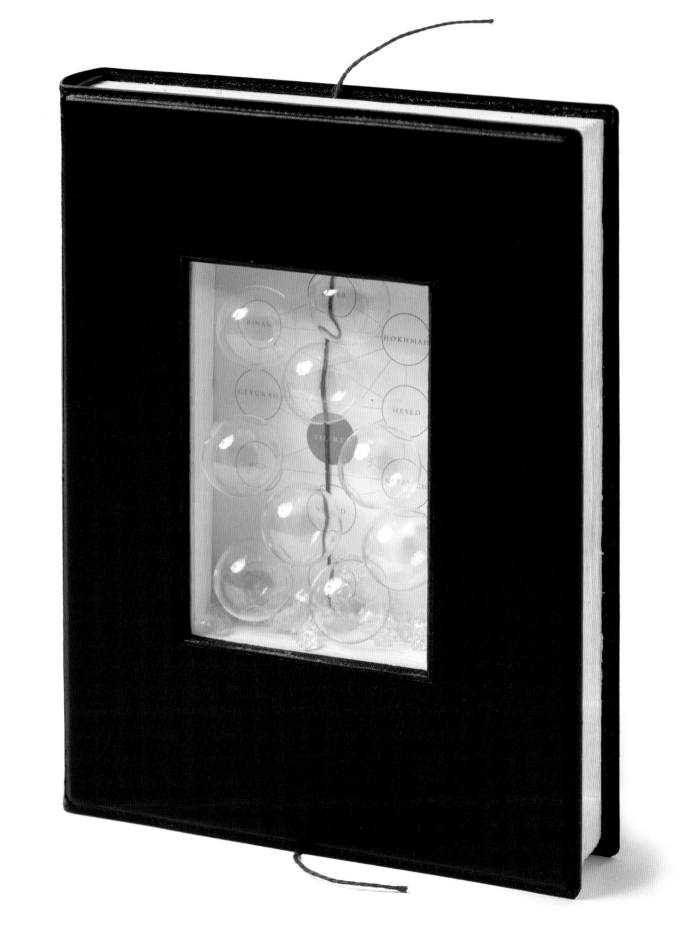

The Book of Sand, 2002
altered book, glass, vials, sand
9 ¾ x 14 ¾ x ¾ inches

After returning home from a residency in Tiberias, Israel, Bart received a blank book to commemorate her trip and was asked to create artwork for it. Rather than draw in it, she chose to transform it into an object. Referencing Jorge Luis Borges's *The Book of Sand,* Bart's book houses seven glass vials of sand collected on her travels – from the Dead Sea, Death Valley, El Santuario de Chimayo, the Gulf of Mexico, the Mediterranean Sea, Petra, and the Valley of the Kings. These vials fit within seven rectangular cutouts in the book's pages.

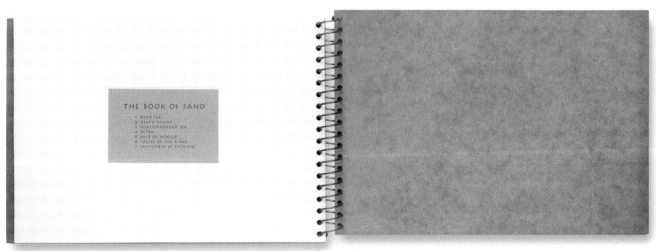

THE BOOK OF SAND
1 DEAD SEA
2 DEATH VALLEY
3 MEDITERRANEAN SEA
4 PETRA
5 GULF OF MEXICO
6 VALLEY OF THE KINGS
7 SANTUARIO DE CHIMAYO

Homage, 2011
mixed media
8 x 6 x 2 ¾ inches
(open)

Made in memory of Bart's longtime collaborator German visual poet Helmut Löhr, the vials within the case hold small circular cutouts of dictionary text. In honor of their collaborative practice of creating small multiples (a series of identical artworks) as gifts for visitors to their exhibitions, Bart offered a vial to each person who attended Löhr's memorial service. She shared these instructions:

Carry it with you,
place it on a mantel or shelf
leave it on a mountain top or at a sacred site.
If you like, scatter the confetti of visual poetry
in celebration of Helmut's life.

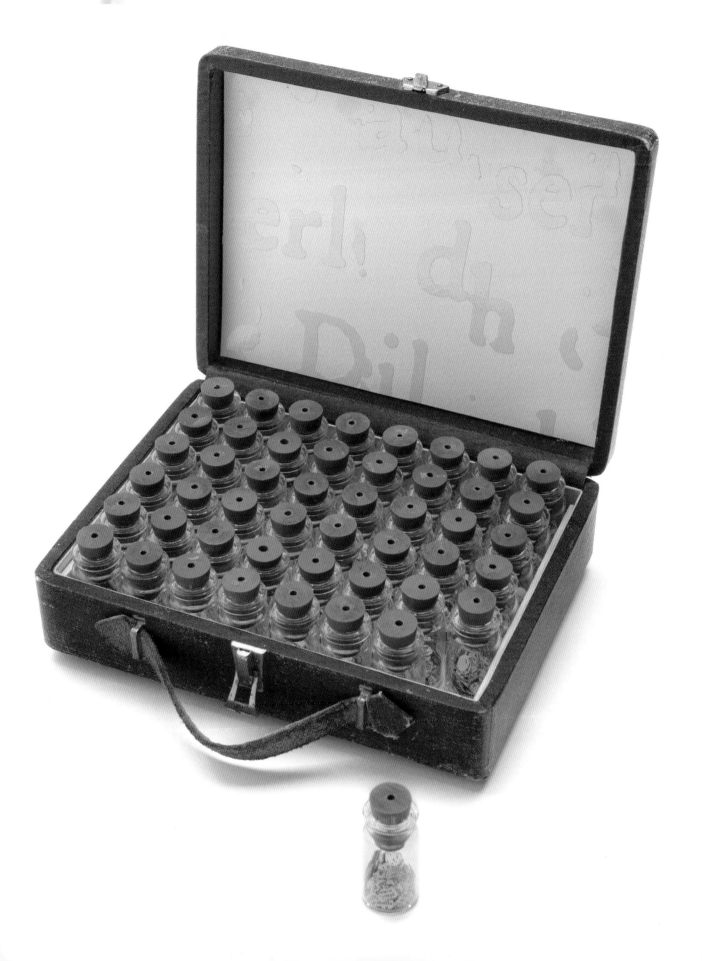

AMULETS
(shielding)

ABRACADABRA UNIVERSE

Joanna Inglot

Entering Harriet Bart's studio in the warehouse district in downtown Minneapolis, one encounters a magical space that is at once reminiscent of an alchemical laboratory, a historical archive, and a modern art gallery. Filled with neatly arranged boxes, tables, little chests, and cupboards, where humble objects are transformed into things of beauty, Bart's studio offers an imaginative constellation of elements that speak of myth, history, science, and memory. Cabinets, files, and bookshelves, as in a *Wunderkammer*, mix with quotidian items like letters, buttons, and vessels, showcasing a wide array of captivating works of art that traverse the trajectory of her prolific fifty-year career. Using paper, stone, metal, glass, wood, found objects, books, and the alchemy of words, Bart works like a magician who turns the ordinary into the extraordinary while silently assuming the role of a cultural storyteller.

Abracadabra Universe (2007) is an assemblage that occupies a key position in Bart's oeuvre. An elegantly framed red vinyl print with the magical incantation ABRACADABRA hangs on the wall next to a metal Bunsen burner, which holds a laboratory flask filled with gold leaf and is connected via a rubber tube to a book titled *The Universe*, evoking legendary alchemical transmutation of base matter into gold. Looking like an alembic apparatus (the iconic alchemical device used for distillation and purification of substances), the globular glass container dazzles with shimmering gilded flakes

that allude to the attainment of the elusive "Philosopher's Stone" or the ultimate wisdom, the Magnum Opus of human endeavor. The unknown contents of the book (Byron Preiss's collection of essays by leading science fiction authors, artists, and scientists), like a furnace in an alchemist's laboratory, provide the power source for the discovery and transmission of physical and metaphysical knowledge. Bart often repeats the famous dictum of the French symbolist poet Stéphane Mallarmé to underscore her deep belief in the book and the magnitude of the written word: "Everything in the world exists in order to end up as a book."[1] Just as Mallarmé considered his imaginary visual poem *The Book* as a total work of art or a cosmic text encompassing "all existing relations between everything,"[2] Bart deftly employs poetic metaphors to tie together diverse cultural referents and incongruent conceptual threads into one everchanging universe.

Abracadabra is probably the best-known magical incantation. From ancient times to the present, the word has been used in charms and spells to ward off demons and evil spirits but also to protect, heal, and bring good fortune. The origin of the word has been traced to the ancient Near East and most likely came from the Hebrew phrase *Ha-Brachah-dabrah* ("Name of the Blessed"), although other sources have also been claimed.[3] According to historical records, Abracadabra was first inscribed in the third century CE by the Roman physician Quintus Serenus

Sammonicus on a papyrus amulet in the shape of an inverted triangle, with letters decreasing line by line until a single character A remained at the very bottom. In his "pharmacological recipe poem" *Liber Medicinalis*, Quintus Serenus prescribed abracadabra amulets for his patients to wear around the neck as supernatural protection against fever, pain, and disease.[4]

The ancient and medieval use of talismans as textual shields for personal protection and medicinal cure diminished with time and has been relegated in Western discourse to the realm of superstition or exercise of "black magic." As the historian Don Skemer discovered, however, textual amulets were not just curiosities but "a geographically widespread Western ritual practice at the nexus of religions, magic, science, and written culture."[5] Like magical papyri of ancient Egypt and medieval illuminated manuscripts, they contribute to our understanding of the history of the book.[6] Bart explores this broadly defined significance of amulets in her installation. She intentionally encased the ABRACADABRA text in a heavy, old wooden frame to preserve its original protective meaning and to present it as a physical artifact of historically transmitted knowledge.

Amulets or talismans based on the magical efficacy of written words, in the form of both legible and illegible scripts, became widely used in ancient Mediterranean cultures, including different strands of the Jewish tradition.[7]

Throughout history, biblical and rabbinic sources and esoteric Kabbalistic teachings contained many references to alchemy, astrology, numerology, divination, and talismanic healing.[8] In these diverse manifestations, the Hebrew language and "the Word" (as the voice of God and the mythical origin of human language at the time of Creation) acquired a special sacred power, leading to the veneration of books and rich collections of manuscripts.

Bart's interest in the written text is deeply rooted in the traditions of Jewish mysticism and in her Jewish heritage. The artist first used abracadabra, along with other magic ciphers or graphemes (such as A.E.I.O.U.), in *Dialogues: Alchemy of the Word I–III* (1993–95), a set of collaborative exhibitions with the German artist Helmut Löhr in which, as Bart claims, she engaged in complex explorations of "the alchemy of the word, the iconography of text, and the labyrinth of the book."[9] In other works, including *Uninscribed Book, Strata: Tales of Power, The Invisible World,* and *Shards,* Bart altered found books by cutting them, erasing or obliterating sentences, or washing away words. In *Without Words* (reminiscent of ancient talismanic lead curse tablets), she deconstructed text to free language from conventional structures and stable meanings. She often appropriates well-known cultural signs and symbols but always defamiliarizes with unexpected juxtapositions of image and text or superimposition of diverse materials.

Harriet Bart's strategies can be seen

as a feminist critique of the social power of disciplinary discourses and institutionalized regimes of knowledge that isolate and delimit human cognitive and imaginative capacities. Calling into question the dominant Western master narrative of the supreme authority of science, she draws on multiple branches of knowledge to open new modalities and to disclose alternative forms of knowing. She interrupts clichés, discredits the binary logic, and unsettles the dominant systems of classification and rigidly established canons while introducing elements of postmodern visual and textual play. Conceived as alchemical transformations, visual poems, and readings into archives of history, science, magic, and mythology, Bart's art, including the spellbinding *Abracadabra Universe,* delights with its refined aesthetic and inspires to unlock the hidden treasures of multivalent narratives.

Notes

[1] Interview with Harriet Bart, January 18, 2009.

[2] See Stéphane Mallarmé, *The Book,* trans. Sylvia Gorelick (Exact Change, 2018).

[3] Don S. Skemer, *Binding Words: Textual Amulets in the Middle Ages* (University Park, Penn.: The Pennsylvania State University Press, 2006), 25.

[4] Ibid.

[5] Ibid., 5.

[6] Ibid., 280–81.

[7] There is a large body of scholarship on the topic. See Theodor H. Gaster, "Amulets and Talismans," in *Hidden Truths: Magic Alchemy and the Occult,* ed. Lawrence E. Sullivan (New York: Macmillan, 1987), 145–47. Even though the words *amulet* and *talisman* were often used interchangeably, talismans rely on astrological images, signs of the zodiac, or images of the constellations while textual amulets refer to brief apotropaic texts, such as Abracadabra, which were often carried on the body in order to heal, protect the bearer against evil spirits, or bring good luck. See Skemer's Introduction in *Binding Words.*

[8] Lawrence H. Schiffman and Michael D. Swartz, *Hebrew and Aramaic Incantation Texts from the Cairo Genizah: Selected Texts from Taylor–Schechter Box K1* (Sheffield: JSOT Press, 1992), 44. See also Joseph Naveh and Shaul Shaked, *Amulets and Magic Bowls: Aramaic Incantations of Late Antiquity* (Jerusalem: Magnes Press, 1985) and their *Magic Spells and Formulae: Aramaic Incantations of Late Antiquity* (Jerusalem: Magnes Press, 1993).

[9] See the artist statement in *Dialogue: Harriet Bart and Helmut Löhr,* exhibition catalogue (Minneapolis: Dolly Fiterman Fine Arts, 1993).

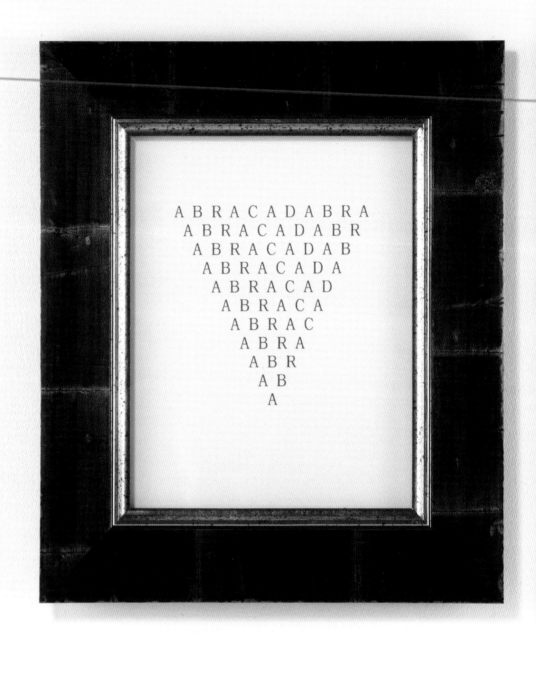

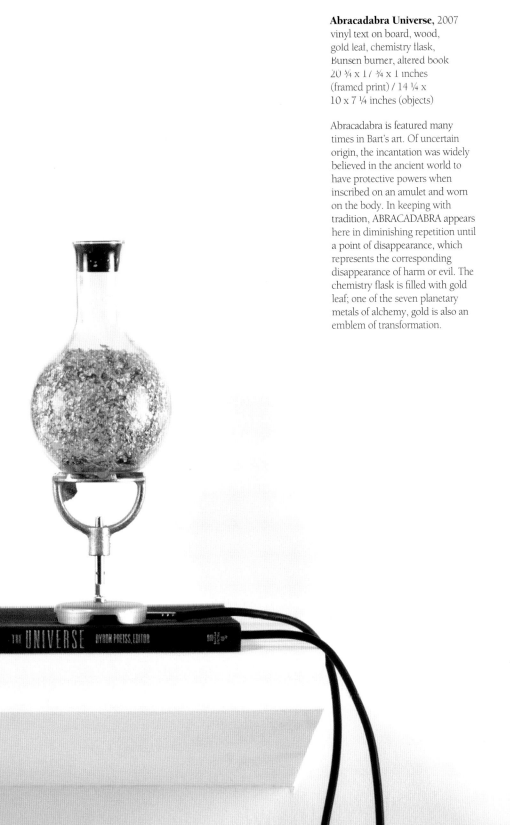

Abracadabra Universe, 2007
vinyl text on board, wood,
gold leaf, chemistry flask,
Bunsen burner, altered book
20 ¾ x 1 / ¾ x 1 inches
(framed print) / 14 ¼ x
10 x 7 ¼ inches (objects)

Abracadabra is featured many
times in Bart's art. Of uncertain
origin, the incantation was widely
believed in the ancient world to
have protective powers when
inscribed on an amulet and worn
on the body. In keeping with
tradition, ABRACADABRA appears
here in diminishing repetition until
a point of disappearance, which
represents the corresponding
disappearance of harm or evil. The
chemistry flask is filled with gold
leaf; one of the seven planetary
metals of alchemy, gold is also an
emblem of transformation.

TALISMAN
Susan Stewart

(Rabbi Nathan ben Abraham I/Cairo Geniza)

Who are you? Where are you hiding?

Were you thrown,

 tumbling through space,

 aleatory,

 radiant, only

 to land, wrapped in dust, coming

 over and down?

Or did you cross the black waves in the bottom of a ship,

 and arrive, shivering,

nameless, on the dock,

 then, and always, alone?

And when you entered the forest, the dark

 series without edge,

 did you look to the bark and

the leaves

 for a name,

 or did you wait by the path,

 asking passersby,

 practicing each syllable

 on your tongue and your teeth,

 memorizing the word until

it meant something fixed,

 something beyond its saying?

The world is full of strangers.

 You never come into their thoughts

 or dreams, yet there they are,

 in yours each night,

or only once,

 those human faces

 ephemeral, stubborn, singular . . .

Do they join the fawn and does

 there in the mist,

at dawn, wandering

 through the ghostly tendrils

 of bindweed,

 and carpets of wild lupine?

The root is the measure of the canopy.

Wool fills the weak heart of the willow.

Was the rabbi, then, the root or the canopy?

Catalog margins, and incompletes,

 jewelweed bursting in the sore eye's

 siteline,

 marjoram, sage, and

sweet pine,

 mint, leafhopper,

 mint again, and mint

 again, perennial surprise.

The rabbi made a list:

 chickpeas,

 saltwort, and

 slowest boxwood –

(These are, each one,

alkali, and ash.)

 purslane, basil,

 vetch, and

 pigweed.

Medicinal: a linen square

held against the thigh.

Sweet basil, cinnamon, ginger,

 clove – and henna,

 and poppy seeds.

What you bring inside, you bring inside.

Where are you? What are you hiding?

 Your right hand extended to the west,

 your left to the east,

though you turn and

 turn in your bed.

Do you know the perils – the sycamore's map,

 the gall on

the grape vine, the

 moth in the kale?

Aleph, pe, and *resh,*

 the silver yad tracing down the column

 when the column's no longer there.

Tattered weeds, seed packets, rags.

What magic hovered nearby to shield you?

Never touch the book with your hand.

Slow motion walk before a moving car,

 fallen from the hayloft,

 fallen on the marl, the fatal

 final ticket of admission –

who remembers

 to study the family tree?

All my notes thrown

 in the trash – the means

to save them,

 at last.

The single word changes, infinitely changing,

ruach,

within the wind a breath

 within the breath

 infinite wind

Difficult word like a stone on the tongue

 The difficult persisting in

 its means of speech.

The difficult persisting in its silence

 and in the dreams of the waiting strangers.

Shards, 2007
altered book, glass,
vintage wooden box
12 ¾ x 10 ½ x 3 ½ inches

Bart has obscured each of the
words on the open pages of
Ian McEwan's novel *On Chesil
Beach* with small shards of glass.
The story explores the lifelong
repercussions of the sexual
disconnections between a young
couple in the sixties, and Bart
found it painful to read. Through
her artistic gesture, she aims
to protect the reader from the
narrative's ability to injure.

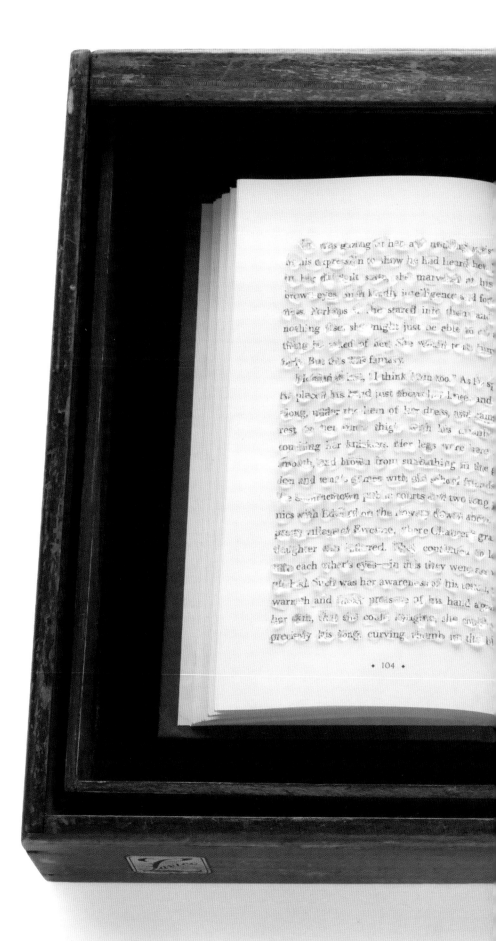

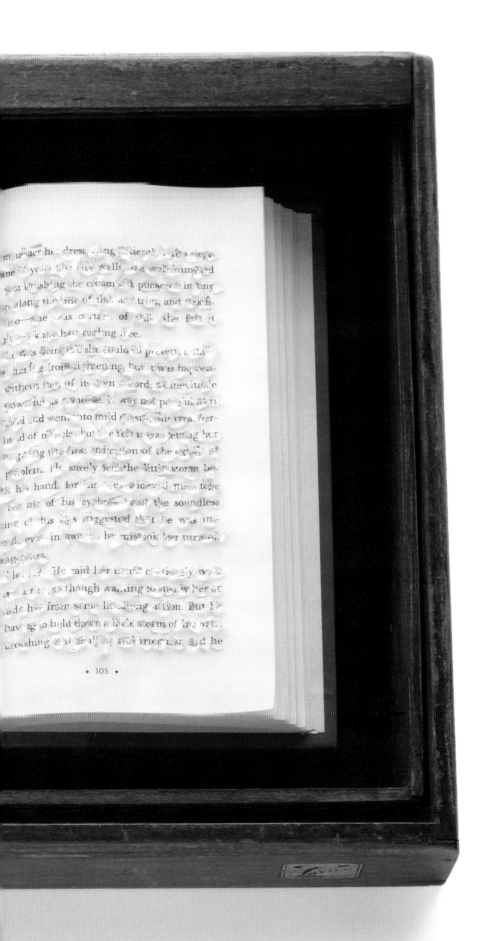

he asked if her side would trust him wi-
But this was fantasy.

said at last, "I think I am too." As he spoke
his hand just above her knee, and slid
under the hem of her dress, and came
her inner thigh, with his thumb just
g her knickers. Her legs were bare and
and brown from sunbathing in the gar-
d tennis games with old school friends on
hometown public courts and two long pic-
th Edward on the flowery down above the
village of Ewelme, where Chaucer's grand-
er was interred. They continued to look
ch other's eyes—in this they were accom-
Such was her awareness of his touch, the
n and steady pressure of his hand against

She was doing all she could to prevent a
...le in her leg from tightening, but it was ha
...ing without her, of its own accord, as inev
...and powerful as a sneeze. It was not painfu
...clenched and went into mild spasm. This trea
...ow band of muscle, but she felt it was letti
down, giving the first indication of the ext
...er problem. He surely felt the little stor
...neath his hand, for his eyes widened mi
and the tilt of his eyebrows and the sou
parting of his lips suggested that he wa
pressed, even in awe, as he mistook her tu
for eagerness.

"Jo...?" He said her name cautiously
dip and a rise, as though wanting to stea
dissuade her from some headlong action.

Without Words, 2007
vinyl on lead-covered wood
12 x 9 x 1 inches

In scale and form, this diptych
(part of an ongoing series) makes
reference to the open pages of a
book. The lead sheeting on the
surface reflects the artist's interest
in the alchemical pursuit of turning
base metals into gold. It is marked
with vinyl lettering created by Bart's
longtime collaborator Helmut
Löhr. The letters imply language
but are unreadable as text.

The Words, 1995
mixed media
40 x 16 x 15 inches

Clipped to the top of a laboratory stand is a chemistry flask containing strips of text. It is positioned at an angle to hint that its contents will spill onto a sphere below. The sphere, which is covered in strips of text, hovers above Jean-Paul Sartre's self-reflexive autobiography *The Words (Les Mots)*. Bart's work suggests that philosophical reflection can produce transformation. She originally made the piece as an element for an exhibition at *Galerie Henn* in Maastricht, Netherlands, with Helmut Löhr.

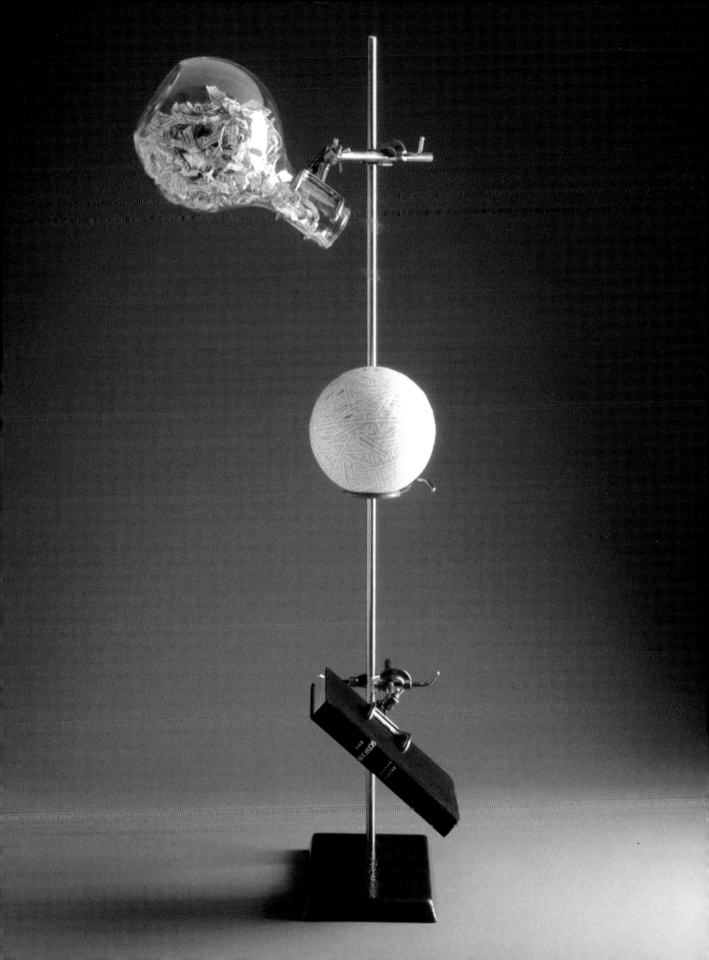

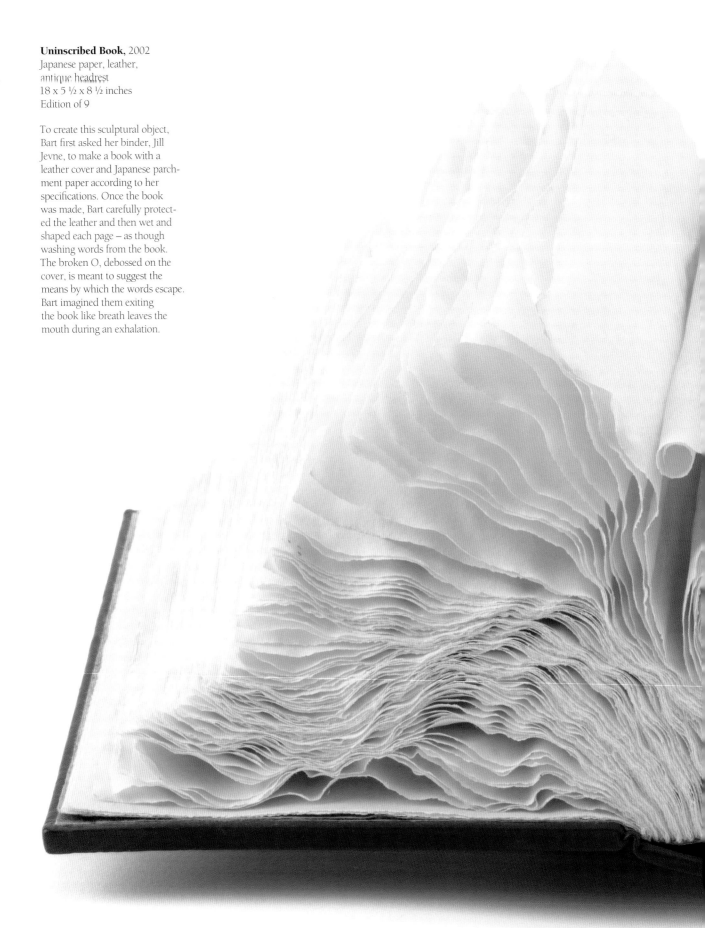

Uninscribed Book, 2002
Japanese paper, leather,
antique headrest
18 x 5 ½ x 8 ½ inches
Edition of 9

To create this sculptural object,
Bart first asked her binder, Jill
Jevne, to make a book with a
leather cover and Japanese parch-
ment paper according to her
specifications. Once the book
was made, Bart carefully protect-
ed the leather and then wet and
shaped each page – as though
washing words from the book.
The broken O, debossed on the
cover, is meant to suggest the
means by which the words escape.
Bart imagined them exiting
the book like breath leaves the
mouth during an exhalation.

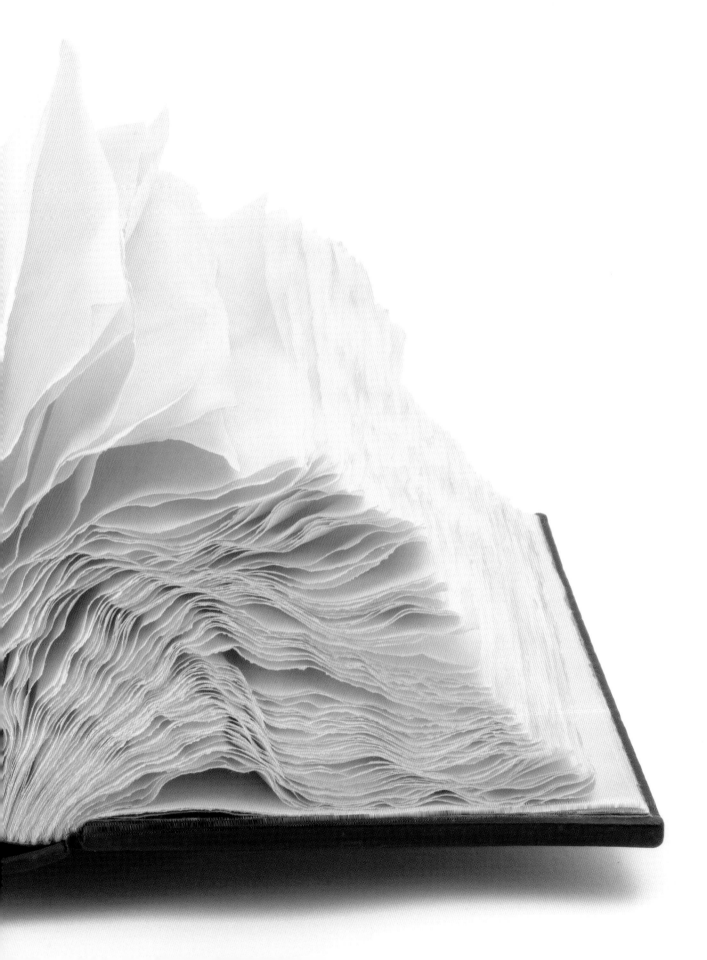

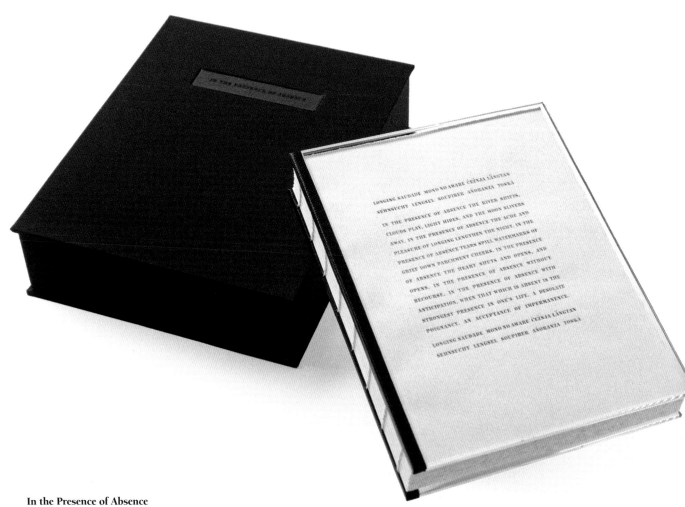

In the Presence of Absence
2002
laser-cut Italian Pergamenta
paper, glass, goatskin
8 x 6 ¼ x 1 ¾ inches
Edition of 15

This is one of twelve fine press books that Bart has published under her imprint, Mnemonic Press. A poem by Bart that calls for "an acceptance of impermanence" and emphasizes shifting and disappearing ("light that hides and the moon slivers away") has been laser-cut into each of the book's pages. The words can be read in the negative space and call attention to that which is absent. Each page bears the same text.

LONGING SAUDADE MONO NO AWARE CEŽNJA LÄNGTAN
SEHNSUCHT LENGSEL SOUPIRER AÑORANZA TOSKA

IN THE PRESENCE OF ABSENCE THE RIVER SHIFTS.
CLOUDS PLAY, LIGHT HIDES, AND THE MOON SLIVERS
AWAY. IN THE PRESENCE OF ABSENCE THE ACHE
PLEASURE OF LONGING AGING HEN THE NICHE. IN THE
PRESENCE OF ABSENCE TEARS STALL STILL WATERMARKS OF
GRIEF DOWN PARCHMENT CHEEKS. IN THE PRESENCE
OF ABSENCE THE HEART SHUTS AND OPENS, AND
OPENS. IN THE PRESENCE OF ABSENCE WITHOUT
RECOURSE. IN THE PRESENCE OF ABSENCE WITH
ANTICIPATION. WHEN THAT WHICH IS ABSENT IS THE
STRONGEST PRESENCE IN ONE'S LIFE. A DESOLATE
POIGNANCY. AN ACCEPTANCE OF IMPERMANENCE.

LONGING SAUDADE MONO NO AWARE CEŽNJA LÄNGTAN
SEHNSUCHT LENGSEL

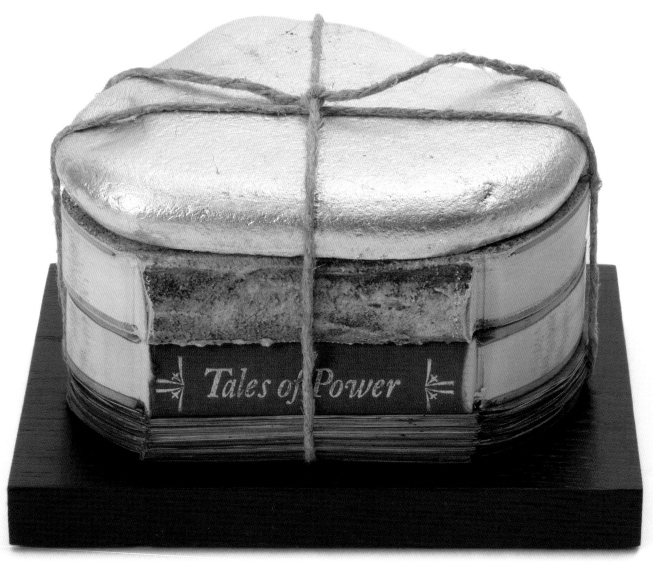

Strata: Tales of Power,
The Invisible World, 2007
altered books,
stone, lead, gold leaf
7 ¼ x 6 x 4 ¼ inches (*Tales of Power*)
4 ¼ x 3 ½ x 3 inches (*The Invisible World*)

Two found stones were the
impetus for this work. Stones
hold deep personal significance
for Bart, as ancestral holders
of time. She gilded the stones and
bound them with books she cut
to reflect their shape. The books,
with their pages exposed like

layers of earth, sit on a base
of lead, the metal that alchemists
of the ancient, medieval, and
early modern worlds attempted
to transform into gold. The gilded
rock at the top of the stack
represents the perfected stages
of transformation.

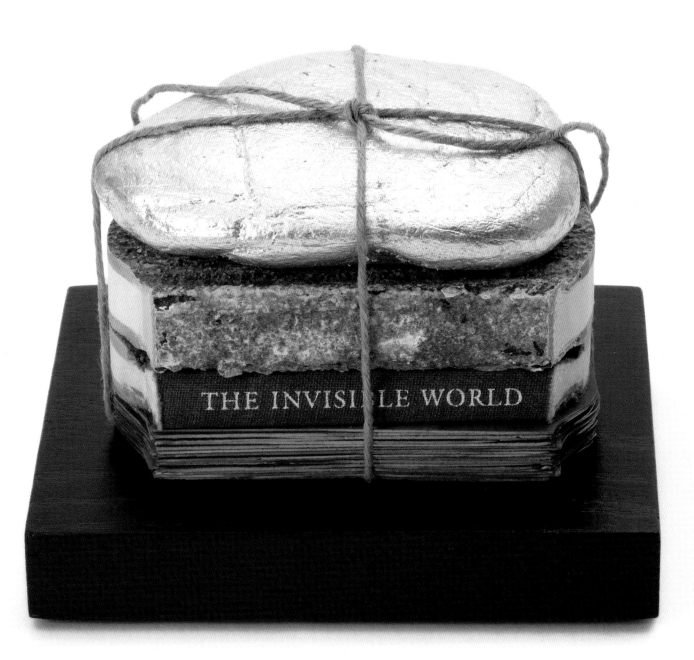

GARMENTS
(shrouding)

PROCESSIONAL

Robert Cozzolino

Harriet Bart repeatedly evokes bodies without ever showing one. No outright depictions but traces, residues, corporeal enunciations, words, skins, shells. Some slow ecstasies on the pleasure of living and being *with;* many mournful incantations of memory, mortuary songs, and rites. Apparitions fill every nook and cranny of her materials, every surface and fold. Bodies hovering at the edge of visibility, converted to names, fetishized as fragments, open space left where it once was, containers constructed to hold its salt. How can a body be at once absent and present? What does it mean to make an image of a body that has no anatomy? How do we access bodies when we cannot see them but know they are emphatically present? What is the body to Harriet Bart's practice?

Processional (1978), an installation, sculpture, and woven construction, poses some of these questions. Among Bart's earliest fiber pieces articulated in her own voice, *Processional* appeared in her 1978 debut solo exhibition at the WARM Gallery in Minneapolis. The work feels like a pronouncement, an assertion of intent, composed of five related forms lined up side by side and suspended at the same height. Together they command attention and provoke anticipation, like a row of sentinels awaiting action. Bart provided identities for each, left to right, naming them *Innocent, Siren, Matriarch, Mourner,* and *Ancestor.* Each shares structural similarities. They hang from two load-bearing threads that attach to the top left and top right of each form. All appear as symmetrical torso-length garments to be wrapped around the shoulders and then allowed to be worn open. Their basic frames consist of tightly woven black fiber, solid in the back and then extending around the sides as a series of two-inch-wide parallel strips that run the length of the garment and curve inward at the bottom to attach to woven panels. All have unique embellishments that mark the distinctive character of each piece.

Processional shares with Bart's other art her tendency to allude to ceremony, magic, and ritual. This has everything to do with the body, and here specifically with female bodies. The installation's arrangement and subtitles foreground Bart's interest in language made visible, embodied. *Processional* is arranged to be read, apprehended as a transformation narrative, each new manifestation building on the one before, leading to further metamorphosis in a potential loop. Every successive form blooms and sprouts lengthening threads from the bottom and shimmers with added textures, colors, or objects. Named to suggest aspects of female experience, from young girl to sexual adventurer to authoritative mother to bearer of grief to spirit guide, they mark time, growth, and change. These identities gesture to societal roles, an impact on community, positions of respect, and expressions of agency.

Bart's installation posits the capacity of

garments to absorb emotional and psychic thresholds, transitions that have been marked across humanity as sacred shifts in individual and group identity. They appear as effigies, stand-ins for the body, but also conjure shells, shed skins, and emptied cocoons. Objects of protection, together they form a sacred site, a shrine at which to meditate on the life force, to mourn its departure from flesh, and to consider what specific bodies mean and the implications of their absence. Bart made five, possibly an allusion to the *hamsa* or talismanic hand, a protective number and image bound to bodies. As garments they assert an intimacy with flesh, shaped for and by it, containers for and witnesses to joy and pain. Intimate spaces, openings made for refuge. Clothing can collect the residues, memories of transition, become part of the body and so represent it as an echo persisting after flesh has returned to soil. *Processional's* repeated motif made multiple is like an emphatic call, the incantation of a name over and over in longing in life and after.

If these sculptures, odd garments, shells inhabited by evasive ghosts, enact a narrative about stages of life, what sort of identities are on display? Do they reinforce societal expectations or celebrate strong female roles critical to communities? Are they both? As a series each form gradually appears to grow, accumulate, organically referring to changes in the body, aging, gained wisdom and experience, visible signs of events shaping one's perspective.

The shimmering copper-laced self-contained and compact *Innocent* gives way to a succulent, fecund writhing trembling red spilling out upon itself like a flower attracting bees. That *Siren* transitions to a form that is as complex, yet subtle and in control, frayed and disarranged but with purpose. When the *Matriarch* becomes *Mourner,* Bart's composition becomes gray like a shadow but with a humming sheen of blue pulsating from within. Keriah ribbons, meant to be torn in grief as a funerary ritual, compose the backbone of the piece. Finally, the most complex construction is that of the *Ancestor,* which has many more embellishments integrated throughout, including medicine bundles containing teeth and other organic material.

Is *Processional* ultimately a meditation Bart initiated on her own multiple roles and projected identities? Is it an early composite self-portrait? Each shell offers an opportunity to consider the nature of lived experience, layers of personality, and the effects of aging. In making meaningful vessels for the body, Bart has transformed garments into a sacred space in which transformation and the afterlife can be evoked through materiality. *Processional* marks an early manifestation of Bart's lifelong engagement with these intertwined issues of female experience, subjectivity, the intangible, and sacred space. It is a landmark reconfiguration of the body equal in force and meaning to any other feminist art made at that time.

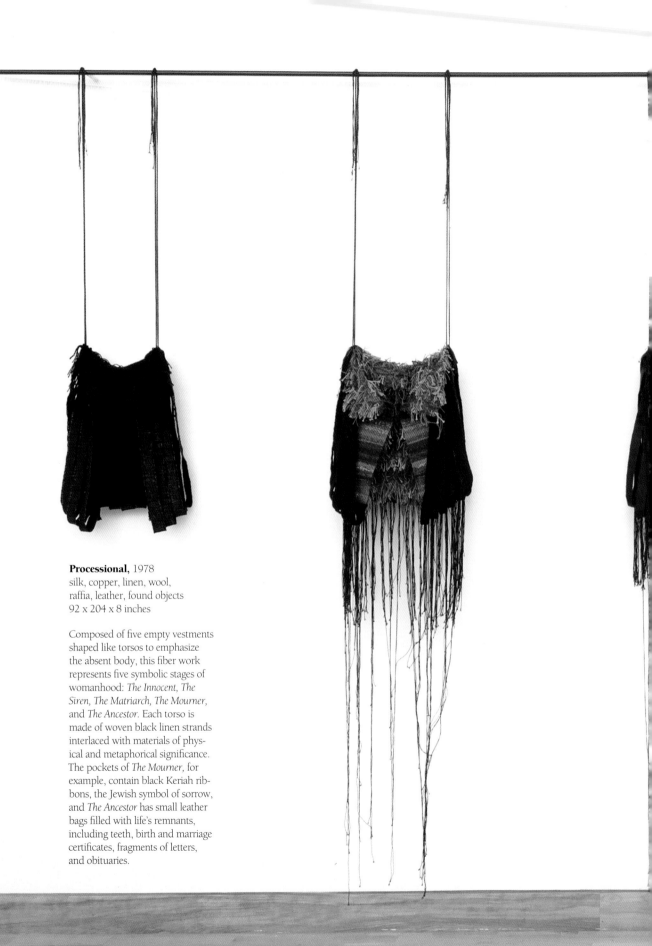

Processional, 1978
silk, copper, linen, wool,
raffia, leather, found objects
92 x 204 x 8 inches

Composed of five empty vestments
shaped like torsos to emphasize
the absent body, this fiber work
represents five symbolic stages of
womanhood: *The Innocent, The
Siren, The Matriarch, The Mourner,*
and *The Ancestor.* Each torso is
made of woven black linen strands
interlaced with materials of phys-
ical and metaphorical significance.
The pockets of *The Mourner,* for
example, contain black Keriah rib-
bons, the Jewish symbol of sorrow,
and *The Ancestor* has small leather
bags filled with life's remnants,
including teeth, birth and marriage
certificates, fragments of letters,
and obituaries.

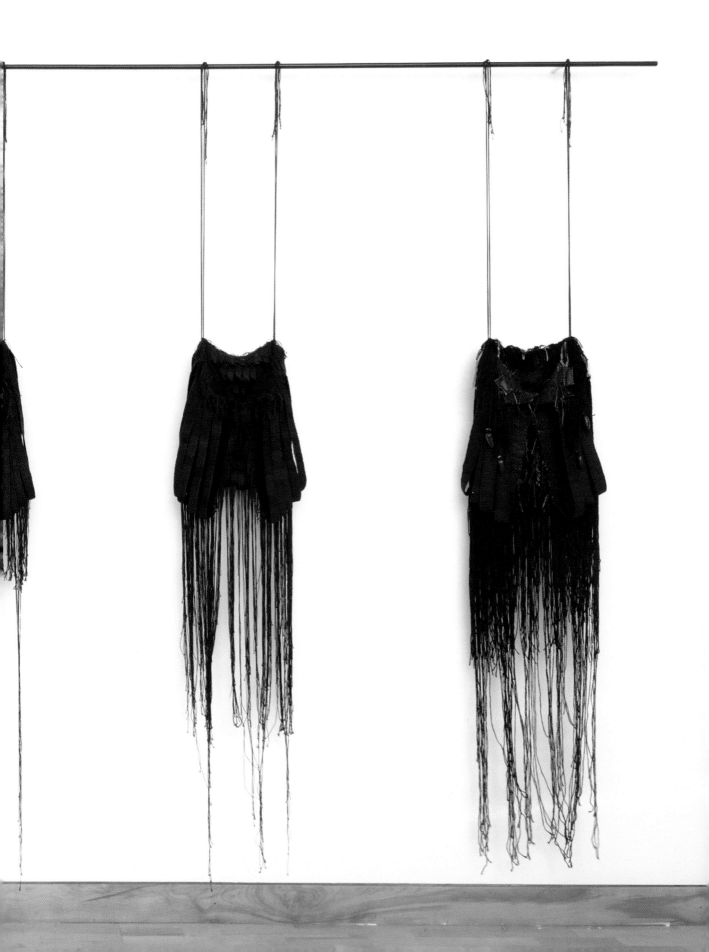

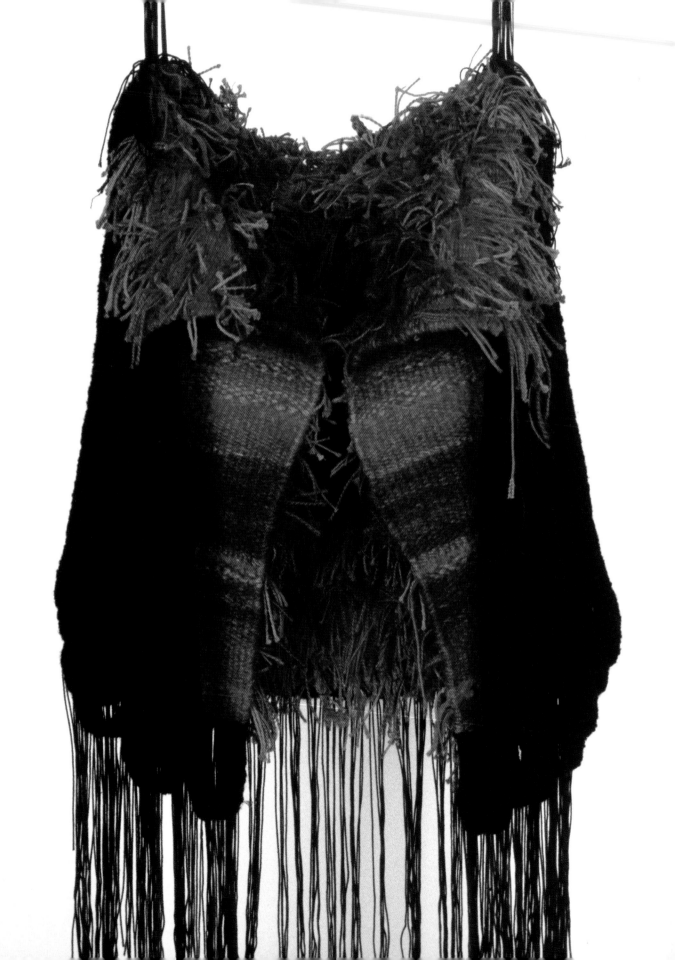

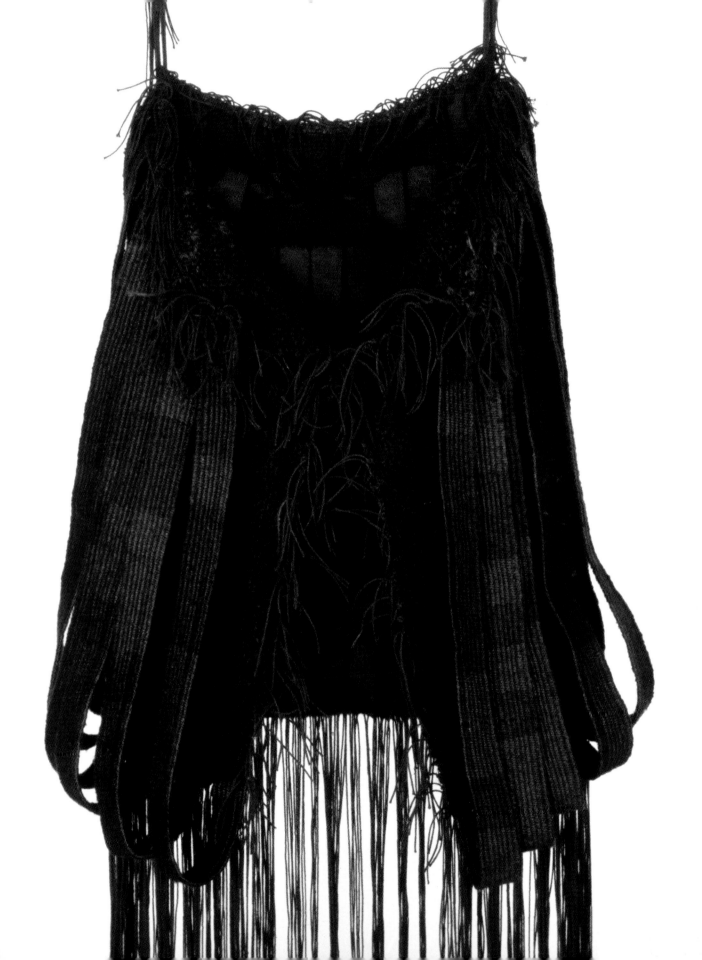

PENUMBRA

Jim Moore

In the country of Penumbra
 the black flag of mourning
is always flying.
 In the country of Penumbra there is a woven heart
broken open. Citizens,
 rejoice: Penumbra is a shadow
matted of our need
 both to hide and to reveal.
Our passport to Penumbra
 will never be revoked. When the sun
hides the moon we will sit together
 in the valley near the two white dogs.
We will ooh and ahh as all is hidden, then all
 revealed. A little hashish. A little
pistachio gelato. Then nakedness
 as the moon slowly slips free
of its darkness. Sliver by sliver
 the silver comes back. All of those years
I lived in darkness,
 then near the end a filament
of brightest silver.
 Another and still another
as the earth slowly moved to one side:
 at long last
neither the light nor the darkness
 was hidden.

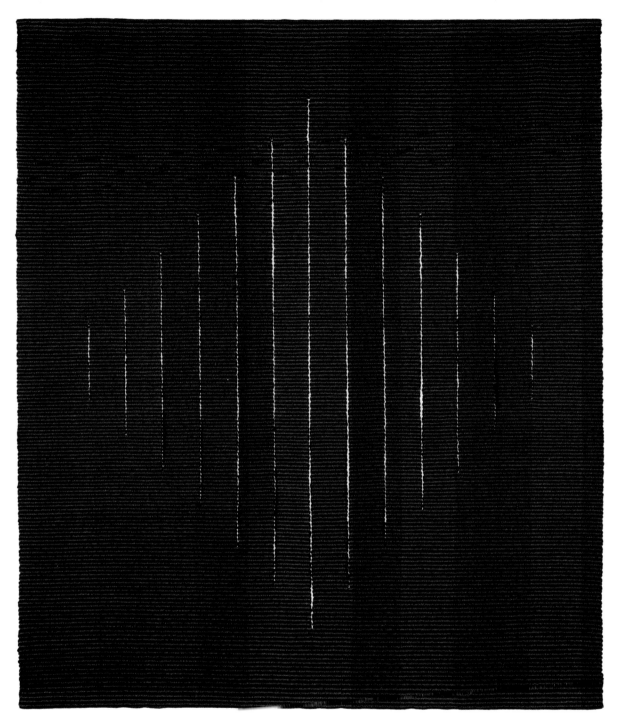

Penumbra
1976–77
linen
47 x 54 inches

Thin slits create a diamond forma-
tion on the face of the black linen
tapestry, resembling a penumbra,
a space of partial illumination
between perfect shadow and full
light. The word *penumbra* also
means to cover, shroud, or obscure.
In this early work, Bart continues
her exploration of the protective
function of textiles and the
garments into which textiles are
often fashioned.

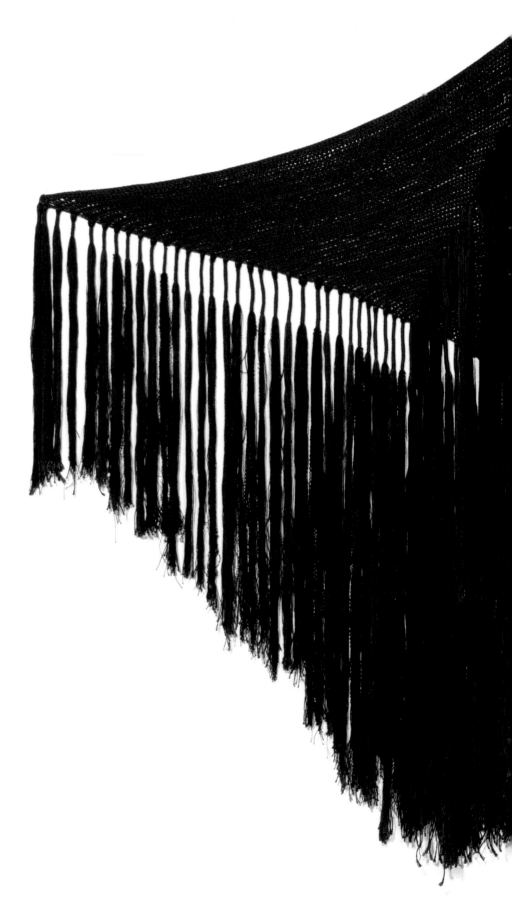

Ascension, 1976
linen
62 x 74 inches

Crocheted in linen, *Ascension* is
Bart's first major work and marks
completion of her formal training
in textiles. This architectural tapes-
try represents a garment that Bart
imagined would transfer power
to the wearer. The piece's shape is
abstract but its wide span and long
tassels of loosely hanging black
thread call to mind a bird and the
upward motion of flight.

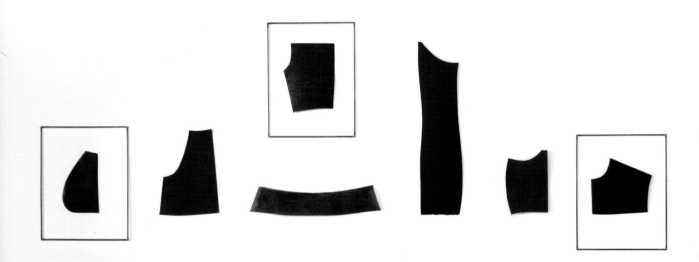

Strong Silent Type I, 2016
blackened steel
installation dimensions
variable

Bart used fragments of
vintage sewing patterns to
trace the abstract shapes
of the larger installation.
Fabricated from blackened
steel, the shapes are remi-
niscent of protective
armor, a shield from the
viewer's gaze.

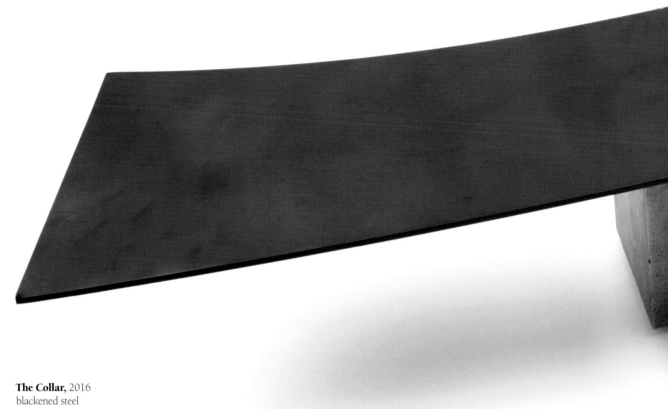

The Collar, 2016
blackened steel
3 x 18 x 5 inches
Edition of 6

The shape and material of this
object conjure associations with
the work of Minimalist artists
such as Richard Serra, but it is
traced from a sewing pattern
of a collar. In this context, the
object's slight curve becomes an
intervention that subverts the
principles of Minimalism. The
small scale of the object and its
base (well suited for shelf or
tabletop) indicate that Bart was
informed by a domestic vocabu-
lary in the making of this work.

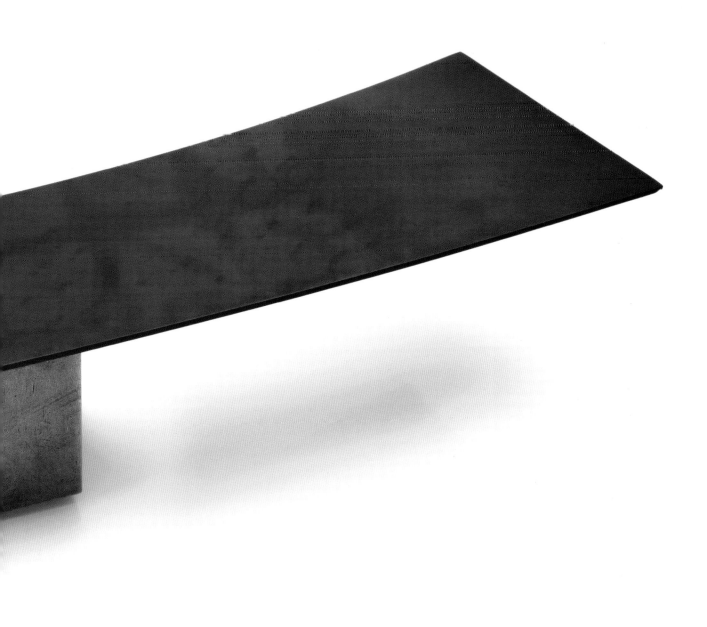

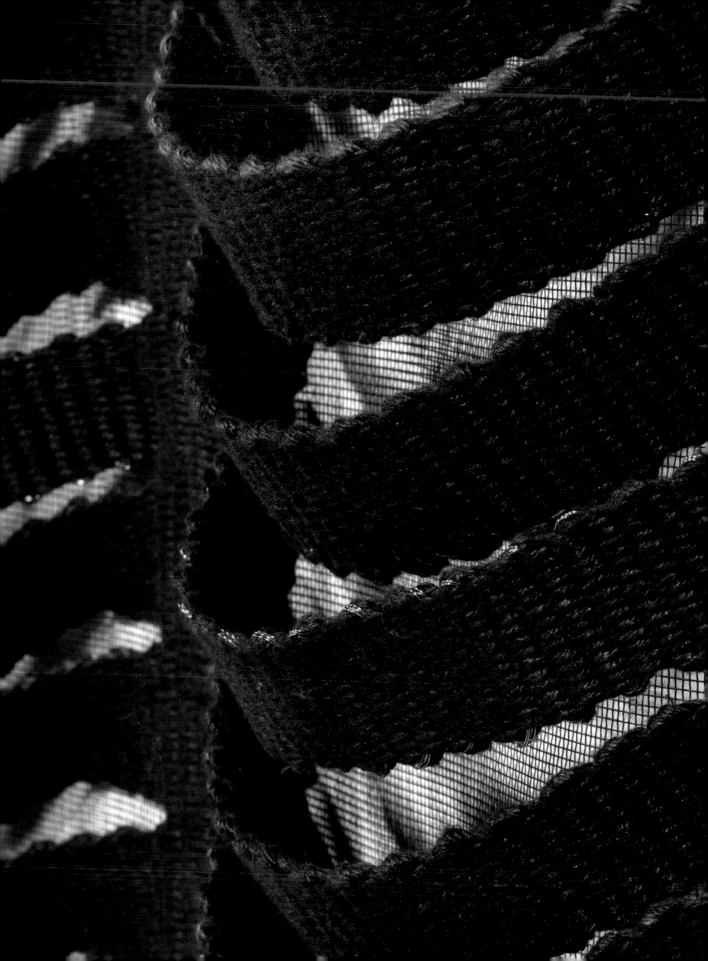

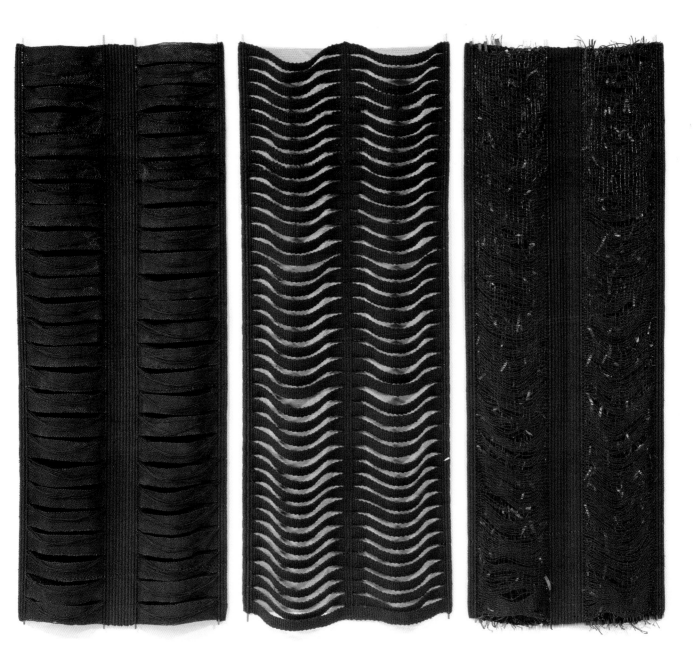

Effigy, 1978
linen, copper, mesh
each 56 x 22 x 4 inches

In these three weavings, Bart
looked to explore the body
and its symmetry through
abstraction. She imagined the
warp-faced woven center of
each of the three pieces to be
the divide of the body.

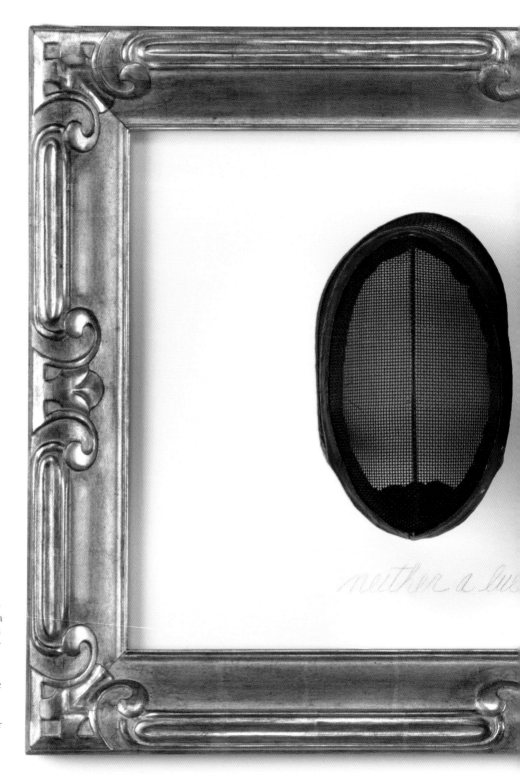

Double Ode, 2008/2015
mixed media
25 x 30 x 7 inches

Two antique fencing masks are sit-
uated side by side at the center of a
gilded frame. Beneath the masks is
a handwritten inscription, "neither
a lullaby nor a storm," which Bart
adapted from a text by Michael
Ondaatje. The work takes its name
from a poem by Muriel Rukeyser
and is an oblique portrait of the
artist's parents, as well as a broader
statement on strategies of seeing
and being seen.

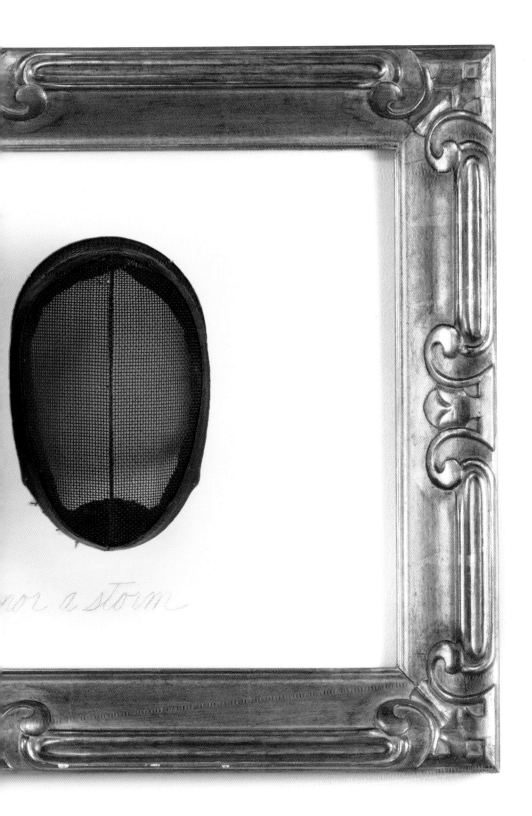

nor a storm

MIRRORS
(reflecting)

REFLEXIONS
Joan Rothfuss

A Room of Her Own

The year was 1778. Angelica Kauffman was at work in her London studio on a *historia*. Her subject was an ancient Greek story about the artist Zeuxis, who wanted to paint a portrait of Helen of Troy, the most beautiful woman in the world, but was unable to find a model worthy of her. He decides instead to audition a series of local women and combine their best features to construct his portrait.

In her painting, Kauffman chose to depict the moment in which Zeuxis is examining one of the women. Three others wait their turn, but the fifth has stepped out of line. She stands behind Zeuxis, in front of his easel, and looks back at the scene, brush in hand. Although his canvas is blank, she has already signed it: *Angelika Kauffmann pinx* ("Angelica Kauffman painted it").[1]

The painting, then, is a kind of mirror in which Kauffman gazes at Zeuxis and his models from both inside and outside the work. By taking his place at the easel, she claims her place in art history as a direct descendant of Zeuxis, the greatest of the ancient Greek painters. More important, she claims Zeuxis's studio for her own. In this room she will not be an object but a subject, one whose creative force cannot be suppressed.

Harriet Bart's sculpture *Reflexions* is a response to Kauffman's painting.[2] It contains six objects, including a small canvas that Bart has called a "deconstruction" of Kauffman's work. Five golden circles mark the positions of each of Zeuxis's models' heads; a sixth unpainted circle stands in for Zeuxis. Bart has taken Kauffman's place in front of Zeuxis's canvas. She left a paintbrush for the next woman who chooses to step out of line.

Mirror, Mirror

Who's the fairest of them all?

This question has pitted women against each other for millennia. Homer told how the Trojan War was launched when Aphrodite, Hera, and Athena fought to claim a golden apple marked "to the most beautiful." The Brothers Grimm wrote of an evil queen whose desire to be the fairest in the land led her to murder her stepdaughter with a poisoned apple. Today, we have competitions that name the most beautiful women in every category imaginable – even the universe. Zeuxis discovered that the ideal does not and cannot exist, yet the contests continue.

Who are the judges? Men. They are the mirrors who reflect on women's beauty. In return for their approval, women do their own reflecting. Virginia Woolf wrote:

> Women have served all these centuries as looking-glasses possessing the magic and delicious power of reflecting the figure of man at twice its natural size . . . How is he to go on giving judgment, civilizing natives, making laws, writing books, dressing up and speechifying at banquets, unless he can see himself at breakfast and at dinner at least twice the size he really is?[3]

Woolf made her observation in 1928, but 'twas ever thus. In ancient Greece, when a woman's eyes met those of a man who desired her, she was assumed to be issuing a sexual invitation.[4]

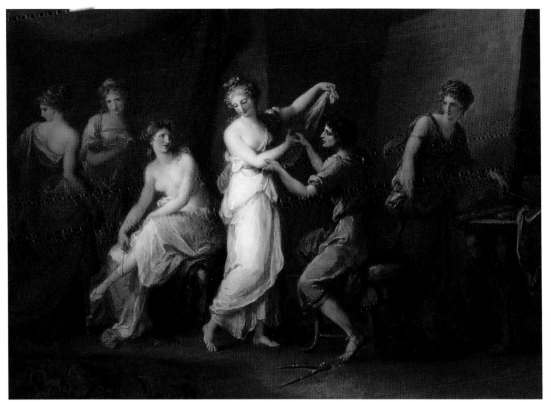

Angelica Kauffman, **Zeuxis Selecting Models for His Painting of Helen of Troy,** circa 1778. Oil on canvas, 32 x 44 inches. Brown University Library, Providence, Rhode Island.

Reflexions contains what Harriet Bart has called a "gazing mirror," one that is only big enough to reflect the eyes. As such, it is not a tool for assessing physical beauty but a device for communing with oneself by studying one's own gaze. Using this mirror, a woman can look at herself looking at herself, as Kauffman did when she inserted herself in *Zeuxis Selecting Models for His Painting of Helen of Troy*. Bart gestures toward this circular relationship in her spelling of the word *Reflexions*, which plays with the similarity between "reflect" and "reflex." A reflexive verb is one whose object refers to its subject, as in "she paints herself" or "I see myself." Never "he sees me."

The apple in this box is a curse that looks like a gift. It is perfectly shaped, golden, and unbitten. But if curiosity compels you to turn it over, your gaze is met by a single black and white eye that seems to have grown out of the apple's calyx. Bart refers to it as an "evil eye," alluding to the apple of discord that the goddess Eris tossed to Aphrodite, Hera, and Athena, or the deadly fruit given to Snow White by her envious stepmother. The apple issues a warning: impelled by desire for male approval, women have been known to curse their sisters.

Boxes

Pandora, the first mortal woman created by the Greek pantheon, was divinely lovely. She was also destructive. This was proven when she opened a sealed box full of woes, releasing them into the world for eternity. The box also contained one blessing: hope. *Reflexions* is a toolbox for every would be Pandora in the world. The mirror and vial of perfume maintain her charm, and the unfinished painting offers hope by providing an outlet for her curiosity, ambition, and confidence. The golden apple, like Pandora herself, is a beautiful evil.

In its form, *Reflexions* suggests a miniature Greek temple, perhaps one

dedicated to Aphrodite or her Roman counterpart, Venus, the goddesses of beauty, love, sex, and fertility. As most temples do, it houses a statue of its patron deity: a copy of the Venus de Milo as a perfume bottle. In Greek myth, Venus/Aphrodite pours beauty on her favorites "as if it were perfume," causing them to shine with divine, golden light.[5] There is an abundance of gold in *Reflexions*, as if Aphrodite has given the box its glow.

Bart found the Venus perfume bottle in an antique store, so it is a coincidence that the scent it contains is Artevida, Spanish for "art life." But it is fitting, for the best reading of *Reflexions* is that it is a portable studio, complete with a work in progress. It is a space for autonomous creative activity, for women and by women.

Notes

[1] For a close reading of the painting, see Angela Rosenthal, *Angelica Kauffman: Art and Sensibility* (New Haven: Yale University Press, 2006), 4–7.

[2] *Reflexions* was made for *Just One Look: An Exhibition of Contemporary Book Arts Exploring the Theme of Women and Vision*, University of Washington Libraries, Seattle, 2016.

[3] Virginia Woolf, *A Room of One's Own* (New York: Harcourt, 2005 [1929]), 35–36.

[4] Ruby Blondell, *Helen of Troy: Beauty, Myth, Devastation* (Oxford: Oxford University Press, 2013), 5.

[5] Ibid., 9.

Reflexions, 2016
mixed media
15 x 10 x 4 inches (open)
10 x 10 x 4 inches (closed)
Edition of 2

Bart's take on the artist's toolbox resembles a cosmetics case: a vintage perfume bottle in the shape of Aphrodite, a golden apple with an evil eye, and a compact mirror with a gilded frame. The inside lid displays a small rectangular canvas, marked with a grid and gold circles to indicate the placement of the female figures in Angelica Kauffman's *Zeuxis Selecting Models for His Painting of Helen of Troy* (circa 1778). The box also contains a scroll with an erasure text from Angela Rosenthal's book *Angelica Kauffman: Art and Sensibility* and an annotated list of all of the box's contents. *Reflexions* was commissioned for *Just One Look,* a book arts exhibition at the University of Washington, Seattle that explored the themes of women and vision.

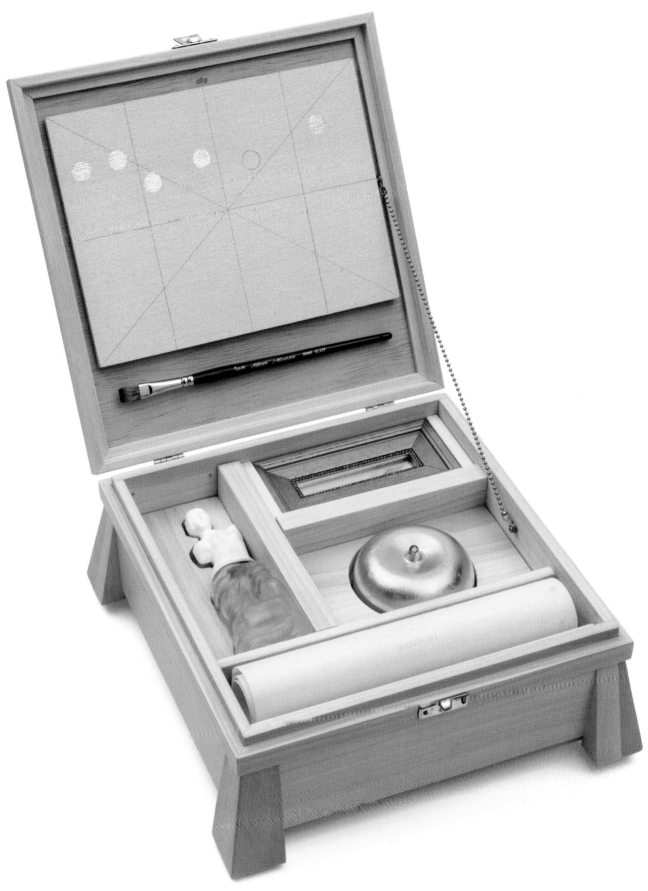

THE PEACE WORK OF PIECEWORK
Matthea Harvey

We seamstresses and tailors take out
our scissors and paper and glue.
Today's warmup consists of designing
a zoo where the animals never bump
into backdrops – no beak bashes against
a fake Sahara, no muzzle mournfully mouths
the peak of a papier-mâché mountain.
Last week we built bridges from life to
death in macramé, arguing over whether
life or death was the tighter or looser knot.
One seamstress razored her string down
into invisibility. Another made an ornate noose
and didn't return the next day. "More donuts
for us," said Carlo, though his smile never
reached his eyes. They're impossible tasks,
it's true, but we are about to attempt the impossible.
Tomorrow we begin dissecting the atlases
to make patterns for the soldiers' uniforms.
In our trials (Code Name: Pangaea), people
wearing clothes secretly made of the continents
stitched together were shown to avoid conflict
at a greater rate than people tripping on ecstasy.
And that's not our only strategy. We've measured
the weight of a hand lingering on a shoulder
and calibrated the epaulettes accordingly,
soaked the gloves in aloe to soothe their trigger fingers.
We'll make the pants just a bit too tight to remind
them of a lover's hand creeping up their thigh,
so they'll pull them on and sigh. Here's our hope:
when the order comes down to bomb or charge
or launch the missiles, they'll hesitate, equivocate.
That's how we'll begin to win the war on war.

Silhouette I–III, 2016
Arches paper sewn
onto Fabriano Artistico paper,
vintage surgical silk
each 35 x 24 inches

This series makes reference to an
early form of profile portraiture.
Prior to the invention of photogra
phy, the silhouette was cut by hand
from black paper. Each piece in
this series features the silhouette
of a single garment pattern, which
is tenuously attached to the paper
behind it with black thread.

The Gaze, 2016
mirrors, gilded wood
installation dimensions variable

In this installation, small gazing
mirrors similar to the one in Bart's
related work *Reflexions* hang
on the wall at various heights.
The mirrors are arranged to catch
reflections of the viewer's eyes.
As a result of the narrow reflective
surface, a viewer who looks in the
mirror sees only her own eyes.
But the image is not simply a
reflection: it is also an image of the
viewer in the process of looking
and being seen. In participating,
the viewer must anticipate her
own gaze and consider the com-
plexities of vision.

Remains of the Day, 2018
found objects, glass
10 ¾ x 10 ¾ x 10 ¾ inches

This assemblage is a response
to Kazuo Ishiguro's book *Remains
of the Day*, a novel set in post–
World War II England in which a
butler reflects regretfully on his
dutiful service and moral abdica-
tion to his flawed former employer.
The reflective sterling silver tray
and glass vessels are emblems of
a world of elegance, but the glass
shards served in the eye cups
reveal the blindness this world-
view can produce.

Genii Loci, 2013
magnifying glasses,
vinyl texts, cord
6 ¼ x 2 ¼ x ½ inches,
each glass / installation
dimensions variable

Genii Loci is part of a body of
work that reflects on the personal
experience of space. Magnifying
glasses, hung from the ceiling at
various lengths, invite close obser-
vation, but the view they offer
is through fragments of vinyl text
that partially cover their surfaces.
These emblems of search and
discovery, when combined with
fragments of indecipherable text,
suggest how we see the world
through the prism of our own
experience.

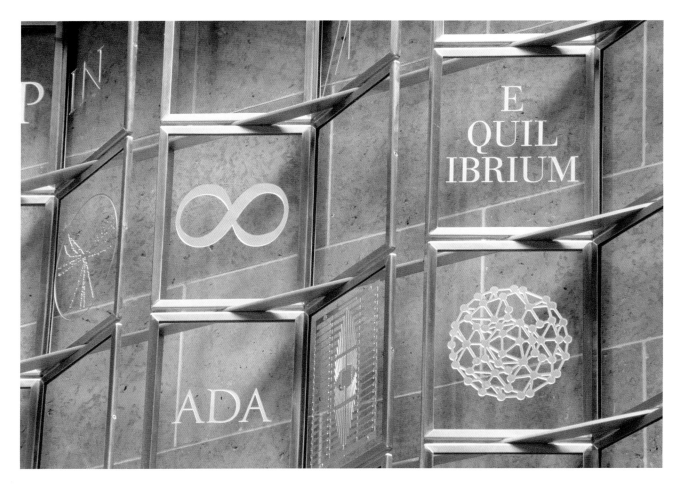

Cento, 2003
glass, stainless steel
99 x 87 x 6 inches

Commissioned for the University
of Minnesota's Walter Library, *Cento*
is made of glass panels meant
to evoke the pages of a book. Each
panel is marked with a different
symbol of science, such as Ein-
stein's theory of relativity, $E = mc^2$.
As Bart explained in her proposal
for the piece, the glass was chosen
"for its special clarity and ability
to reflect light" as well as to reflect
the idea of a library as a "quiet
place of illumination." The title
refers to a literary work composed
of quotations from other works.

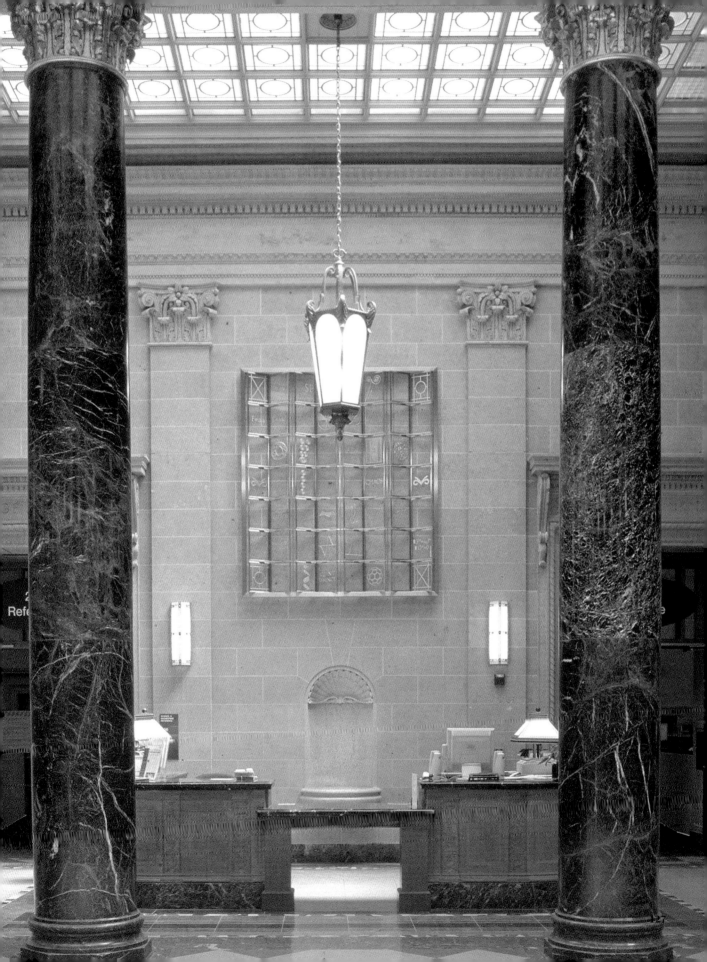

Strong Silent Type II
2016
mirror-finished chrome
steel, felt backing
installation dimensions
variable

Made up of numerous flat,
irregularly shaped chromed-steel
parts arranged in an interlacing
pattern on the floor, the fragment
shapes in *Strong Silent Type II* are
not immediately recognizable.
The chrome material has associa-
tions with the fins or hubcaps
of a traditionally masculine car
culture, but the shapes represent
yokes, bodices, sleeves, collars,
and other clothing elements traced
from vintage sewing patterns.

MEMORIALS
(remembering)

DRAWN IN SMOKE
Samantha Rippner

While a fellow at the Virginia Center for Creative Arts in the spring of 2010, Harriet Bart acquired a small pipe carved with rosettes at a local antique shop and a book of poetry titled *Fragments from the Fire,* by Chris Llewellyn. The unusually feminine pipe, admired by Bart for its handcrafted, utilitarian beauty, and the book, appreciated for its poignant verse, would serve as material and thematic inspirations for *Drawn in Smoke,* a large-scale project begun after she returned to her studio in Minneapolis. Composed of 160 smoke drawings hung on the wall in a large grid, *Drawn in Smoke* commemorates the centenary of the Triangle Shirtwaist Factory fire in New York City on March 25, 1911, one of the worst industrial disasters in American history.[1] Bart personalizes the needless tragedy by diligently inscribing the names of the fire's forgotten victims – mostly immigrant women and girls from Russia and Italy – on the bottom of each drawing. In acknowledging those who perished in the fire, she and, by association, we remember and honor their lives.

Although the Triangle fire occurred a century before Bart tackled the subject, it fits well within the scope of her work. Her commitment to the personal and cultural expression of memory has been a polestar throughout her career. The daughter of a skilled seamstress and granddaughter of a Jewish immigrant from Kiev who toiled in a lingerie factory, Bart had previously taken up the subject of the anonymous garment worker in *Garment Registry* (1999) and has used her practice to shine a light on those whose stories have been overlooked or lost to history.[2] *Drawn in Smoke* was the natural return to a topic for which Bart held strong personal associations. She transforms Llewellyn's verse into visual notations after being stirred by the poet's searing words:

> Rosie runs to the stairway, The door, Locked! The telephone, Dead! Piling red ribbons, fire backs girls into windows. They stand on sills, see the room a smashed altar lamp, hear the screaming novenas of flame.[3]

Bart's images are luminous, built up with a rich range of dark and light tones from which ghostly apparitions seem to appear. Though abstract, the drawings give the impression of a tightly knit group of portraits, each one revealing a distinct emotional tenor, a fleeting gesture, hints of a life lived.[4]

The billowing images serve as a counterpoint to the strict geometry of the grid in which they are set. They continually meld and transform before our eyes, filling

the impersonal framework with images that possess an indisputable humanity. Bart upends the grid as a device of purely formal reduction (typified by artists such as Donald Judd) by using it to account for her subjects: *Anna Altman*, *Sarah Brodsky*, *Josephine Carlisi*, *Albina Caruso* . . . With their names meticulously inscribed on each sheet, they stand before us in attendance, no longer forgotten to the passage of time. Bart re-presents the victims to the viewer and, in the sheer number of her drawings, finds a vital presence in their absence.

Bart's desire to memorialize those lost finds its spiritual equivalent in the Jewish practice of *yizkor*, meaning "to remember," a word and deed that pervades Jewish literature and tradition. The repetitive act of saying the victim's name and writing it down on each drawing became a personal incantation for Bart, connecting her to her subject. When publicly installed, *Drawn in Smoke* transcends the artist's private act of remembering, inviting viewers to partake in a communal one. The work moves from a private to public realm and, in so doing, acknowledges not only the memory of the victims but also the collective of past events required for social change.

As Bart's interest in memory can be linked to her religious and cultural upbringing, it derives too from her long-standing identification as a feminist. Her commitment to challenging existing narratives and artistic practices is possible only with the knowledge and understanding of our shared history. Remembering those individuals who in life were disregarded and in death forgotten lies at the core of *Drawn in Smoke*. Bart's memory of them resounds loudly today.

Notes

[1] The most recent records held at the Kheel Center for Labor-Management Documentation and Archives at Cornell University list the total number of victims of the fire at 146. This number has fluctuated over the years accounting for, among other things, multiple spellings of the victims' names.

[2] Bart would address the topic of garment making six years later in her installation *Strong Silent Type* (2016). Together these three works represent the artist's ongoing interest in the complex role of female labor in the garment industry.

[3] Chris Llewellyn, *Fragments from the Fire: The Triangle Shirtwaist Company Fire of March 25, 1911. Poems by Chris Llewellyn* (New York: Penguin Books, 1987), 6.

[4] Although inspired by her purchase of the pipe, Bart used the smoke from a candle to execute these drawings. The process required her to set up a temporary scaffolding in the basement of her studio building; she affixed the sheet to the underside of the scaffolding and stood beneath it, manipulating the smoke from the candle to render the images.

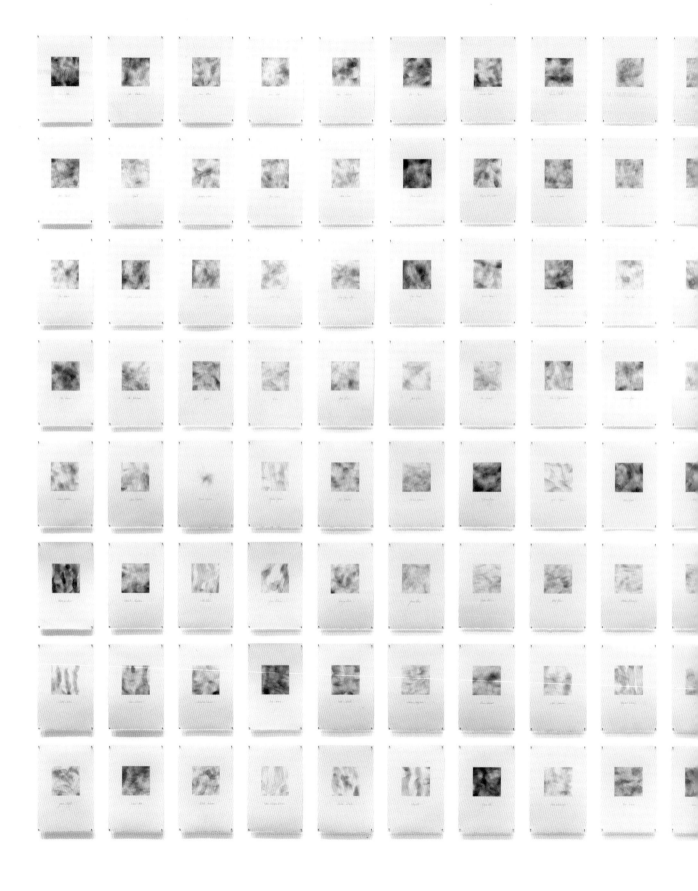

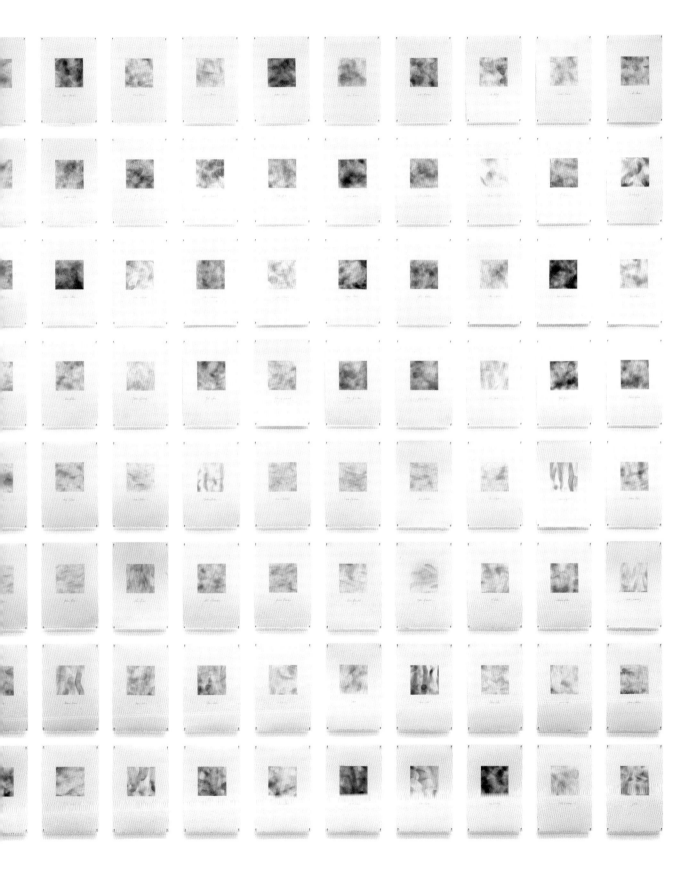

EDGES BURNED

Eric Lorberer

I wanted to put it in a box.
And then the dawn came, and I realized
it might require a bell jar, a filmstrip,
a cup of lava, a motion detector, a cartoon tsunami…
Does the wind ever hear
the ground's wish? Doesn't matter.
These fragments in a clay pot
smolder…

Then it was finally gone, and the triangles
of sky fell like letters in a distant tongue.
Alchemy is just another word for chance,
glass and metal giving birth.
I wanted to put it in a box.
Dangerous web. Dark star. Edges burned.

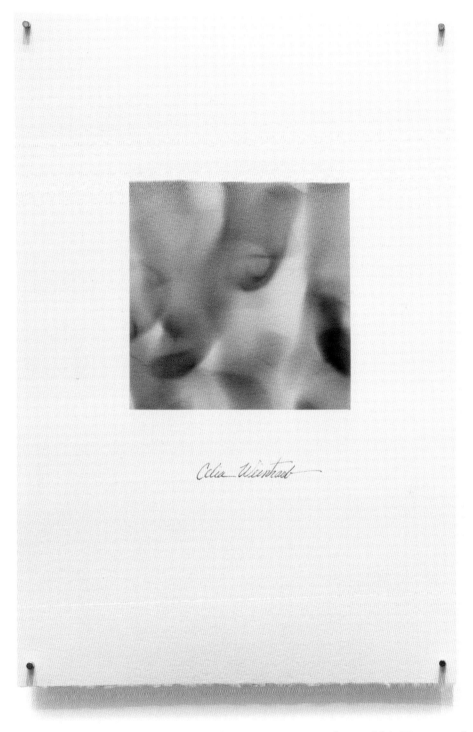

Drawn in Smoke, 2010
soot and ink on paper
each 11 ⅞ x 8 inches (sheet)
4 x 4 inches (image)
installation dimensions variable

Drawn in Smoke commemorates the deaths of 146 people (most of them young immigrant women and girls) who died in the Triangle Shirtwaist Factory fire of 1911. Bart created what she has called a "smoke" drawing for each person. She hung masked pieces of paper from a scaffolded ceiling, then she moved under the suspended pieces of paper while holding up a candle to expose each to smoke. The unmasked part of the paper was left marked by the soot. She then removed the masking and inscribed the name of each victim below the drawing with an ink dipping pen. She obtained the list of names from Cornell University Archives.

Mary Ullo

Re-Marks (Memorial)
1986
acrylic and stitching
on canvas
62 x 91 x 2 inches

Re-Marks (Memorial) is in a series of
works on canvas that record events
of personal and historical signif-
icance and reflect the continued
influence of textiles on Bart's art.
Handwritten text drawn from Marie
Cardinal's psychoanalytic auto-
biography *The Words to Say It* spirals
across the canvas. Using a needle
and thread, Bart overlaid the text
with series of stitched lines meant
to recall a ledger and the unknown
names of people who died in the
Vietnam War. She then painted the
canvas red acrylic and finally went
over the stitched lines in white
acrylic with a sable brush.

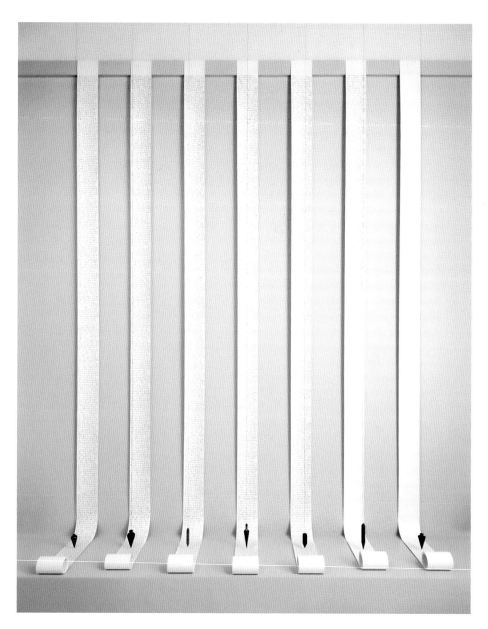

Requiem (Inscribing the Names: American Soldiers Killed in Iraq), 2003–11
ink on paper, plumb bobs, cord, rocks
12 x 12 x 3 feet

Bart commemorates the American soldiers killed in the war in Iraq through a solitary act of writing. Over the course of the war, Bart wrote the names of the more than four thousand people killed onto long, vertical scrolls of paper. In the final installation seven scrolls, hung from the ceiling, extend more than twelve feet down a wall and spill onto the floor. Six of the seven scrolls are filled with names; the seventh scroll has been left blank, representing those killed whose names are not known. Metal plumbs attached to filament hover just above the floor in front of each scroll, calling attention to that place where the true vertical reaches its horizontal destination, and where standing bodies fall into recumbency.

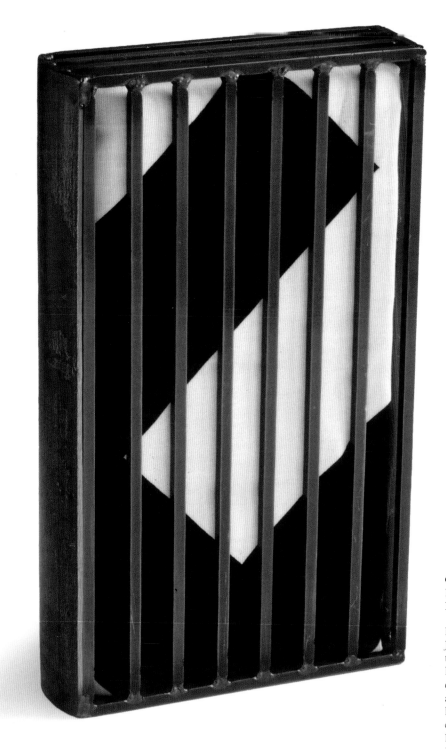

Caged History, 1995
Nazi flag, steel
13 ½ × 7 ¾ × 2 ½ inches

Bart grew up in a first-generation
Jewish immigrant family in
the wake of World War II, and
her creative consciousness is
deeply informed by the spiritual
and intellectual background of
her childhood. This Nazi flag was
captured by her uncle in battle in
Metz, France, in 1944. It made
its way to her parents' house in
Duluth, Minnesota, though Bart
was not aware of its existence until
much later. Upon discovering it,
she created a cage – without locks
or openers – to contain it, while
keeping it visible.

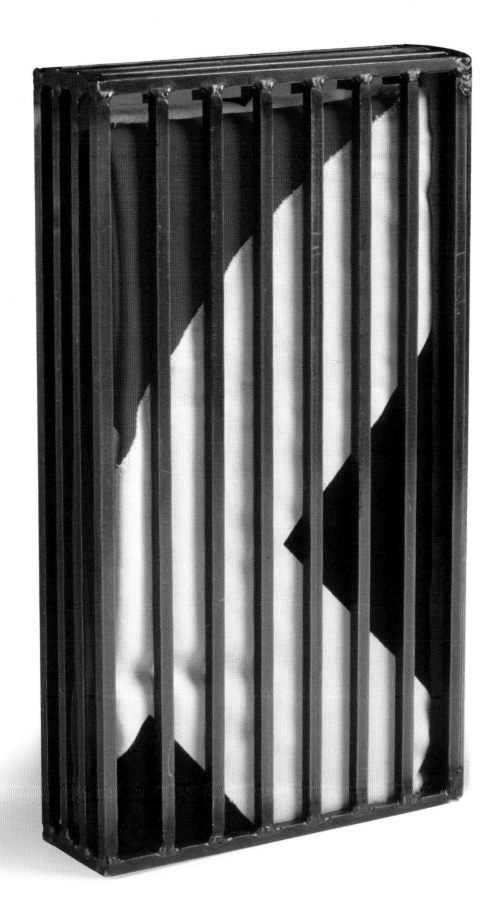

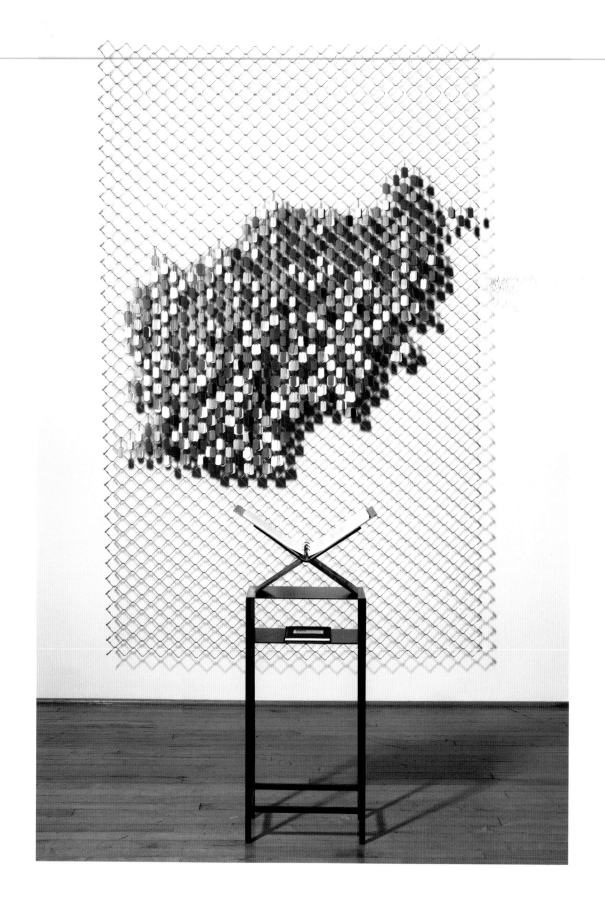

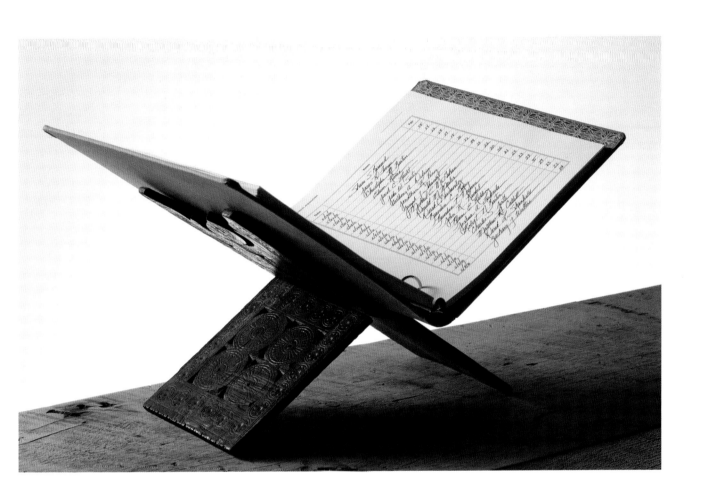

Enduring Afghanistan
2008–15
dog tags, ball chain,
chain link, vintage ledger,
ink on bound paper,
Koran wood stand table
108 x 72 x 7 inches
(chain link map)
43 x 18 x 12 inches
(table with Koran stand)

Christina Schmid, curator of the
exhibition *Deceptive Distance,*
which featured this work, wrote:
"Enduring Afghanistan commemo-
rates American soldiers who died
in Afghanistan. Military ID tags,
affixed to a piece of chain link
fence suspended from the ceiling,
form a metallic map of Afghanistan.
The depth of the tags corresponds
to the numbers and locations of
soldiers' deaths. The fence speaks
of separation but is also reminiscent

of the fence of Ground Zero, which
was repurposed for memorializing
practices. In front of the fence sits
a ledger, displayed on a carved
wooden Koran stand, which pres-
ents a handwritten list of names
of fallen soldiers. Taking the place
of the Koran, these names have
become a new text to be revered."

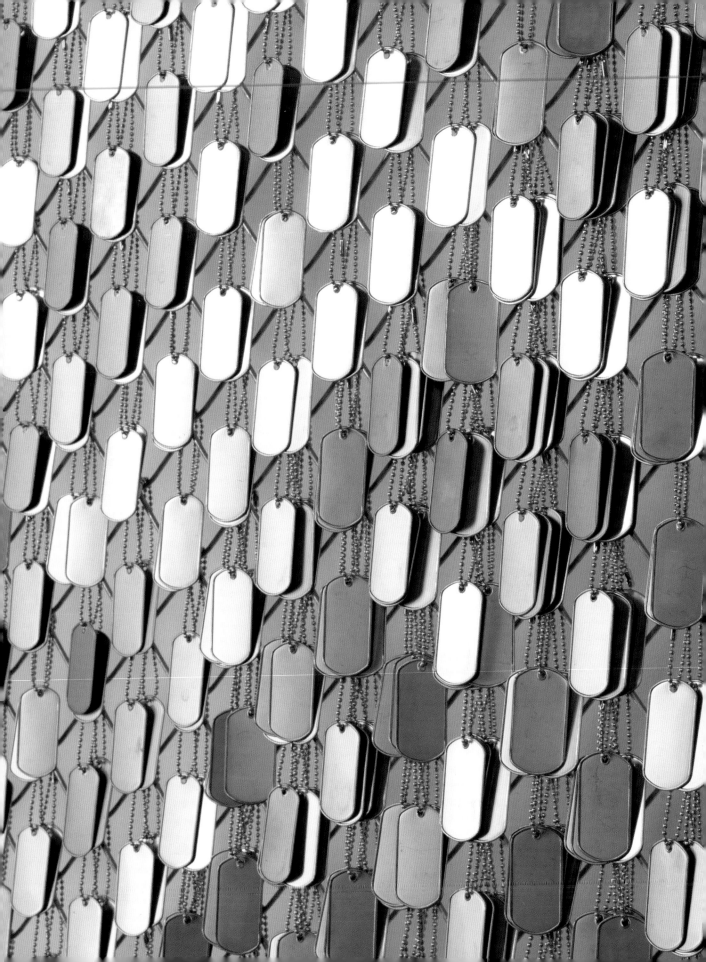

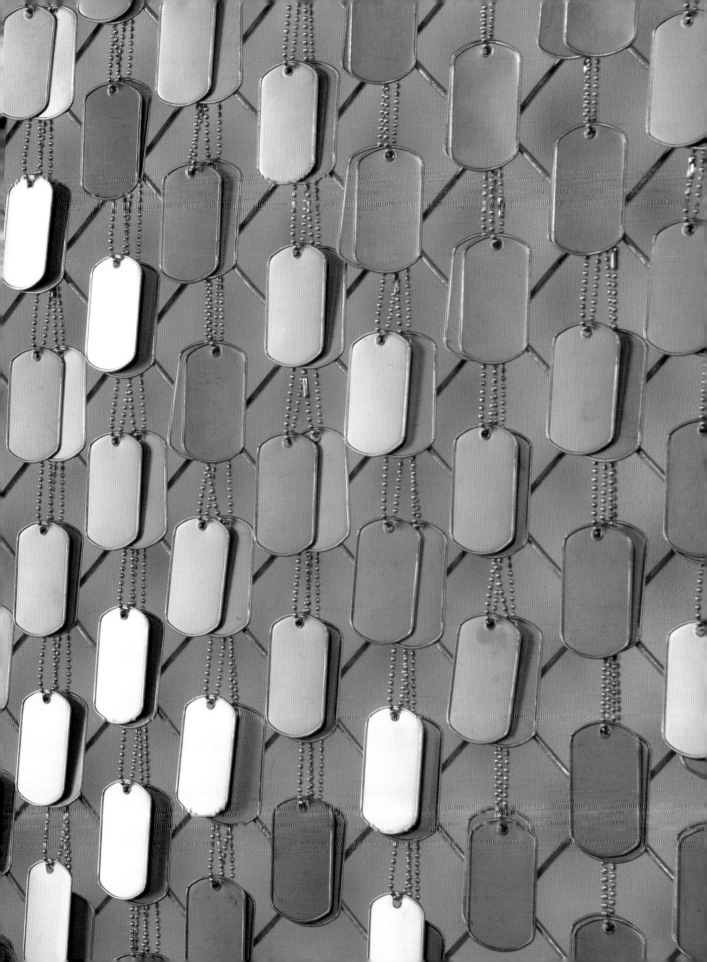

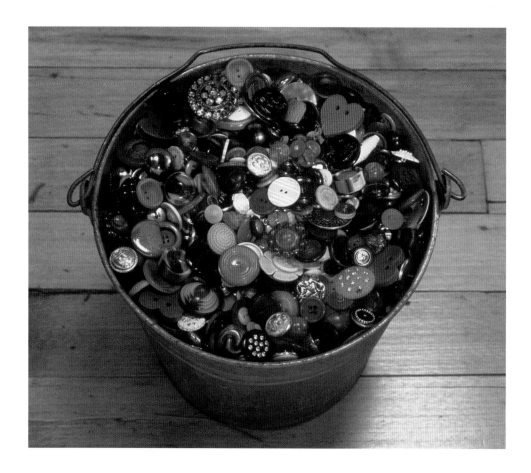

Garment Registry, 1999
altered ledger, vintage
dresses, clipboards, Japanese
paper, steel desk and chair,
buttons, bucket, light bulb
installation dimensions variable

A steel chair and desk face an
arrangement of patterned house-
dresses belonging to unknown
women. Carefully ironed and
folded, each dress is wrapped in a
translucent bag that is printed with
a quotation from Virginia Woolf:
"We are only lightly covered with
buttoned cloth; and beneath these
pavements are shells, bones, and
silence." Attached to clipboards
and hung in a grid, the dresses defy
the sterility of their confines. On
the desk is a ledger of photographs
of unknown women juxtaposed
with fabric swatches that corre-
spond to the dresses they wear in
the images. Adjacent to the desk
is a bucket of colored buttons.
Garment Registry pays homage
to the invisible labor of anonymous
women who worked in garment
factories during the first half of the
twentieth century.

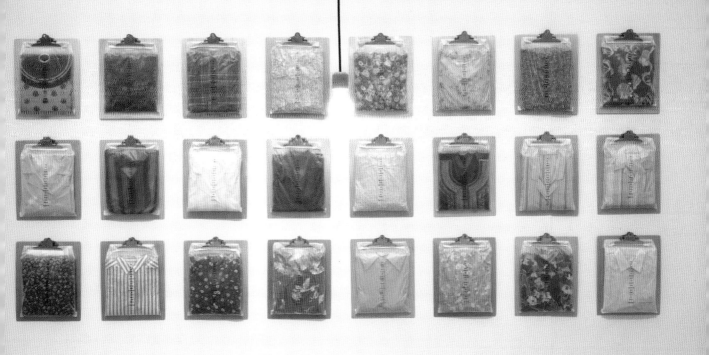
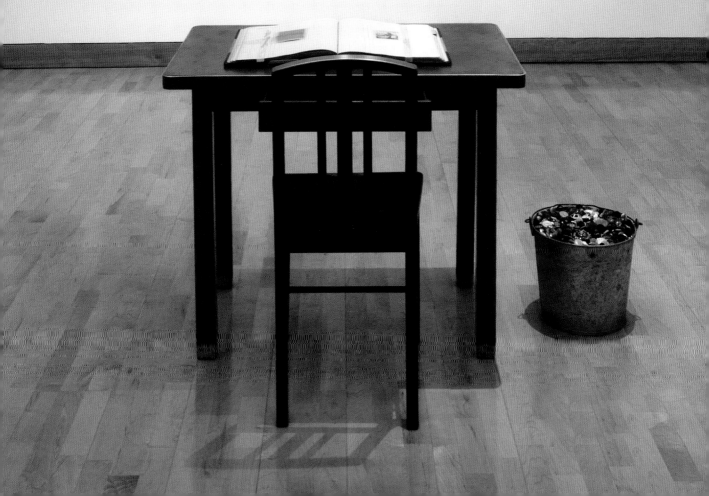

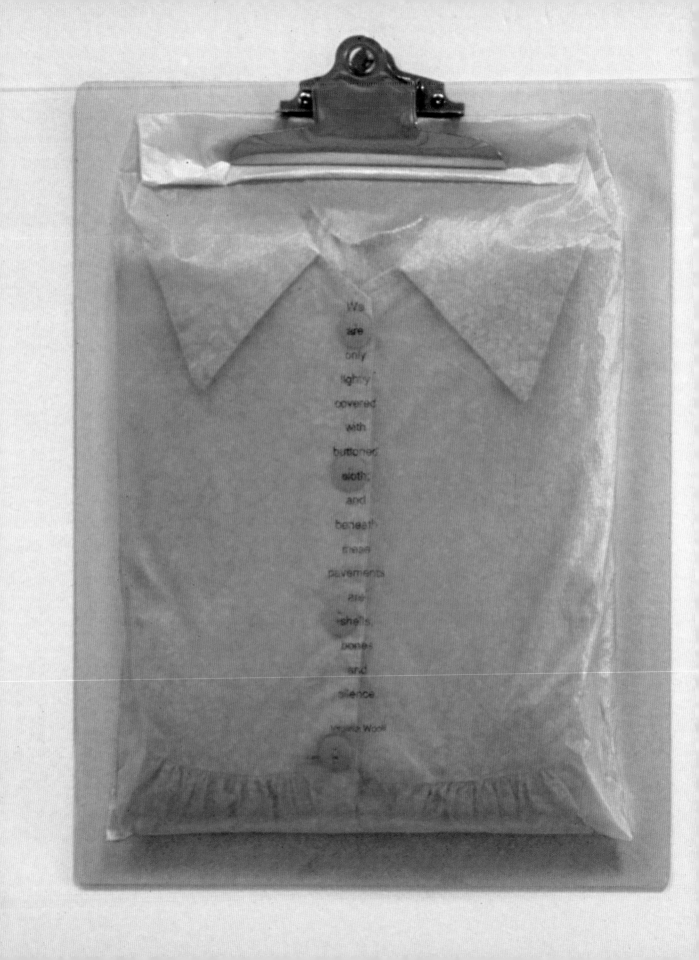

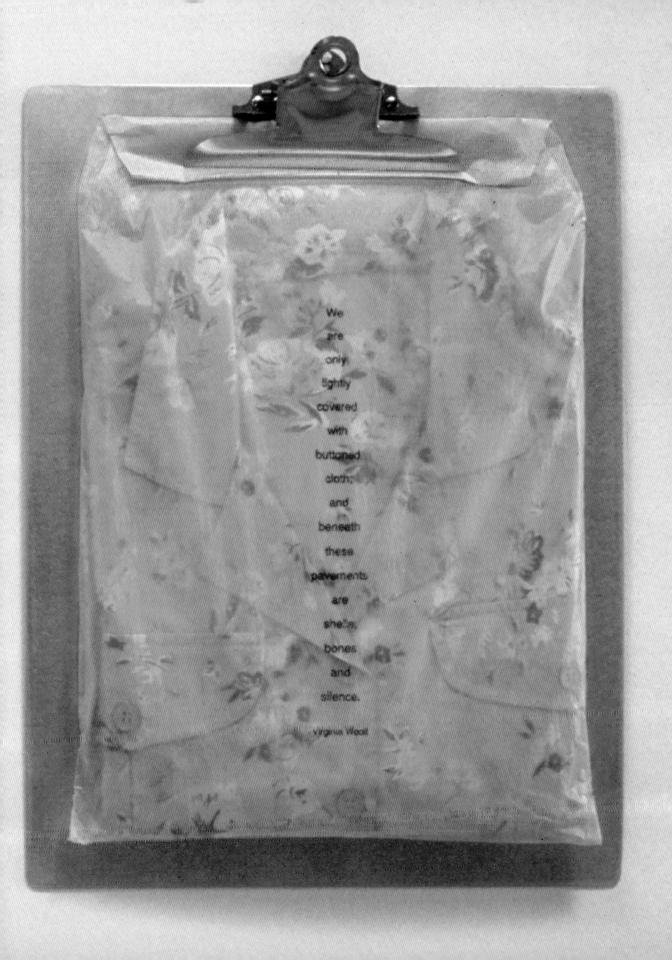

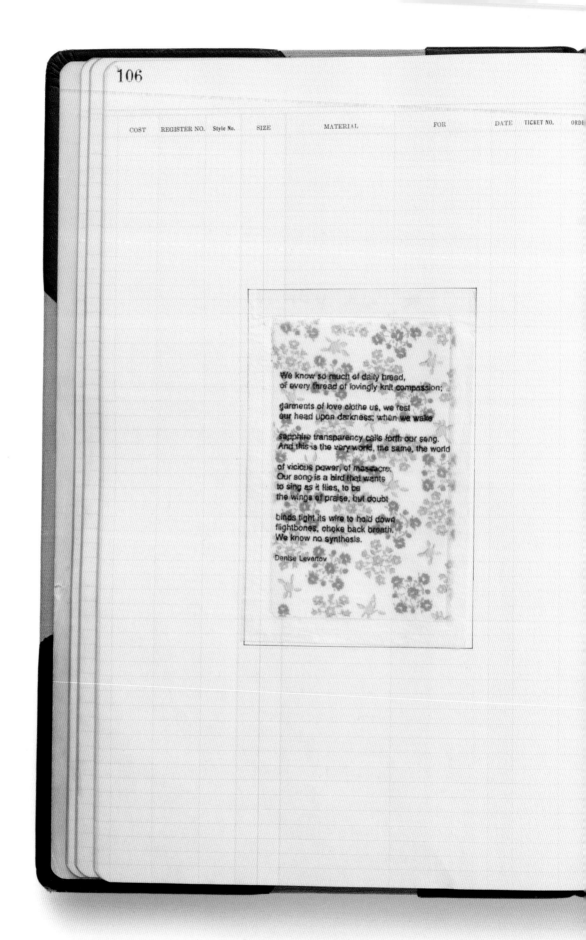

We know so much of daily bread,
of every thread of lovingly knit compassion;

garments of love clothe us, we rest
our head upon darkness; when we wake

sapphire transparency calls forth our song.
And this is the very world, the same, the world

of vicious power, of massacre.
Our song is a bird that wants
to sing as it flies, to be
the wings of praise, but doubt

binds tight its wire to hold down
flightbones, choke back breath.
We know no synthesis.

Denise Levertov

REGISTER NO.	Style No.	SIZE	MATERIAL	FOR	DATE	TICKET NO.	ORDER NO.

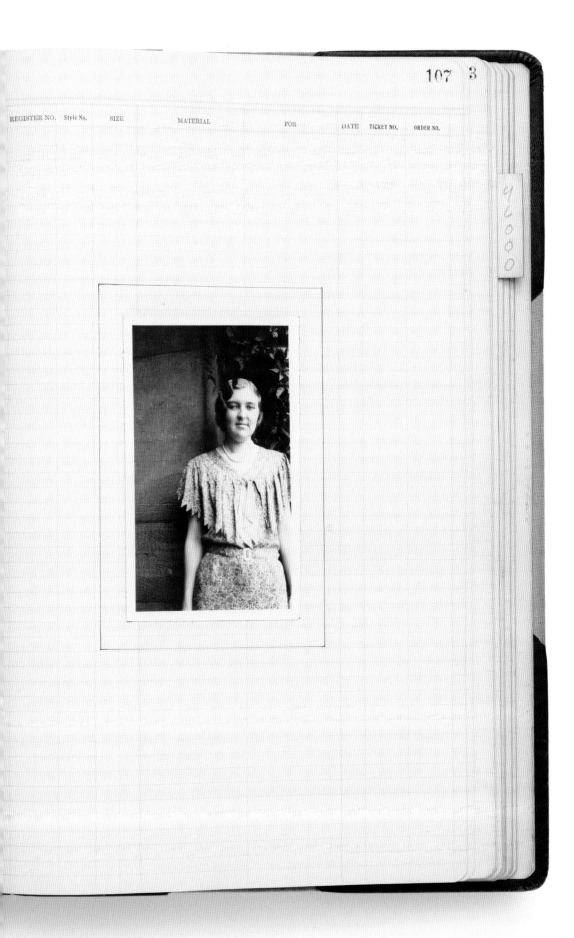

REGISTER NO.	Style No.	SIZE	MATERIAL	FOR	DATE	TICKET NO.	ORDER NO.

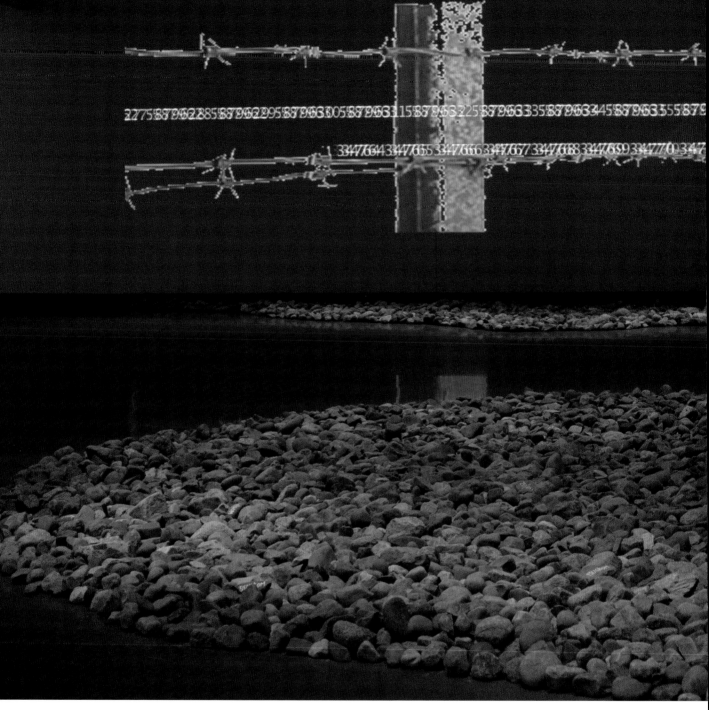

Crossings, 2016
video, acrylic on river rock
30 x 60 feet

Bart collaborated with Boston-based artist Yu-Wen Wu to create this site-specific installation at Carleton College's Perlman Teaching Museum in response to the global refugee crisis. The United Nations Refugee Agency had reported that nearly sixty million people were forced to flee their homes in 2014 because of war and persecution. On one wall in the

exhibition space, a horizontally oriented video projection juxtaposed open skies and vistas with borders and fences, interspersed with scrolling numbers. Filling the rest of the room was a river-like formation of six tons of rocks, many of them numbered. The elements of the installation reflect on the difficulty of comprehending the staggering number of refugees.

TOOLS
(navigating)

PLUMB BOB
Betty Bright

The box glitters, a metallic, reflective trompe l'oeil. With touch, the jewel-encrusted treasure transforms into a toolbox assembled from quotidian materials: wood with aluminum covers that are overlaid with brass wire screen and trimmed with brass nails. Lean in to lift the lid, and Harriet Bart's book *Plumb Bob, A Book Object* awaits within, blurrily reflecting the reader in its brushed brass cover, a glimmering invitation.

Another surprise: this slim book is substantial, its weight a subtle reference to gravity's role in setting a plumb line. Once lifted and held, fingers explore the brass covers edged with steel hinges, in contrast to the exposed sewn spine and velvety text paper. All good book artists are sensualists, and Bart's use of unconventional binding materials powerfully signals the plumb's attributes of weight and machined precision. A final ingredient, the conjuring at the heart of *Plumb Bob*'s initial illusion (treasure chest or repurposed toolbox) also infuses Bart's installations and exhibitions, where plumbs shapeshift from miniature to massive. Imagine a length of wall where seven palm-sized plumbs hover above scrolls that mark the war dead in Iraq, while in the next room a massive bronze plumb hangs suspended like a levitating colossus.

When telescoped into book form, *Plumb Bob* invests reading with a physicality precious in our current screen culture. An engraved glyph, *Pb*, the chemical symbol for lead, glows from the brass cover, inviting touch. The book's subtitle, *A Book Object,* denotes Bart's dual preoccupations of the conceptual and the material. Early in the book, a line drawing illustrates a plumb bob, its oscillation indicated by a dotted line and arrows. It is the only suggestion of movement in a book anchored by a center alignment.

Bart introduces *Plumb Bob* with a facsimile of a letter tucked into a pocket in the book. Her father and his friend Yakov Grichener visited Bart in her studio as she designed an installation with the plumb. Grichener followed up his visit with a letter relating the background of that "impeccable instrument," and Bart, a hunter–gatherer of overlooked objects and the stories they suggest, was hooked. In subsequent installations she explored the plumb bob's practical, metaphorical, and divinatory resonances.

She then chose to extend her investigations into a book, "a way of finishing," as she put it, although in truth this finishing required her to upend her expressive lens by pivoting from the gallery to the intimate, hand-held book. Fortunately, envisioning an artist's book is a natural progression for Bart, a voracious reader. She appreciates the book's paginated structure that allows a reader time and space to explore and savor.

Books inhabit a fluid identity across today's artistic spectrum. In the wider art world, artists may publish documentation of an ephemeral project or of work in other media; these publications are not artists' books. In a different overlap, the field of book art produces diverse works that metaphorically engage ideas about books not only as bound book but also as sculpture, performance, or installation. Bart's books clearly inhabit a recognizable book form, but their material richness imbues their reading with a sculptor's

expressive palette. Far from a simple container for image and text, successful artist's books such as Bart's succeed when content aligns with material, craft, and a wholistic design informed by a physiology of reading.

Once Bart's bookish vision has clarified, discussions ensue with longtime collaborators printer Philip Gallo and binder Jill Jevne, whose considerable skills marry Bart's vision to a book's possibilities at the highest standards of bookmaking. The result is that every one of Bart's twelve Mnemonic Press books thus far stands alone as a unique expression, while also relating conceptually and materially to her gallery works.

Plumb Bob embodies the particular strengths of an artist's book, beginning with the reader's discovery of the Grichener letter, like the unearthing of a family keepsake. That sense of intimacy continues in spare poetic vignettes that explore different aspects of the plumb bob, as if Bart herself is describing its multivalent character while circling around one of her immense plummets. She tells us that the plumb has determined a structure's vertical line at least since ancient Egypt, with lead soon supplanting stone as a weight. Masonic initiation, the pyramid of Cheops, and Greek temples—architects, builders, and diviners have reached for the modest tool throughout history. The book's centered page design and the lengthened ascenders of the Koch-Antiqua typeface appear to repeatedly pull taut a typographical plumb line as texts explore its manifold associations Silhouette drawings of plumb bobs from Bart's collection also appear, their curves comprising a poetic accompaniment to the texts as each bob's pointed end denotes its service to gravity, ever seeking ground.

Late in the book, a quotation from writer John Berger evokes the plumb as he invites us to find our own true center, where we live: "Home was the center of the world because it was the place where a vertical line crossed with a horizontal one. The vertical line was a path leading upwards to the sky and downwards to the underworld. The horizontal line represented the traffic of the world . . . Thus, at home, one was nearest to the gods in the sky and to the dead in the underworld. This nearness promised access to both."[1]

As if summoned by Berger's words, the following page depicts a lengthy plumb line that bisects and continues through a human figure. The back endsheet pictures lead's alchemical symbol, illustrating our liminal existence, caught between worlds. The book has conveyed us from the material to the immaterial, all held within the arc described by the plumb. Harriet Bart makes books that carry us through time and into the spaces opened by reflection. Her *Plumb Bob* offers us safe passage as we navigate this chaotic twenty-first century, adjuring us to remain open to transformation and to the gifts hidden within the ordinary, while we each seek that which remains upright and true.

Note

[1] This quotation was originally published in John Berger, *And Our Faces, My Heart, Brief as Photos* (New York: Pantheon Books, 1984).

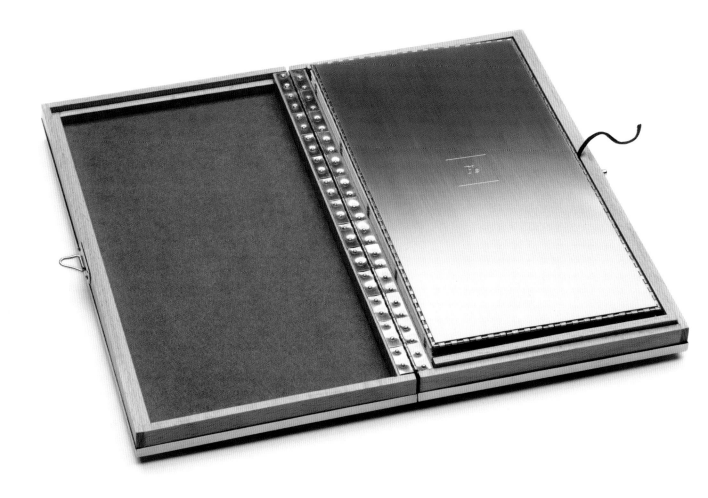

Plumb Bob, 2009
mixed media
10 ⅜ x 5 ⅔ x ½ inches
(book closed) / 11 ½ x 6 ½
x 1 ½ inches (box)

In her project prospectus for *Plumb Bob,* Bart writes: "I have explored the plumb in its many guises: as an instrument of precise calculation, as object of initiation and divination, as a metaphor for the pursuit of what is timeless and true. *Plumb* *Bob, A Book Object*, reflects on this extensive body of work. In keeping with the modest origins of the plumb, the binding and case are fabricated from common hardware store materials. The chemical symbol for lead, Pb, is engraved on the brass cover."

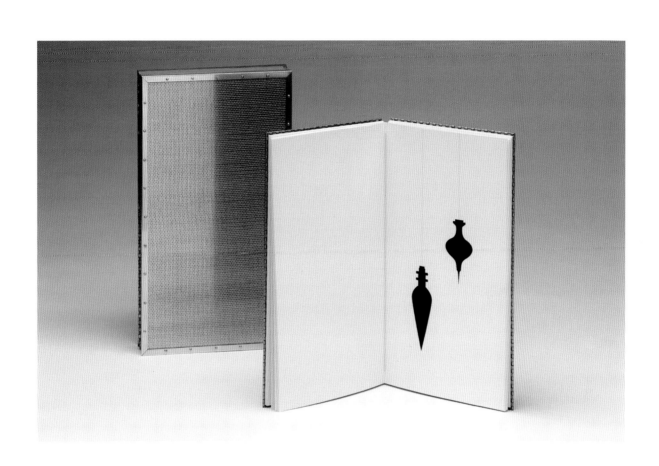

THIS BURNT SPACE
Sun Yung Shin

The Minotaur ---------- field-gathered -------- flower, a head packed with azure ---------

--------- *aurum* atomic number 79 --------- rare element --------- seams bright sown in rock

--------whose branches hold air --------- a graphite cup --------- sunlight sinks

to the bottom

--------- the labyrinth made of light --------- the hollow hall --------- the bull's eye ---------
 white horns the body's

door handles --------- the wrecked red body --------- the white body under the roof of
 skin --------- bone

body of strange and tactile corals ---------

 *

* *

O Minotaur our elder our buttoned-up child --------- 7 vials of temporal adjustments
 --------- we will send our hands and feet ahead --------- light the fires --------- temper the

shadows --------- this collection of forking paths --------- rough hedges or baked brick ------
 your wall of comets ---------

the face behind your face is ~~not~~ a loop --------- don't look back ---------
 in the wet religions where we

sleep underground --------- the hot scent of gold roses ---------

 *

* *

Minotaur our *mater* --------- the white bull our brother --------- we forgot
 how to make unmixed

matter --------- the beeswax lay cold on the workbench ------ feathers,
 gathered --------- arms,

tethered or bound --------- what about the compass fixed behind each eye ---------
 bury this *ikon*

along the inner path --------- beware the interruption of doors --------- count each
 resurrection and

make a dark mark --------- our holy legibility of space ---------
 *

* *

No, Minotaur, your alchemy the geography of grief --------- *topos* a forgotten
 hospitality --------- the industry of dowsing and the deep well --------- remember you
are rent through with infinitesimal

magnets --------- fate of iron and copper --------- remember you are a fine cut
 --------- you are a lavish

meal --------- you are exile ---------- your back is the table --------- you are bread,
 which is why you, too,

are broken ---------

Elements, 1993
glass, lead pellets, gold
dust, shredded found
text, bee pollen, chalk,
iron dust, graphite, paper
21 x 13 ½ x 1 ¾ inches

Betty Bright described this work
in the exhibition publication of
Dialogue: Alchemy of the Word:
"*Elements* might be Bart's personal
mandala. The labyrinth represents
humankind's ultimate challenge,
however unfashionable: to dedicate
oneself to a search for wisdom.
The elements which signify alche-
my and industry are metaphorical
linkages to lead one through the
labyrinth – whimsically summed
up in nature's miracle of bee pollen.
But Bart reserves the substance of
the greatest power, poetic insight,
for the center vial, and rightly
aligns it with a direct route to the
labyrinth's core."

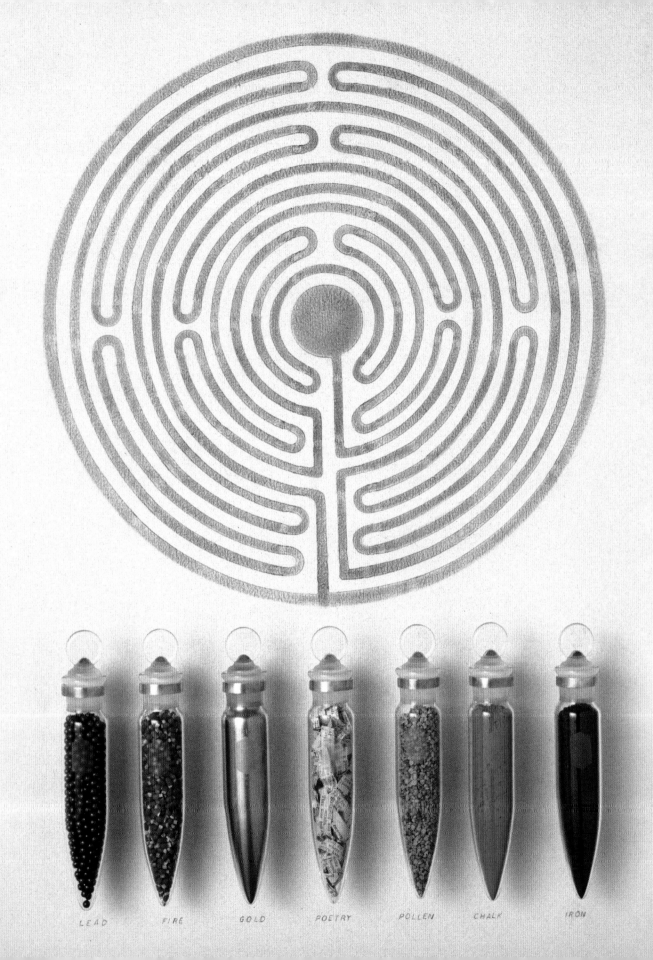

LEAD FIRE GOLD POETRY POLLEN CHALK IRON

Pendulum, 2003
bronze
48 x 16 inches

This cast bronze object is Bart's largest-scale engagement with the pendulum, a weighted instrument that hangs from a line suspended from a pivot. The object has interested Bart for many reasons: she appreciates its humble origins, elegant proportions, mathematical precision, gravitational energy, and divinatory associations. In her art it often serves to draw attention to the point between the vertical and horizontal, here and there, while oscillating through equilibrium.

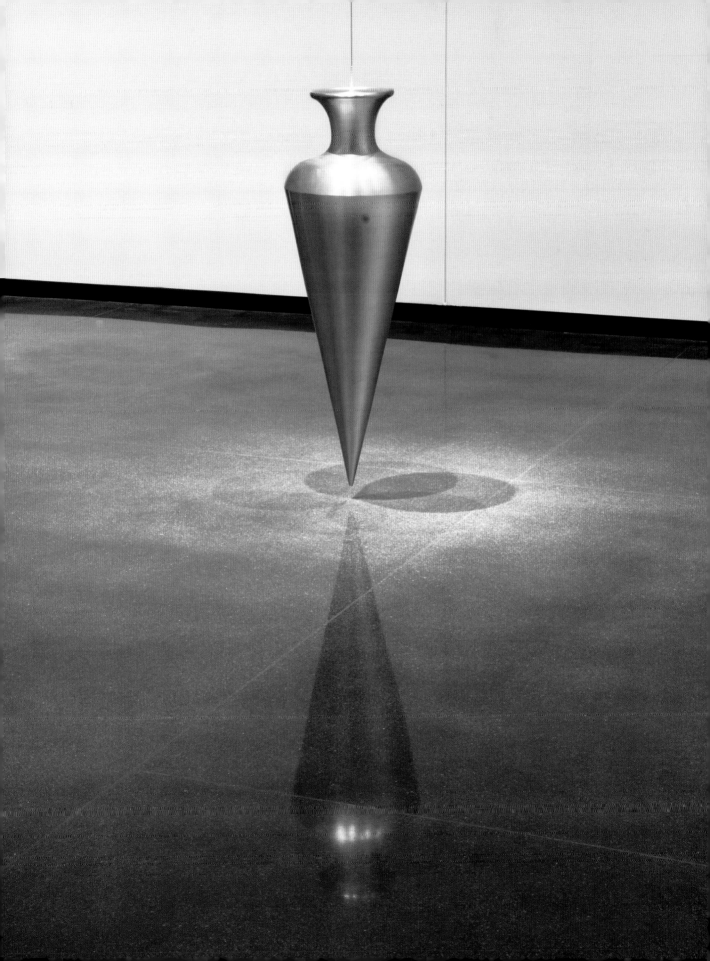

film could be dispensed with and the cheaper paper made the accumulation of

many books a matter of industry rather than of wealth." Since, however,

Leibnitz indicated merged in the news-

Book I deals ... fame.

In the same way "the achievements of medieval kinematics were very ... mosaic of ... (p. xxiii)

Print, with its uniformity, repeatability, and ... at all.

underwent the great changes

retained from manuscript

for understanding this process, however, ... sense is the ... For the modern physicist, as ... By c

The discovery ... quite ... also ... like those of

Cicero ... Dr. Busb ... Westminster

"profane" space and ... "concerning the achievements of functions and senses and ... "numerically us ... and above ... the world of

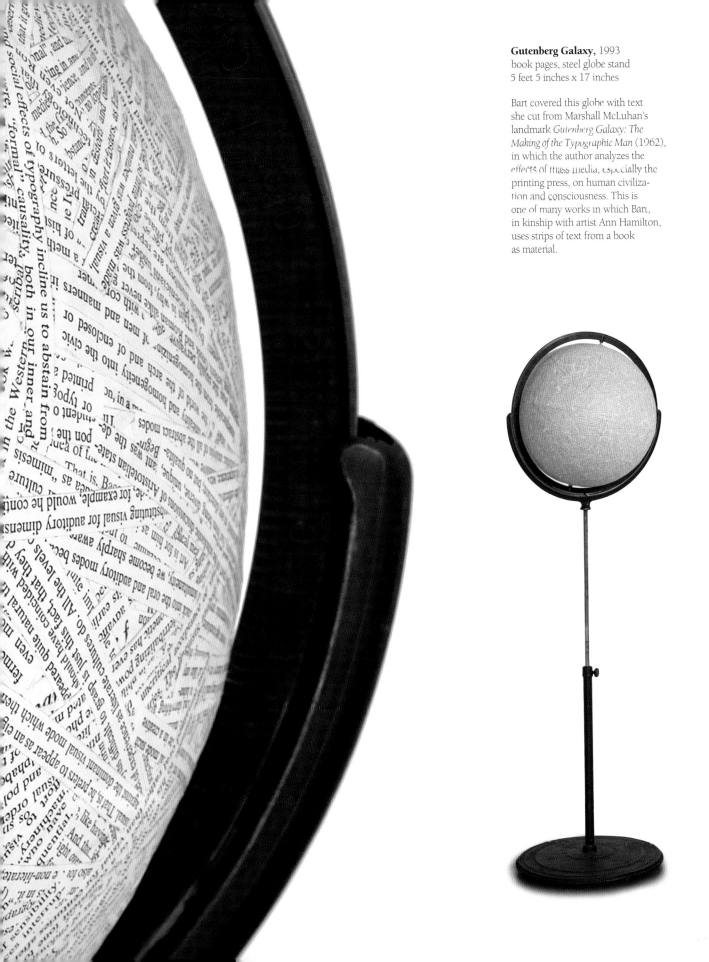

Gutenberg Galaxy, 1993
book pages, steel globe stand
5 feet 5 inches x 17 inches

Bart covered this globe with text
she cut from Marshall McLuhan's
landmark *Gutenberg Galaxy: The
Making of the Typographic Man* (1962),
in which the author analyzes the
effects of mass media, especially the
printing press, on human civiliza-
tion and consciousness. This is
one of many works in which Bart,
in kinship with artist Ann Hamilton,
uses strips of text from a book
as material.

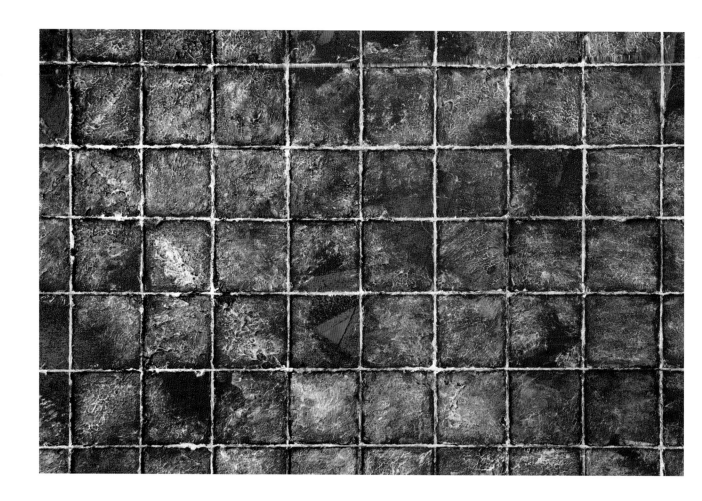

Geography, 2015
acrylic and jute on canvas
78 x 50 inches

Reminiscent of an aerial topo-
graphic map of Earth, this is an
imaginary landscape. Given the
map-like appearance of the canvas,
the grid, which the artist creat-
ed with pieces of jute, suggests
longitudinal and latitudinal lines –
geographic tools that help us locate
ourselves. Yet these lines aren't ori-
enting: we are left to wonder if we
are looking up into the sky, down
into a pool of water, or at a surface
without physical reference.

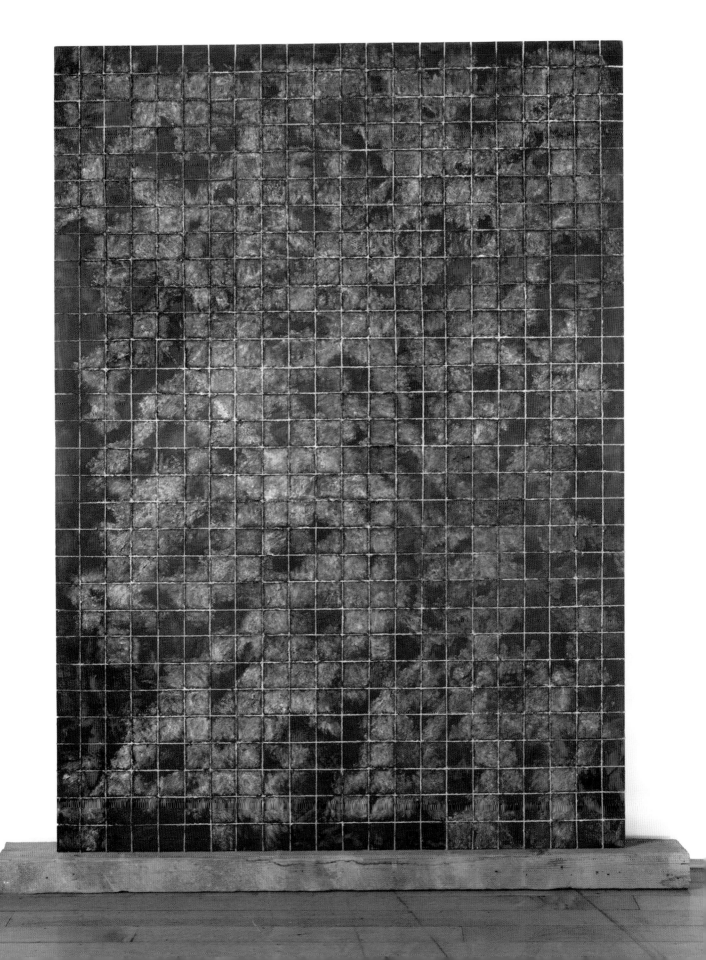

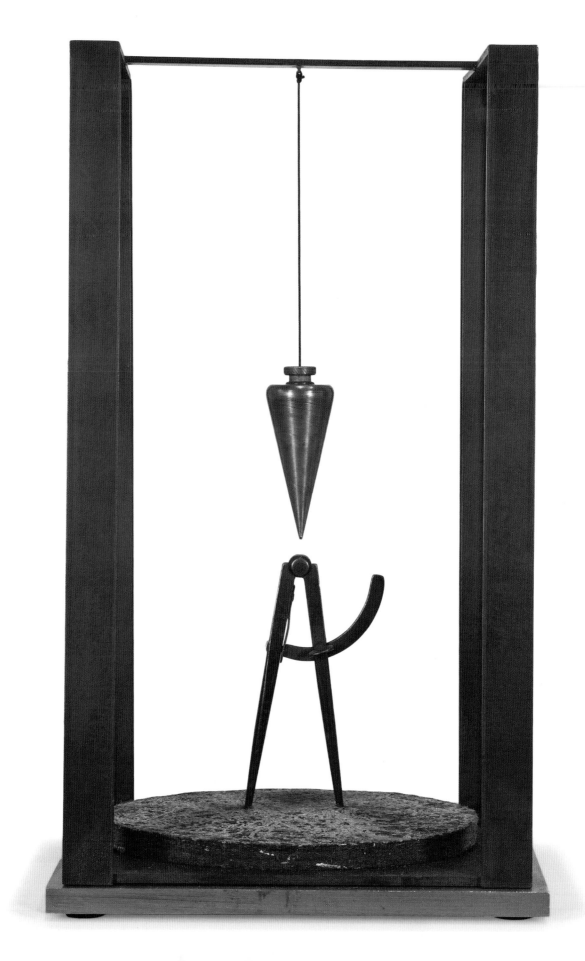

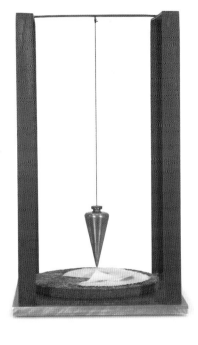
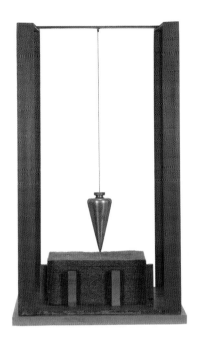
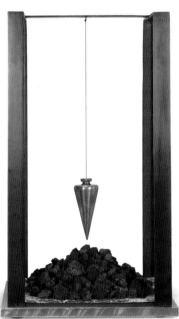
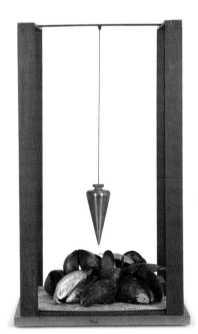

Cultural Structures, 1992
mixed media
each 16 ¾ x 10 x 10 inches

Cultural Structures is a series of
five small steel frameworks contain-
ing objects that relate to Bart's trips
to Düsseldorf, Germany, and her
creative engagements there. Some
make explicit reference to place:
plumb bobs hanging from the
center of two of the objects point
to maps of Düsseldorf and Krefeld,

for example. Others hold objects of
artistic significance: gilded mussel
shells refer to the work of Marcel
Broodthaers (colleague, competitor,
and critic of Joseph Beuys), and a
paper collage by Düsseldorf-based
artist Helmut Löhr represents the
collaborative relationship between
him and Bart.

Invisible Cities, 2013
archival pigment prints on rag paper
each 11 x 14 inches

Invisible Cities is a series of nine images drawn from *Ghost Maps,* a fine press book that resulted from Bart's residency fellowship at the Virginia Center for Creative Arts in Amherst, Virginia. When she arrived at her temporary studio space, she saw the paint-splattered and stained floor as a palimpsest or a record of the artists who had preceded her. She set out to create a personal map of the space. With blue painter's tape she marked off areas that intrigued her because of their color and patterning. She then scrubbed the spaces in between with everyday cleaning supplies to make space for later markings. Bart took aerial photographs of the preserved spaces and then overlaid the resulting images with maps of her choosing to create an imagined topography of the creative process.

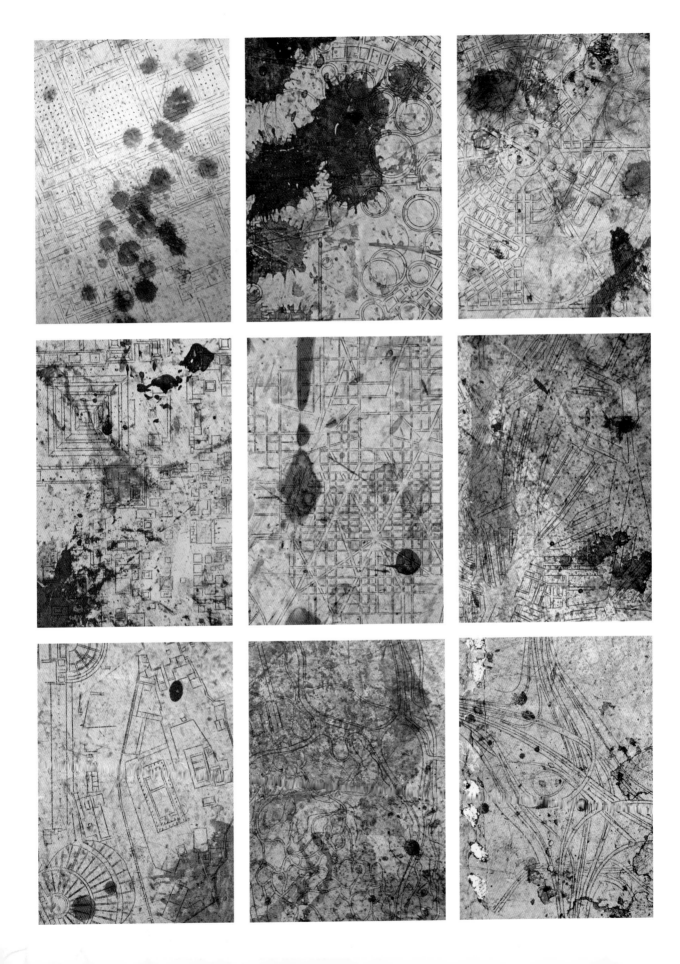

FOUND OBJECTS
(transforming)

FORMS OF RECOLLECTION (STORIED)

Diane Mullin

Walls have been a characteristic of the built environment since at least the twelfth millennium BCE. The walls of the temple Gobekli Tepe in Urfa in southeast Turkey, the oldest known extant wall relics, date to 11,500 years ago. Urban fortification walls first appeared in Jericho (now West Bank, Israel) and Uruk (now Iraq) around the tenth millennium BCE. Defensive walls to separate regions emerged in Sumeria around 2100 BCE. Unlike walls that surrounded cities, these defensive walls marked and maintained quasi-national, rather than private, territory. The Great Wall of China, which was built over several centuries, was one such defensive wall. Walls also enclosed individual personal dwellings in the Neolithic age (9000 BCE – 3000 BCE), such as the structures in Banpo, China (circa 4800 BCE) and the stone dwelling of Skara Brea in present-day Orkney, Scotland. Hadrian built a great wall to barricade Roman-occupied Britain from its enemies in the north. The traditions of walled homes and walled-in cities continued into modern times, even finding an incarnation in the gated communities of American suburbs. Despite the differences between these wall types, they all address an intention to enclose,

realized through the mechanism of shielding certain individuals and keeping others at bay. A blunt and straightforward form of protection, walls are necessarily unequal, leaving some safe and some vulnerable.

Harriet Bart's *Forms of Recollection (Storied)* (1989) uses altered books as bricks to build a wall that spirals in, on, and out from itself. Neither delineating nor blockading the viewer, this installation draws one in, at least conceptually. Not to be catapulted over or burrowed beneath, this wall offers protection through a path that beckons, encouraging one to enter more deeply. It suggests a labyrinth, a primordial symbol that combines the circle and the spiral to create a meandrous path facilitating purposeful thought and meditation. To nurture such pondering, Bart guides an alchemical-like transformation of the building blocks of walls (bricks and stones) into books and words. Like the elemental symbols she employs, books, words, and the stories they construct are presented as essential human tools able to unlock knowledge and profound consciousness.

In its structure and in its own act of

becoming, *Forms of Recollection (Storied)* envisions and enacts powerful journeys. Each time this work is exhibited it may be shown anew, as the book/stones configure the wall at a specific moment, without a plan or scheme. This element of the work embodies the act of contemplation and healing the artist seeks to convey. True to Bart's fascination with words, the book figures as the keystone to this artistic endeavor. Stories, told and kept, can be glimpsed through the many titles scratched pentimenti-like on the book/brick surfaces. As the viewer circles the perimeter and goes inside, or imagines doing so, the juxtaposition of words sparks thoughts, associations, and memories in the beholder/participant. Embarking on this quasi-journey, we encounter a nonconstricting wall that reveals its talismanic power without separating us from each other. Bart's spiral wall becomes not just an object but also an experience. Evoking memory, the journey undertaken through *Forms of Recollection (Storied)* — one of remembrance, difficulty, and acceptance – is itself storied, much like the copious, timeless tales that in their voyage-like recitations bestow safety, wonder, and solace on the listener.

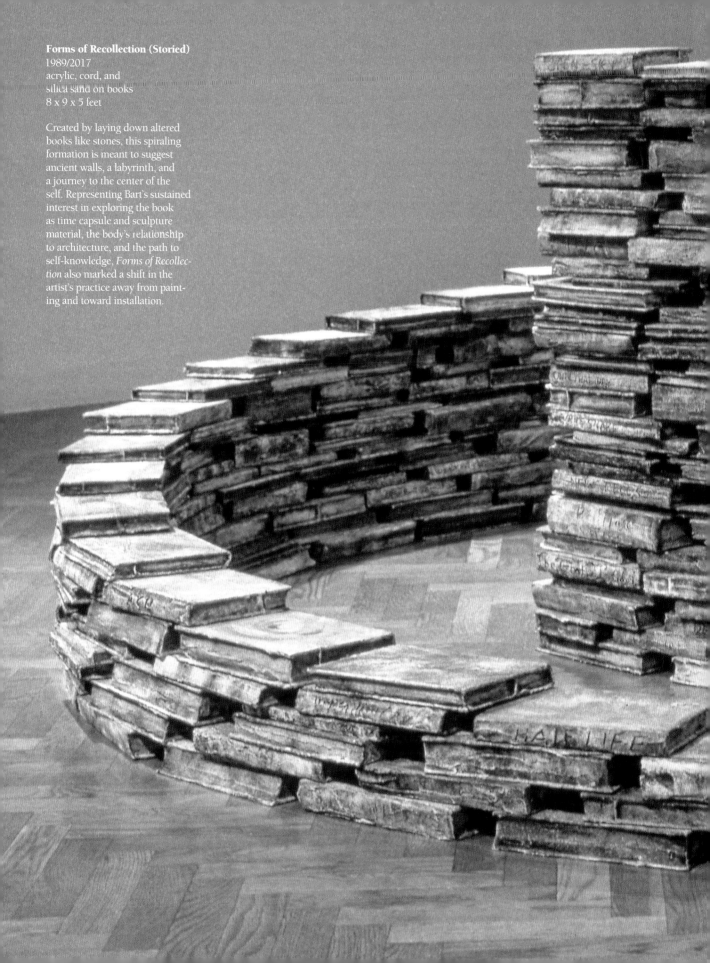

Forms of Recollection (Storied)
1989/2017
acrylic, cord, and
silica sand on books
8 x 9 x 5 feet

Created by laying down altered
books like stones, this spiraling
formation is meant to suggest
ancient walls, a labyrinth, and
a journey to the center of the
self. Representing Bart's sustained
interest in exploring the book
as time capsule and sculpture
material, the body's relationship
to architecture, and the path to
self-knowledge, *Forms of Recollec-
tion* also marked a shift in the
artist's practice away from paint-
ing and toward installation.

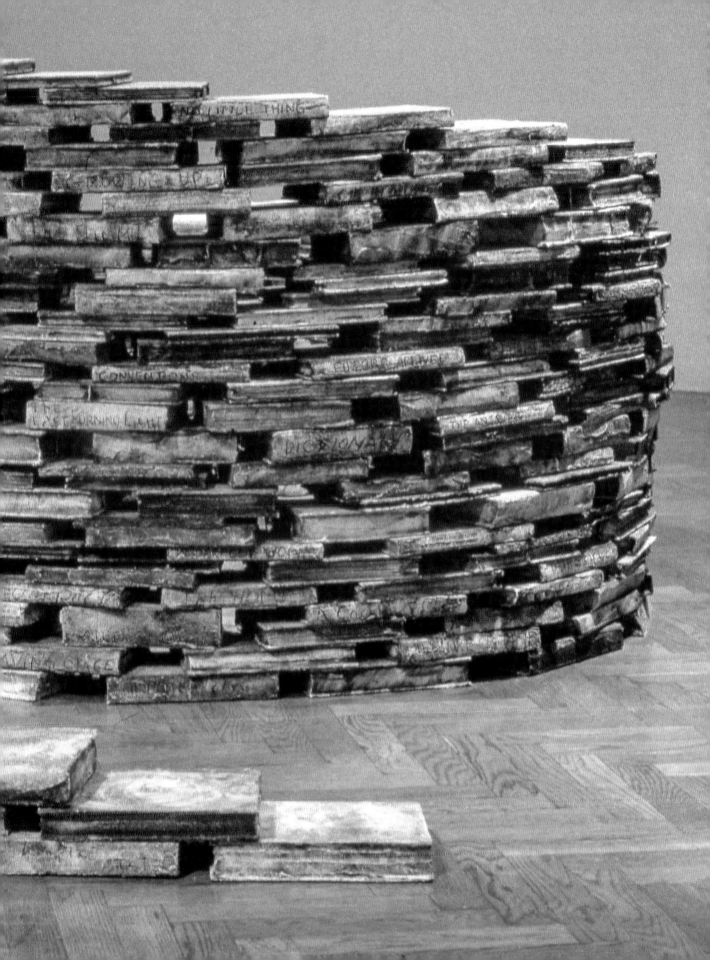

TRAVEL
Elizabeth Erickson

Old – the place
was old and burnished,
she said,
streets narrow.
Of everything in Italy,
I loved the walls.
Could you feel the center of things,
the places of power,
circles of light,
the moment of
absolute
concentration in
the old basilica?
I asked
Yes, she said
Yes,
I could.
See, see
how the paintings
I remember the piazza shaped like a fan of pink
bones
I rode on a canal
every night
the water was shallow
and safe, the boatman
had been pressing his stick to the
close floor for
five hundred years.

From the prairie, our lives there,
we watched those faces
Giotto placed, just
beyond the reality
of flesh. I said, when I move
down in myself I think I'll
move in darkness and find that
not so.
I squint at the light,
though my eyes are closed, the paradox
and reality of light
in depth. How far to go?
When I came home,
she said,
I found an old
drawing of mine
a pink fan
of herringbone

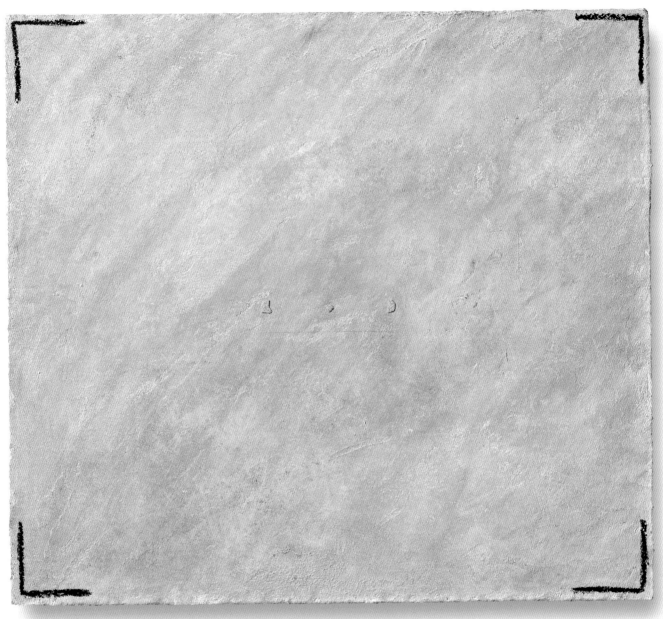

Remembrance: Florence, 1985
acrylic, oil stick, silica sand, and
stone fragments on canvas
47 x 42 x 1 ½ inches

This work is reflective of the
artist's memory of visiting Florence
and experiencing it as a palimpsest.
While there, she found three
small stones that had crumbled
off a nearby building. These frag-
ments inspired her to create a
painting with a surface that emulat-
ed the textured walls of the city.
She adhered the stones to the cen-
ter of the composition. The painted
brackets reference the framed view
seen through a photographic lens.

Notion, 2016
found objects, acrylic
24 x 12 inches

Bart found a large spindle wound
with cotton fiber at Indigo, a
Minneapolis store co-owned by
Mary Pawlcyn, a weaver who had a
studio next to Bart's in the Wyman
Building. Bart was drawn to the
object's ordinariness and its asso-
ciations with feminized labor. Its
curved forms and scale struck her
as reminiscent of prehistoric female
figurines. Although the function
and histories of the figurines
are unknown to us, Bart is com-
pelled by the speculation that
they functioned as talismans.
In appropriating this object, she
has designated it a talisman.

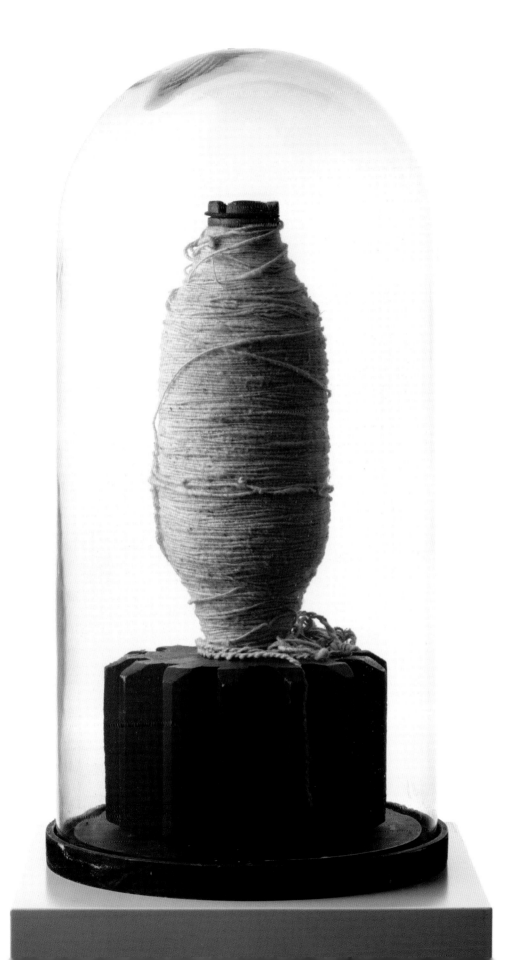

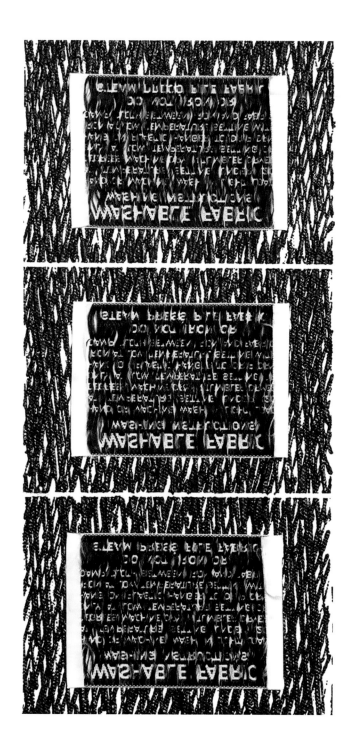

Concrete Poem, 1985
acrylic and found
clothing labels on canvas
40 x 39 ½ x 1 ½ inches

In her studio (which had previously been occupied by a garment manufacturing company), Bart found hundreds of washable fabric instruction labels that she used to create a work that explores the canvas as cloth. Against neatly ordered rectangles of black cross-stitches, she attached the labels with their backsides showing. By reversing the label and rendering the text abstract and indecipherable, she writes a visual poem in homage to women's work that is in plain sight but that we still fail to see.

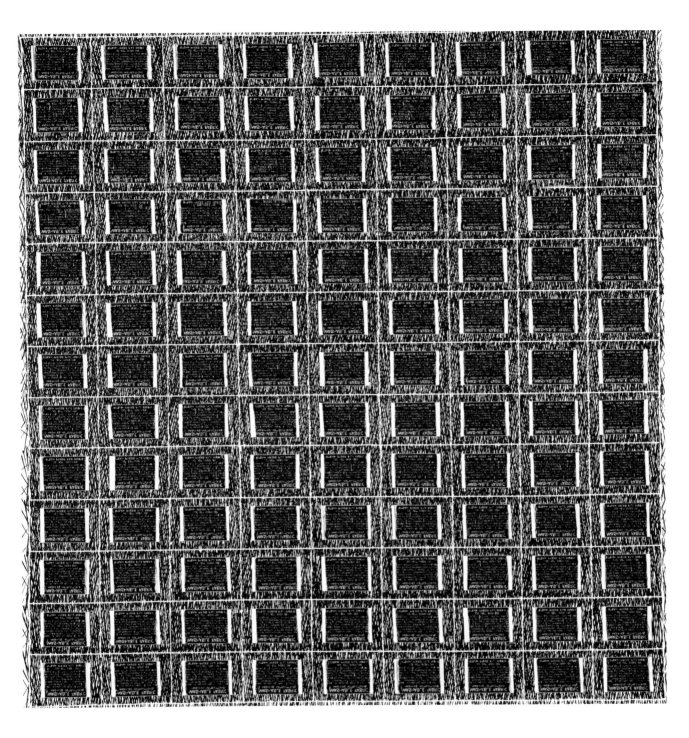

Ledger Domain, 2009
vintage ledgers, wood
31 x 17 x 12 inches

Bart created this assemblage by
combining found objects: two
vintage ledgers she had collected
and a large block of wood that
she found in the basement of her
studio, which was built in 1886
and once served as a warehouse.
After many years of looking at the
objects separately, she saw that
they belonged together. She was
especially drawn to the vertical
striations in the wood block, which
seemed continuous and integral
to the textured edges of paper.

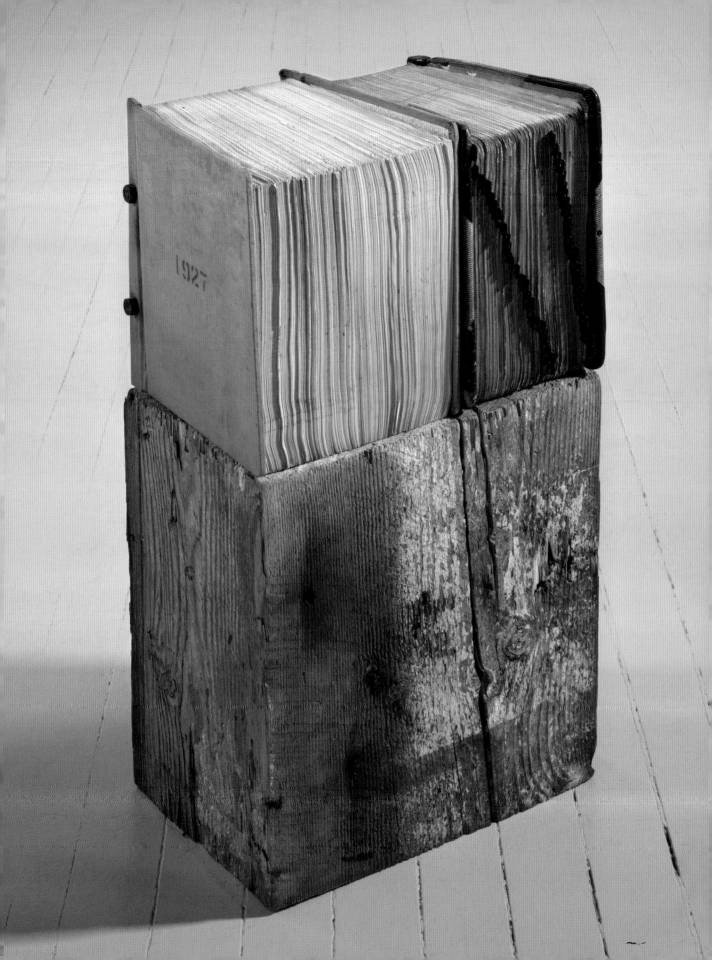

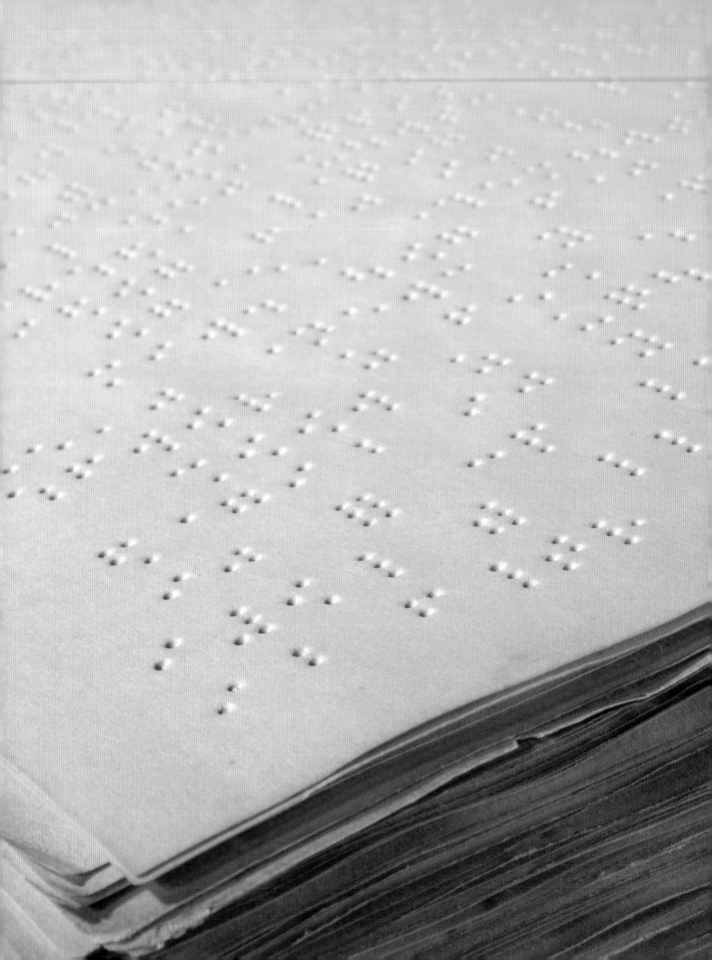

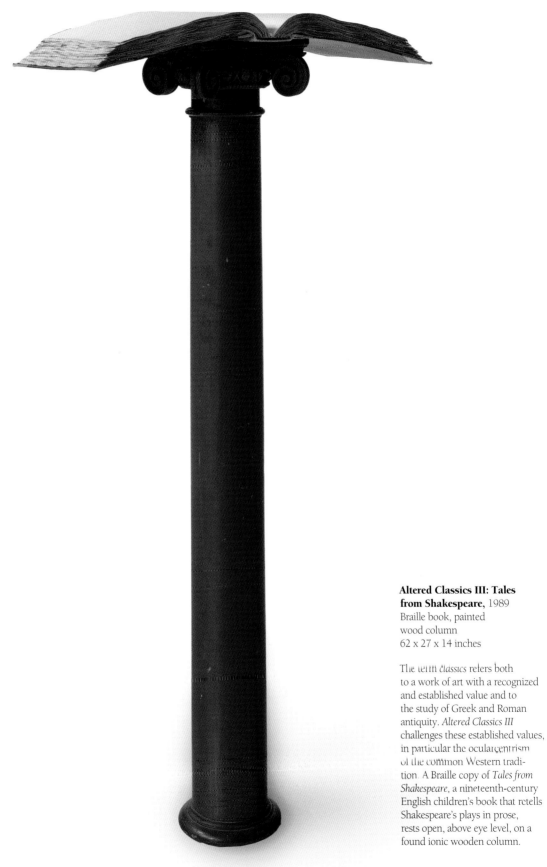

Altered Classics III: Tales from Shakespeare, 1989
Braille book, painted wood column
62 x 27 x 14 inches

The term *classics* refers both to a work of art with a recognized and established value and to the study of Greek and Roman antiquity. *Altered Classics III* challenges these established values, in particular the ocularcentrism of the common Western tradition. A Braille copy of *Tales from Shakespeare*, a nineteenth-century English children's book that retells Shakespeare's plays in prose, rests open, above eye level, on a found ionic wooden column.

195

Campaign Chest, 2018–19
wood, glass, powdered steel (case);
mixed media (contents)
36 x 89 x 17 ¼ inches (open)
36 x 42 ½ x 17 ¼ inches (closed)
Fabricated by Tom Oliphant
and Scott McGlasson

After deciding to donate her archive
to the Weisman Art Museum at
the University of Minnesota, Bart
began to assemble a small body
of "evidence" that would remain
with her family. In the creation
of this work, she was inspired by
Marcel Duchamp's *Box in a Valise*
(1931–41), a series of suitcase-like
boxes containing miniature replicas
of his work. Many of the objects
contained within Bart's *Campaign
Chest* are studies or fragments from
larger projects, not objects she
created after the fact. In safeguard-
ing things past for future reference,
Bart was also informed by the
Jewish practice of geniza.

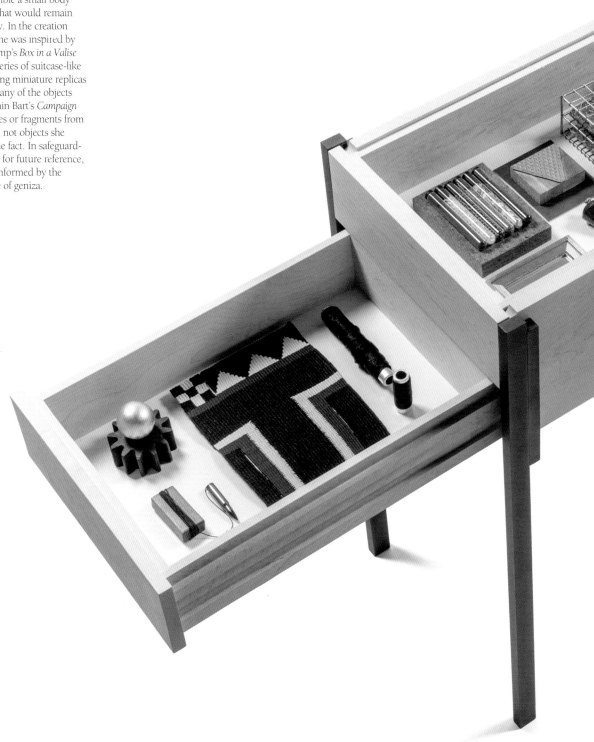

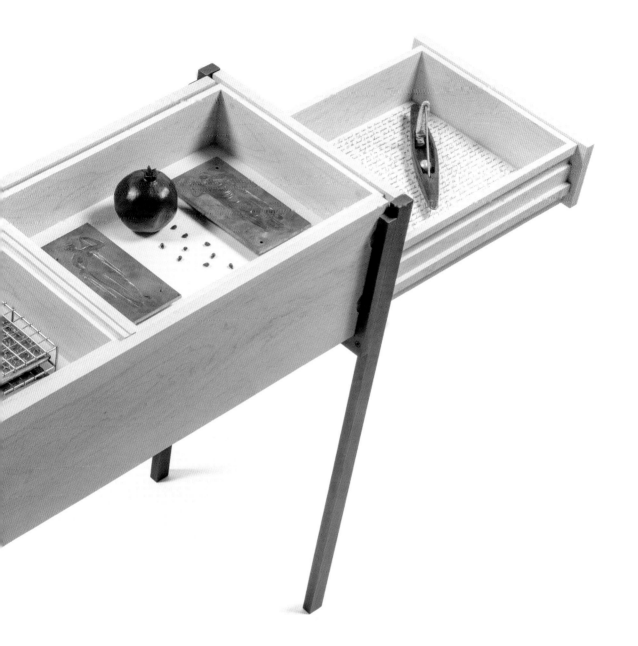

CHRONOLOGY
Heather Everhart

I have been Harriet Bart's studio assistant for a decade.
Between projects, we have been building an archive of record
for her long career. This chronology shares the history
I have been able to explore with the artist, thanks to her habit
of always keeping the hard copy. Harriet is a consummate
professional, which I appreciate in our work together
and aspire to in my own practice.

I have observed the ever-evolving similarities of our ethos:
- archiving life (collections, lists, and maps)
- considering materiality (in dressing and in making)
- revering histories (the art of memory)
- sharing through mentorship (you catch more flies with honey)
- grasping for solitude (silence in the void)
- desiring to collaborate (noise in the present)
- a lot of black (an exploration)

These characteristics are consistent elements throughout her work and life:
- cyclical (the subject > the study > the book > the objects > the installation: repeat infinitum)
- consuming (never not working)
- devoted (and devotional)
- elevated (and elaborate)
- precise (inimitable perfectionism)
- refined (superior attention to detail)
- a lot of black (an armor)

I believe the work of great artists should be held in collective memory for
future generations. From the moment I first encountered her in the hallway
of Traffic Zone, I knew Harriet Bart was not to be forgotten.

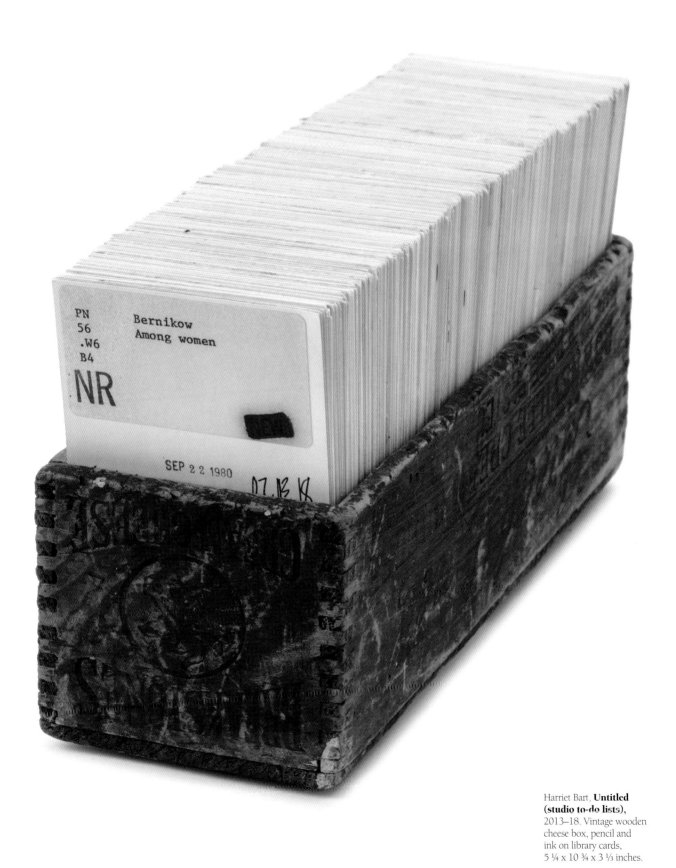

Harriet Bart, **Untitled (studio to-do lists),** 2013–18. Vintage wooden cheese box, pencil and ink on library cards, 5 ¼ x 10 ¾ x 3 ⅓ inches.

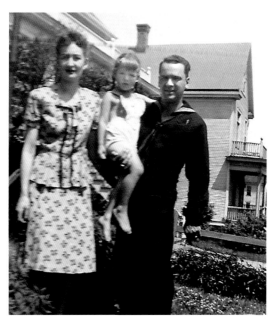

LEFT:
Bart and
her parents,
1945

BOTTOM LEFT:
Bart with her parents
and Tamara, circa 1953

RIGHT:
Bart's childhood
home in
San Francisco,
circa 2018

BOTTOM RIGHT:
Harriet Bart, **Chess
Board**, carved
wax teeth (1938)
and chess game
board (1984).
8 x 8 x 1 ½ inches.

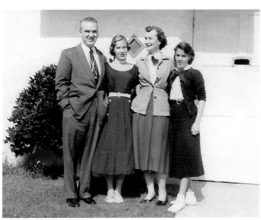

1941 Harriet Bart (née Levine) is born in Duluth, Minnesota, to Natalie and Morton Levine (both born in 1916). The family moves to the rural town of Hansboro, North Dakota, where Mort accepts a position as an immigration inspector for the U.S. Immigration and Naturalization Service (INS).

1943 Mort is transferred three hours west to Portal, North Dakota, where he handles investigations and deportations along the U.S.–Canadian border.

1944 The family receives three war department telegrams: notifications that Bart's uncle was seriously wounded and her great uncle and second cousin were killed in World War II.

1945 Mort is drafted into the Navy. After his departure, Bart and her mother move to Duluth and live with Natalie's parents, Eva and Tom Davis, and their large extended family.

1946 After the war ends, Mort is honorably discharged from military service and returns to Duluth. The family moves back to Portal after Mort accepts another position with the INS.

1948 Mort is transferred to San Francisco, and the family leaves North Dakota. They move to a veterans' benefit public housing apartment in Richmond, California.

1949 The Levine family moves to a house in the Outer Sunset neighborhood of San Francisco.

1951 Mort and Natalie contact the Jewish children's home in San Francisco, Homewood Terrace, and take in a nine-year-old foster child, Tamara Seacor (born 1942).

1952 Natalie, a skilled seamstress, teaches Bart to sew, and she makes her first garment.

1953 Encouraged by her parents' appreciation of books, Bart spends hours at the Parkside Library on Taraval Street, a place that allows her to be on her own, do her homework, and spend time with friends. She reads classics by Ernest Hemingway, John Steinbeck, and Charlotte, Emily, and Anne Brontë.

1955 On a visit to the de Young Museum with friends, Bart happens into a room filled with black paintings, which intrigue her over the course of her career.

1957 Mort is transferred to Washington, D.C., and the family moves from San Francisco to Silver Spring, Maryland. Bart visits the National Gallery on weekends. She buys her first art book, *Masterworks from the National Gallery*.

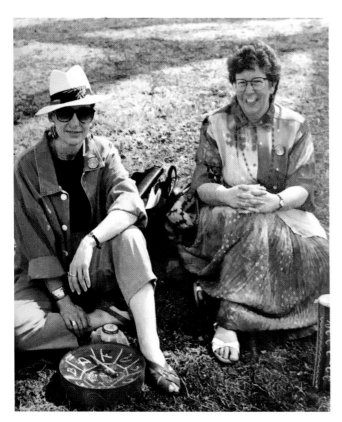

Leslie Gillette and
Harriet Bart, 1978

Harriet and Bruce Bart
with their children, Gavin,
Brad, and Eden, 1970

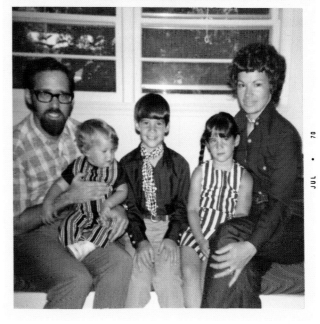

1958 Bart graduates from Montgomery Blair High School in Silver Spring at the age of sixteen. She had been working at her dentist's office and, at her father's urging, submits an application to the University of Minnesota School of Dental Hygiene; she matriculates there in the fall. She enjoys dental anatomy and cultivates skills required to carve teeth out of clay and wax and cast in gold and metal.

Harriet Bart and
Carol Daly at
Earth Day action at
the Minneapolis
College of Art and
Design, 1990

1960 Bart finishes her program and obtains her first job as a dental hygienist; she will continue this work on and off for the next ten years. She marries Bruce Bart on Christmas Eve in 1960.

1961 The Barts move to Arlington, California, for Bruce's medical internship at Riverside County Hospital. While in Arlington, Bart begins drawing classes.

1962 Son Bradley is born in January at Riverside County Hospital. Bruce completes his internship in June, and the family returns to Minneapolis. Bart goes back to work as a dental hygienist and enrolls in evening classes at the University of Minnesota, where she studies the humanities.

1964 Daughter Eden is born. Bart makes most of the clothing for herself and the children—a creative outlet as well as a necessary utilitarian task.

1965 Bruce finishes his training and is invited to join a medical clinic in Fargo, North Dakota. Bart meets Jim O'Rourke, who runs an art gallery in Moorhead, Minnesota. O'Rourke teaches painting and sells art supplies in the gallery. Bart takes classes and begins to paint and experiment in a variety of art mediums.

1967 The Bart family returns to Minneapolis, where Bruce joins the faculty of Hennepin County General Hospital (now Hennepin County Medical Center). Bart returns to work as a hygienist.

1969 Son Gavin is born and Bart retires from her job. She meets Carol Daly at a women's gathering, and the two develop a lifelong friendship. Daly, an educator, activist, and collector, is a supportive sounding board for Bart. With their shared feminist and political interests they engage many political activists visiting Minnesota, including Bella Abzug and Gloria Steinem.

1971 Bart visits California and attends Magdalena Abakanowicz's solo exhibition at the Pasadena Art Museum; Abakanowicz's bed and rope installation was particularly memorable. Bart sees the landmark UCLA Art Galleries exhibition *Deliberate Entanglements*, which is exciting and highly influential for her. She is impressed by the tremendous power and scale of the muscular fiber works by women. For Bart, these pieces refute fiber's associations with small crafts or garments and announce themselves as art.

1972 Bart meets neighbor Leslie Gillette, who is involved in mail art, a populist practice of sending small artworks via the postal service. They become lifelong friends. Bart starts classes at the Weavers Guild (now the Textile Center) in Minneapolis. She quickly takes to weaving.

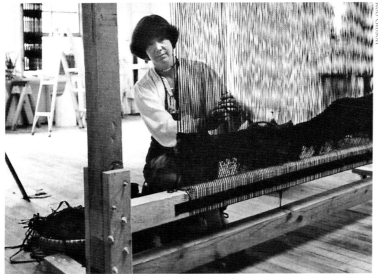

Rob Gibson

TOP LEFT:
Josep Grau-Garriga's
workshop class
at California State
University at
Fullerton, 1975.
Bart is second from
right in the back
row, next to teacher
Clinton MacKenzie.

LEFT:
Harriet Bart at
the loom in
her studio, 1980

ABOVE:
Harriet Bart in her stu-
dio, with her weaving
in the background,
1980

NEAR RIGHT:
Harriet Bart and
Hazel Belvo at WARM
Gallery, 1978

FAR RIGHT:
Bart caped in Wonder
Woman mode, 1982

1974 Bart is accepted into the University of Minnesota's University Without Walls program. There is no formal major in textile art, but this flexible program allows Bart to design her own plan of study. She takes fiber art courses with Charlene Burningham at the university.

1975 As part of Bart's work in University Without Walls, Burningham suggests she take classes with significant fiber artists; she studies with Walter Nottingham at the University of Wisconsin–River Falls and visiting artist Clinton MacKenzie at Macalester College in St. Paul.

Bart travels to California to study with Josep Grau-Garriga, taking his course "Contemporary Tapestry" at California State University (CSU) at Fullerton. The Catalan artist subsequently becomes her mentor. Bart meets Lenore Tawney at CSU, sees an exhibition of her work, and attends her lecture.

Bart submits her textile work *Ascension* to a juried exhibition at the Rochester Art Center in Minnesota and wins first prize.

1976 Bart graduates from the University of Minnesota's University Without Walls program with a B.A. in contemporary fiber arts.

A busy mother of three children, she begins her fine art career by making sculptural body pieces and experimental fiber objects. Working in isolation in her basement studio at home between the children's activities, Bart is intrigued to read in the *Star Tribune* that the Women's Art Registry of Minnesota (WARM) had opened a new gallery downtown at the Wyman Building in the Minneapolis Warehouse District. Bart visits WARM: A Women's Collective Art Space (also known as the WARM Gallery), where she meets artist Elizabeth Erickson, who eagerly emphasizes that WARM is a feminist gallery. Bart identifies with her feminist perspective and becomes a member in the fall of 1976. WARM functions as a kind of graduate school for Bart, teaching her to establish a professional studio practice and exacting exhibition standards. She participates in discussions with influential visiting artists, critics, and scholars such as Germaine Greer, Lucy

Lippard, and Linda Nochlin. Through members' meetings and consciousness-raising sessions, she becomes comfortable with collaborative processes.

In August, Bart attends Josep Grau-Garriga's environmental sculpture collaborative workshop in Costa Mesa, California. She arranges for him to visit Minneapolis to teach an intensive contemporary tapestry workshop, "Sculptural Form in Fiber," at the Sabes Jewish Community Center in late October.

1977 Bart meets artist Mary Walker. Walker becomes a member of WARM.

1978 Bart has her first WARM solo exhibition, *Bart/Belvo*, alongside friend Hazel Belvo. Belvo exhibits a series of ethereal, mostly white paintings on the lower level of the gallery; Bart creates an installation of black tapestries in the upper gallery. Art historian Kathryn Johnson writes in the exhibition's publication: "Symbolism of color and material is important and specific for

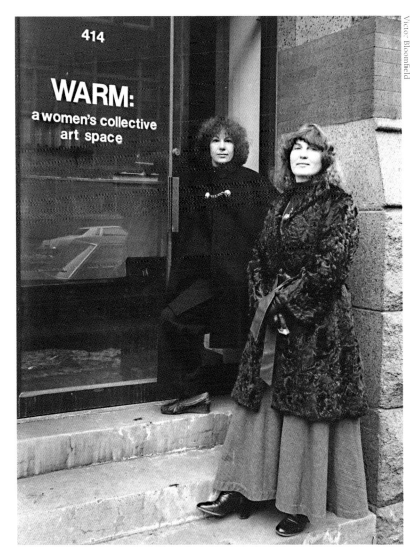

Victor Bloomfield

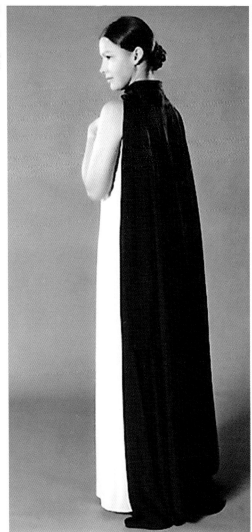

Alan Forrest

Ms. Bart, who feels that black at once compels and repels the viewer. Certainly her use of black, modulated by the most skilled woven or tied textures, recalls the paintings of Manet, seductive and uncompromising."[1]

1979 Bart exhibits a series of sculptural woven works and, for the first time, two interwoven canvas paintings in her first Minnesota Artists Exhibition Program (MAEP) show at the Minneapolis Institute of Arts. *Contents/Structures* also features works by David Marquis, Ann Marie Penaz, John Sonderegger, and Terry Streich. According to a review in the *Minnesota Daily*, the works of the five artists share "a use of highly personal, symbolic images."[2]

1980 Bart receives a grant from the Minnesota State Arts Board to explore painted and woven constructions. She creates a series of large-scale, unstretched, and interwoven canvas paintings. This breakthrough work expands the vocabulary of Bart's woven projects, and she leaves her looms to explore other media.

Bart and Mary Walker have a duo exhibition at WARM; Bart exhibits the painted woven canvases. They find a studio together in a former coat manufacturing company in the Kickernick Building on First Avenue North in Minneapolis, next to WARM.

The artists work at the Kickernick building until it is sold and rent rises due to gentrification of the neighborhood. Looking for new studios, they find an open space with good light and ample room at 700 Washington Avenue North. The building manager requires that the entire floor be rented. Bart and Walker consult Artspace, an organization established in 1979 to advocate for artists seeking safe and reliable workspace.

Artspace arranges a lease for the third floor of the building and recruits other artists to build studios there. Jim Conaway, Elizabeth Erickson, Susan McDonald, and Jantje Visscher, among others, join Bart and Walker. Studios at 700 is the first artist-run studio project in the Minneapolis Warehouse District.

1982 Bart is a regional panelist for the Wonder Woman Foundation, a grant-making arm of DC Comics created by president and publisher Jenette Kahn.[3] Bart and the panelists select eighteen women over the age of forty to receive $7,500 each in honor of their Wonder Woman qualities: Wonder Woman embodied compassion, courage, honesty, strength, and wisdom.[4] The fictional superhero had inspired Bart since childhood; they were born the same year.

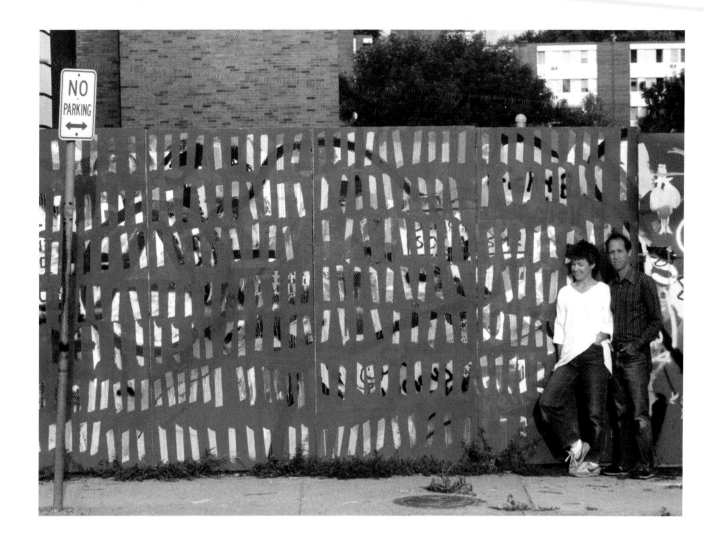

1983 The Walker Art Center in Minneapolis is under construction, and the large plywood fence that surrounds the work zone attracts graffiti artists. Regularly driving past it between the studio and home, Bart sees an opportunity for a family activity. She designs a mural that the family covertly paints on the plywood in early dawn: they are pleased with their work. The next day, their mural is mostly painted over and the graffiti cycle begins again.

Harriet and Bruce Bart with their family's mural outside Walker Art Center, 1983

1984 Bart and Mary Walker invite artist Scott Seekins to join them in a Minnesota Artists Exhibition Program show, *Character Reference*, at the Minneapolis Institute of Arts. The works in the exhibition reference ancient myths and archetypal figures and are arranged to create a theatrical experience for the viewer. Bart makes several paintings about the river Styx. After the exhibition, she is unhappy with her paintings and destroys them. A small catalogue designed by the artists was published for the exhibition, and it begins with a quotation from Samuel Beckett's *Waiting for Godot*:

> ESTRAGON: I can't go on like this.
> VLADIMIR: That's what you think.

Bart reflects in her project statement that "sometimes that is what it feels like, to be an artist."

1985 Bart and her husband travel to Italy, enjoying the company of friends while exploring the art and architecture of Florence, San Gimignano, Siena, and Venice (during the Biennale). She returns home with new ideas inspired by the daily rhythm of Italian life and the aesthetics of the country. The memory of light and the wash of color on ancient walls stays with her, and she creates a series of evocative paintings, *Remembrances*.

Bart teaches a lecture class at the Walker Art Center, "Women in Art: Evolution/Revolution."

1986 *Structure and Metaphor: Six Contemporary Visions* is a significant exhibition at WARM Gallery, pairing three WARM members (Bart, Elizabeth Erickson, and Jantje Visscher) with three New York artists (Jeanette Fintz, Pat Hammerman, and Judith Murray). The exhibition catalogue features an essay written by Ronny

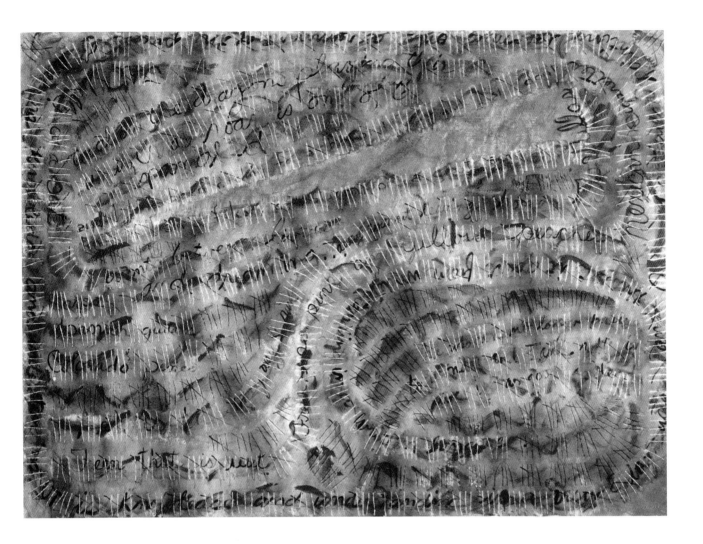

Cohen, a leading arts writer and curator. Cohen notes that among these artists' works the thesis elements of structure and metaphor "immediately stand out, forming a thematic thread that passes through the deepest avenues of the senses and settles into the soaring reaches of the spirit."[5] Bart shows art from her *Re-Marks* series. For each painting in the series, she meets with a small group of people around a theme, collaborating with her family members, artists, poets, and dancers. In the exhibition publication, she explains the process: "Each participant is asked to come to my studio one at a time for the purpose of writing something of his or her own choosing on a gessoed canvas . . . I study their remarks and respond to the patterns that have emerged with an overlay of stitched abstract marks. When the marking process has been completed the actual painting begins."[6]

1988 After painting for almost a decade, *Re-Marks: Memorial* is Bart's last painting of the series and of this period—as had happened in her transition from textiles to painting, she is eager to move forward with something new. While thinking about what she is trying to accomplish as an artist, Bart turns to her books, recalling Stéphane Mallarmé's words: "Everything in the world exists in order to end up as a book." She looks at her bookcases, removes the books from their shelves, and stacks them into spirals and towers. A revelatory moment: books quickly become her focus. She amasses books from libraries, garage sales, and friends. Inspired by the ancient ruins, sacred sites, and village walls of her travels, she paints the books to resemble stone and uses them as building blocks, creating sculptural structures that take the form of columns, walls, and spiraling paths. Bart refers to these works as an architecture of history and memory.

1989 Bart has her third MAEP exhibition at the Minneapolis Institute of Arts with Rob Lawrence, Sandra Menefee Taylor, Jeff Wilcox, and Karen Wirth. *Volumes* premieres her new large-scale altered book installations. Following this exhibition, New York–based book arts dealer and collector Tony Zwicker sends a letter to MAEP to contact Bart. They meet in New York.

Harriet Bart,
Re-Marks: Artists,
1984. Acrylic and
stitching on canvas,
56 ½ x 90 inches.

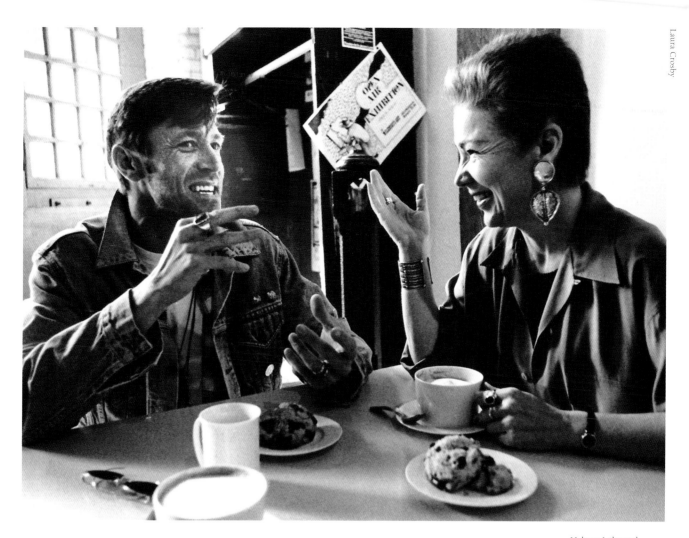

Helmut Löhr and
Harriet Bart, 1993

1990 Bart travels to New York to create an in-
stallation for the exhibition *The Book as Art / The
Book in Art* at the Barbara Fendrick Gallery. Tony
Zwicker tells her the German artist Helmut Löhr
is also in the exhibition and they must meet, as
their art has much in common. In an interview,
Bart recalls her first meeting with Löhr: "After
leaving Tony's Gramercy Park apartment, I
walked to the Center for Book Arts to pick up a
package. The center was closing, but there was
one other person there, a man, and we exited
the building together. He introduced himself as
Helmut Löhr and we walked to the opening at
the Fendrick Gallery." They have lunch together
a few days later. Löhr invites Bart to visit him in
Düsseldorf, and in May she does.

The two artists are mutually influenced by the
German Fluxus icon Joseph Beuys, who died
in 1986. During one of Bart's visits to Germany,
they travel to Krefeld, the town of Beuys's birth,

to see an installation of his work, and they meet
Beuys's widow and children at a posthumous
Beuys exhibition at the Kunsthalle museum in
Düsseldorf. Bart and Löhr spend many hours
discussing life and art and working on projects
together. They will be artistic collaborators for
the next twenty years.

Toward the end of 1990, Bart is invited to the
MacDowell Colony for a five-week residency.
She meets painter Marylyn Dintenfass there, and
they become lifelong friends and champions of
each other's work. The residency is productive.
Responding to the architecture of her studio,
which was once a chapel, Bart expands the
vocabulary of her large-scale book constructions.
She explores new materials and makes rubbings,
drawings, and paintings on sandpaper. Carving
words and images into acrylic plates, she creates
cast acrylic pages to complete her first artist's
book, *Gatherings,* a book of days.

Bart begins a durational, Fluxus-inspired
studio project. Each holiday season between
1990 and 2010, she creates twenty-one unique
small sculptural objects, one each year for
twenty years. Each object is made in an edition
of sixty-five and mailed as winter-season gifts to
colleagues and friends. She gives away more than
1,300 small sculptures through this gift of art.

1991 Bart wins a competition to create her first
public art project for the entrance plaza of a new
public library in Ibaraki, Japan. While the library
is still a dirt construction zone, she visits the site
for three days and begins to develop plans for
her work, a spiral enclosure comprised of 650
individually cast bronze books. This is Bart's first
bronze casting, which she executes in collabora-
tion with Minnesota-based foundry J. A. & M.
Studio.

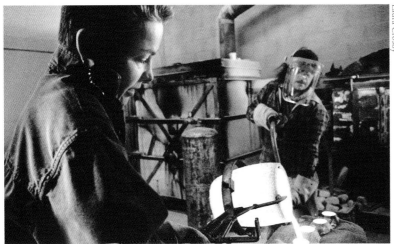

TOP:
Harriet Bart and
Helmut Löhr, **Visual
Communication,**
1992. Mixed media
on paper, image from
Dialogue catalogue,
page size 10 ¼ x 8 ¼
inches.

ABOVE:
Bart at J. A. & M.
Studio, Minneapolis,
1991

Harriet Bart and
Marylyn Dintenfass
at Dintenfass's
studio, New York,
New York, 2011

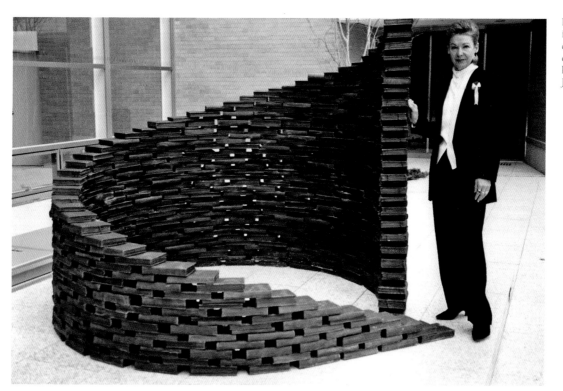

1992 Bart returns to Ibaraki to attend the unveiling of her sculpture *Helicon Volumes* at the library opening. She visits Kyoto and travels to Beppo, Hiroshima, and Kobe.

Löhr and Bart attend Documenta 9 in Kassel. Bart remembers an exquisite and influential installation by James Lee Byars. While in Kassel, they see The Red Train, and they socialize outside the train station with artists Dick Higgins, Alison Knowles, and Emmet Williams; all were involved in the Fluxus movement and exhibited with Galerie Schüppenhauer in Cologne.

Concerns about gentrification motivate Bart and several other artists from Studio 700 (formerly Studios at 700) to approach Artspace (now Artspace Projects, a developer of affordable artist spaces). The artists ask the organization to help them buy a building in which to house their studios. With a grant from the McKnight Foundation, Artspace Projects and the artists purchase a six-story limestone building in Minneapolis's Warehouse District, originally the site of Moline, Milburn and Stoddard Company and later the National Biscuit Company (Nabisco). Renovation begins, in anticipation of reopening as an artists' studio cooperative.

1993 Bart meets Minneapolis gallerist Dolly Fiterman, who invites Bart and Löhr to exhibit at her gallery. This is the impetus for their collaboration *Dialogue: Alchemy of the Word*, an exhibition of individual and collaborative sculptures, collage, and photography that opens at Dolly Fiterman Fine Arts later that year.

Helmut Löhr, Dolly Fiterman, Christel Schuppenhauer, and Harriet Bart in Cologne, 1994

1994 Bart and Löhr's collaboration at Dolly Fiterman Fine Arts, *Dialogue: Alchemy of the Word II*, is exhibited at Galerie Schüppenhauer in Cologne, Germany.

Bart is commissioned to create an outdoor work for the Doubleday Book and Music Clubs in Garden City, New Jersey. *Double Ode* is a 28-foot curving wall-like formation comprised of individually cast bronze books.

1995 The newly renovated artists' studio cooperative Traffic Zone Center for Visual Art opens. Bart's studio moves to a serene, light-filled space on the northwest corner of the third floor, where she has been since.

The third and fourth iterations of Bart and Löhr's exhibition *Dialogue* is presented at Galerie Henn in Maastricht, Netherlands, and at Galerie Horst Dietrich in Berlin, Germany.

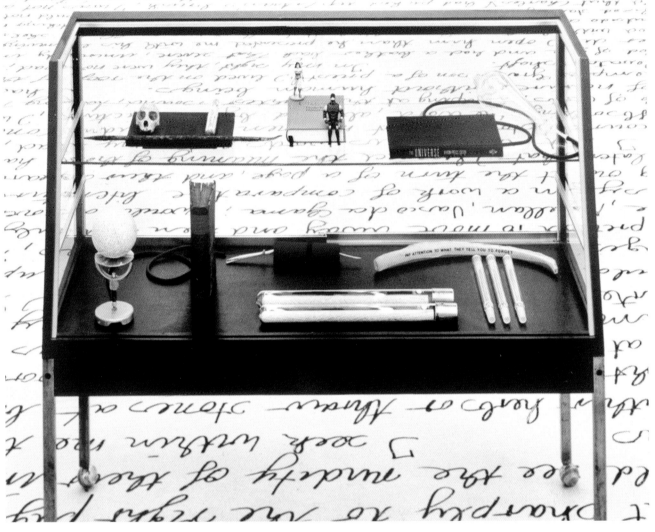

Installation views of Harriet
Bart and Helmut Löhr,
**Dialogue: Alchemy of
the Word III,** 1995.
Galerie Henn, Maastricht,
Netherlands.

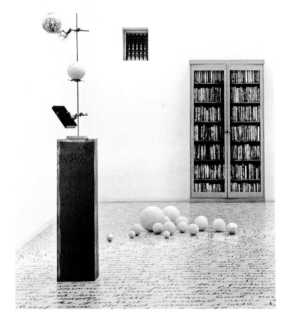

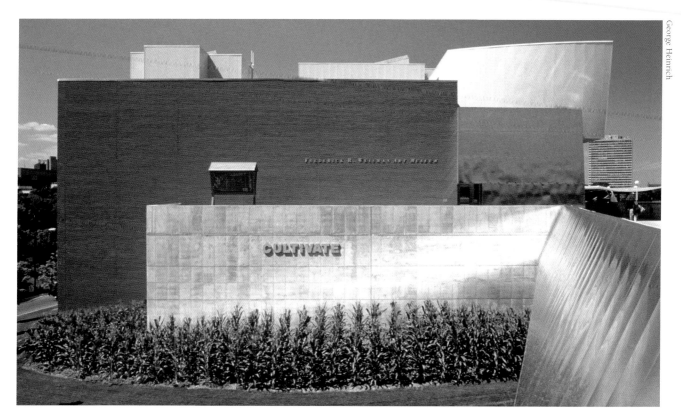

George Heinrich

Harriet Bart,
Harvest, Weisman Art
Museum, 1996

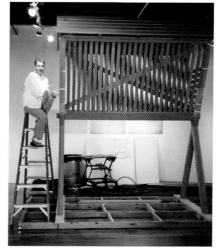

Bart works on
Harvest in
her studio, 1996

1996 Bart is commissioned by the Jerome Foundation and the Weisman Art Museum at the University of Minnesota to create a work for the sculpture plaza of the museum's new building, designed by Frank Gehry. Because the University of Minnesota is a land grant institution, she chooses cultivation as the theme for *Harvest*, a cross between an early Scandinavian corn crib and a Shinto shrine. The structure is filled with books that have been gathered by students and, in collaboration with the School of Agriculture, students plant corn at the base of the Weisman Art Museum. Bart explains that *Harvest* is a reflection on "the origin of this state and this land-grant university; the hunger of the body and of the mind; and the fertility of the land and the mind."

1999 Bart receives a McKnight Artist Fellowship, a grant for mid-career Minnesota artists. She creates the installation *Garment Registry*, a commentary on the working conditions of women in garment factories during the first half of the twentieth century. The installation is exhibited at the Minneapolis College of Art and Design.

2000 Bart receives a Bush Foundation Artist Fellowship. Tony Zwicker tells her that master printer Philip Gallo lives in Minneapolis, and she uses the fellowship funds to work with him to publish her first fine press artist's book, *Garment Register*. She wins her first Minnesota Book Artist Award.

Harriet, Bruce, and friends travel to Israel. During drives along the highways, she observes pomegranate shrubs, which will appear in later work.

2001 Bart is selected for a residency in Israel through Partnership 2000: A Cultural Exchange Encounter, which begins just after the events of September 11. American artists are paired with Israeli artists to create public art projects for Poriya Medical Center (since 2005, The Baruch Padeh Medical Center), located at Poriya Ridge above Tiberias in the Galilee region. The visiting artists live and work on a kibbutz. Bart works in a ground-level studio space at Kibbutz Ashdot Ya'acov Ichud and is paired with artist Avrahamik Hazan. She is unsettled by the bombing in Haifa that takes place while she is there.

Inspired by Bart's decade-long letter and mail art collection, Bart and Carol Daly teach a class together, "From Personal Letters to Public Art," at the Elder Learning Institute; Daly is the leader and Bart is the artist. They discuss the importance of letters throughout history, their significance in storytelling, and their role in Bart's art. The participants write letters and share family correspondence. Bart's affinity for letters influences her future book work.

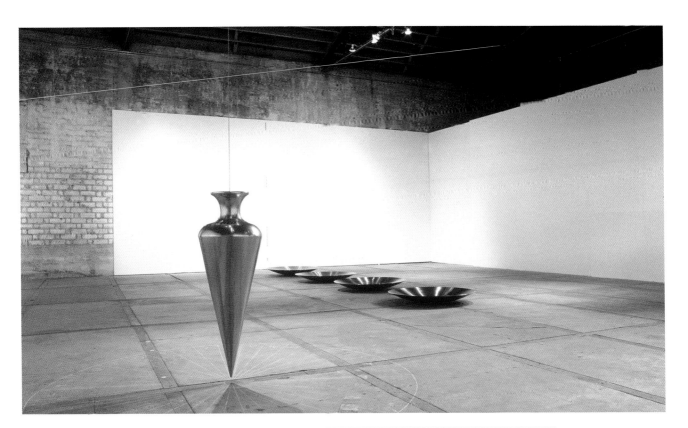

Harriet Bart and Helmut Löhr, **Dialogue: In the Presence of Absence,** Center for Contemporary Art, Santa Fe, New Mexico, 2003

Nor Hall and Harriet Bart perform **Aphrodite's Back** at the Southern Theater, Minneapolis, 2005

2002 Bart completes her third artist's book, *In the Presence of Absence*. A prose poem on longing written by Bart is laser cut into each of the book pages. The book is bound with glass covers.

2003 Bart publishes *The Poetry of Chance Encounters*, an artist's book comprised of found texts juxtaposed with gold-leafed iconic images – a cross between illuminated manuscripts and Surrealist games of chance.

She shows her artist's books and book objects in a solo exhibition, *The Art of the Book*, at Babcock Galleries (New York's oldest art gallery, renamed Driscoll Babcock in 2012). This begins a long professional association with gallery director John Driscoll.

Bart and Löhr's collaboration continues in Santa Fe, New Mexico, where they exhibit *Dialogue: In the Presence of Absence* at Evo Gallery and at the Center for Contemporary Art where they create a multimedia site-specific installation.

2004 Bart publishes *13 ÷ 14*, the confluence of a poem and a puzzle, bringing together the polygonal forms of the *Loculus of Archimedes* and the poetic vision of Wallace Stevens's *Thirteen Ways of Looking at a Blackbird*. *13 ÷ 14* is a continuation of Bart's studio work, pairing disparate text and images to create new contexts for everyday objects. The fourteen shapes of the ancient puzzle create dynamic silhouette figures for each of the thirteen stanzas of the poem. The book wins the Minnesota Book Artist Award in 2005.

2005 Informed by her time in Israel, Bart publishes her fifth fine press artist's book, *Punica Granatum*, in which the pomegranate is presented as the fruit of love and seduction. The profusion of pomegranate trees in Israel, and the many images of them inscribed on ancient stone fragments, instigated her interest in this fruit of the gods. Excerpts from classical and contemporary sources are threaded together to form a new text that extols the mythic powers of the pomegranate.

On Valentine's Day, Bart and writer Nor Hall perform *Aphrodite's Back*, a staged reading of *Punica Granatum*, set to music by Franz Kamin, at the Southern Theater in Minneapolis.

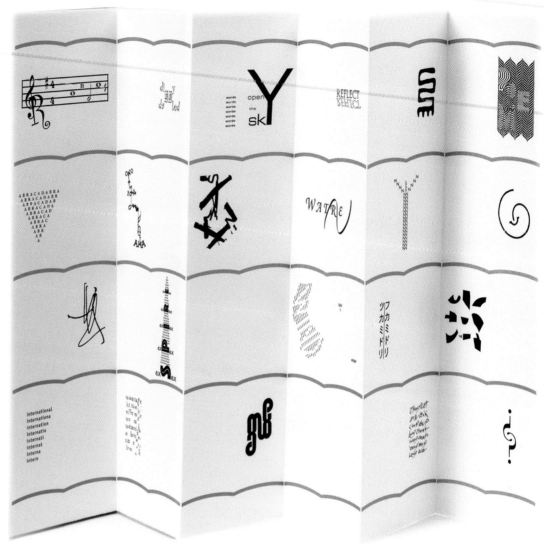

2006 Bart is included in an exhibition at the Weisman Art Museum titled *WARM: 12 Artists of the Women's Art Registry of Minnesota.* Curated by art historian Joanna Inglot, the exhibition features work by Bart and fellow WARM members Hazel Belvo, Sally Brown, Elizabeth Erickson, Carole Fisher, Linda Gammell, Vesna Kittelson, Joyce Lyon, Susan McDonald, Patricia Olson, Sandra Menefee Taylor, and Jantje Visscher. The exhibition explores themes of the second-wave feminist art movement, including the body, domesticity, sexuality, and the social construct of femininity, and features art that was in the WARM Gallery from the 1970s to the 1990s. In her essay for the exhibition catalogue, Inglot says that she "wanted these decades to mark a point in history. I wanted to commemorate what the women of Minnesota gave to the feminist movement."[7]

2007 Bart is commissioned to create an 11 x 20 foot glass wall for the Rondo Community Outreach Library in St. Paul, Minnesota. This becomes the impetus for a new collaborative artist's book, *Rondo: Miscellany of Visual Poetry.* A montage of concrete poetry, the wall and the book present text-based iconography created by Bart and other artists she invites to participate in the project: John Bennett, KS Ernst, Philip Gallo, Bob Grumman, Takako Hasekura, Scott Helmes, Geof Huth, Bill Keith, Richard Kostelanetz, Helmut Löhr, Carlos Luis, Bonnie Maurer, Sheila Murphy, and Uwe Warnke.

Bart completes a mixed media outdoor installation, *Riversong Anthology,* for the Fort Dodge Library in Fort Dodge, Iowa. Both *Rondo* and *Riversong Anthology* aim to create lasting and iconic imagery for their communities using diverse materials and symbols.

2008 Bart's father Mort dies in January. Influenced by his life and work, she keeps several tokens from his career and includes them in her small object assemblages. Ten weeks later in March, Bart's mother Natalie follows. Bart created *Double Ode* in honor of her parents.

Bart premieres a significant durational work, *Requiem (Inscribing the Names: American Soldiers Killed in Iraq),* at the Form + Content Gallery exhibition *Party Party in a Tweety Land b/w This Republic of Suffering,* curated by Colleen Sheehy and Camille Gage. A solitary work of reading and writing as public remembrance, paper scrolls inscribed with the names of more than four thousand American soldiers killed in Iraq spill down the wall to the floor. Metal plumb bobs hover, calling attention to that place where the true vertical reaches its horizontal destination.

Bart's book *In the Presence of Absence* is included in a Walker Art Center exhibition, *Text/Messages: Books by Artists,* co-organized by Walker Art Center librarian Rosemary Furtak and curator Siri Engberg.

2009 Bart's sister, Tammy Seacor-Farace, dies.

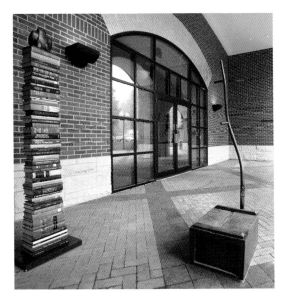

Installation view of **Riversong Anthology** at Fort Dodge Library, Fort Dodge, Iowa, 2007

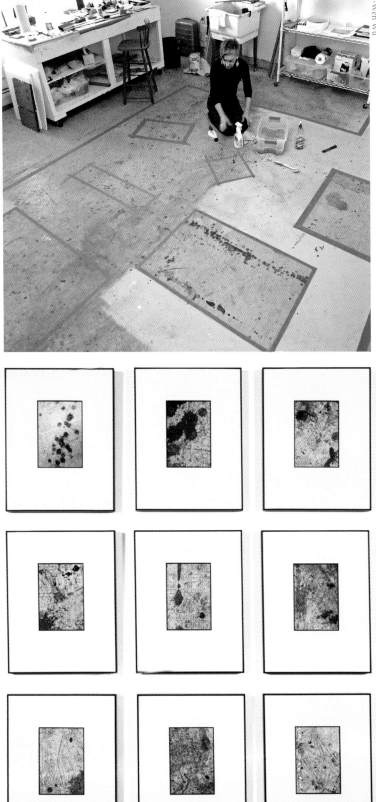

Bart cleans her studio floor at Virginia Center for Creative Arts, 2010

Harriet Bart, **Invisible Cities,** 2013. Set of nine archival pigment prints on rag paper inspired by **Ghost Maps,** 14 x 9 inches each (framed).

2010 Bart attends a residency at the Virginia Center for Creative Arts (VCCA) in Amherst, Virginia. She begins a documentary process recording the absence and presence of myriad artists preceding her in Studio VA5. Using the encrusted studio floor as a palimpsest, she marks sections of the floor with tape, scrubs the spaces between, and takes aerial photographs. This process resulted in the award-winning artist's book *Ghost Maps*. While at VCCA, Bart meets Boston-based artist Yu-Wen Wu, and the two become creative collaborators.

In December, Helmut Löhr dies unexpectedly.

2011 Bart helps to plan a memorial service for Löhr at the Zane Bennett Gallery in Santa Fe and creates *Homage* in honor of his life, work, and their long-lasting friendship and creative partnership.

Bart's project *Drawn in Smoke* recognizes the centenary of the Triangle Shirtwaist Factory fire in 1911. She creates 160 soot-on-paper drawings that commemorate the event and records the names of the mostly young immigrant women and girls who died in the fire. The exhibition *Drawn in Smoke* opens at Babcock Galleries in New York in January and also includes two other significant feminist works by Bart, *Garment Registry* and *Processional*.

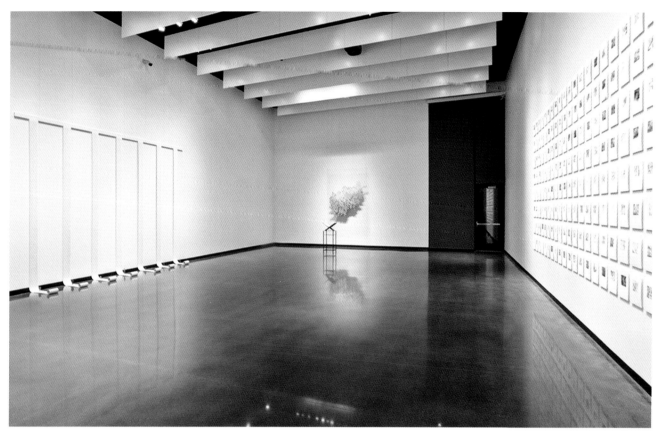

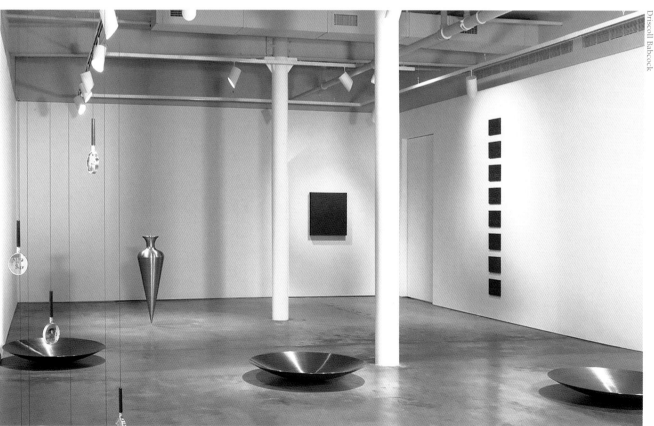

Driscoll Babcock

214

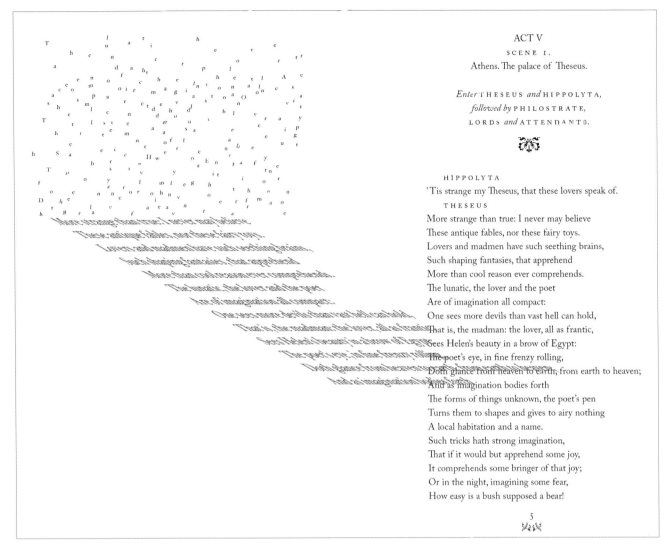

ACT V

SCENE I.

Athens. The palace of Theseus.

Enter THESEUS *and* HIPPOLYTA,
followed by PHILOSTRATE,
LORDS *and* ATTENDANTS.

HIPPOLYTA
'Tis strange my Theseus, that these lovers speak of.
THESEUS
More strange than true: I never may believe
These antique fables, nor these fairy toys.
Lovers and madmen have such seething brains,
Such shaping fantasies, that apprehend
More than cool reason ever comprehends.
The lunatic, the lover and the poet
Are of imagination all compact:
One sees more devils than vast hell can hold,
That is, the madman: the lover, all as frantic,
Sees Helen's beauty in a brow of Egypt:
The poet's eye, in fine frenzy rolling,
Doth glance from heaven to earth, from earth to heaven;
And as imagination bodies forth
The forms of things unknown, the poet's pen
Turns them to shapes and gives to airy nothing
A local habitation and a name.
Such tricks hath strong imagination,
That if it would but apprehend some joy,
It comprehends some bringer of that joy;
Or in the night, imagining some fear,
How easy is a bush supposed a bear!

5

2012 Carol Daly dies in March. Bart gathers artist friends to create three hundred small canvas artworks for Daly's memorial service. Everyone who attends is given the gift of art, commemorating Daly's passion for and love of art.

Bart donates her twenty-year Fluxus-inspired work *Winter Projects* to the Walker Art Center library in memory of Rosemary Furtak.

Bart's solo exhibition *Between Echo and Silence* inaugurates the Law Warschaw Gallery at Macalester College in St. Paul, Minnesota. In a written piece for the exhibition, curator Joanna Inglot describes the work as "a carefully choreographed ensemble of objects and drawings that resonate with loss, history, and preserved memory. With its stark physicality of form and subtle ephemeral gestures, Bart's work instantly arrests the viewer's attention and captivates with its refined minimalist aesthetic."

2013 Bart receives a Minnesota State Arts Board Artist Initiative Grant to create a new fine press artist's book. *ACT V* explores the idea of public art as a vehicle for engaging nontraditional audiences with visual art. This special edition book is produced to complement Ten Thousand Things Theater Company's production of Shakespeare's *A Midsummer Night's Dream*. *ACT V* is distributed after the performance to audience members at Cornerstone, a domestic violence shelter for women, and at Wayside, a women's residential addiction recovery community. This book is produced in collaboration with Bart's usual fabricators, master printer Philip Gallo and binder Jill Jevne.

Bart opens a new solo exhibition, *Locus*, at Driscoll Babcock in New York, transforming the gallery setting into a site for exploring the difference between space and place. The works are simultaneously poetic, philosophical, and architectural. In a statement about *Locus*, Bart says: "We are restive beings, often displaced by natural or human disasters. Whether rebuilding after a hurricane or emigrating to a new country, we long for a personal place of protection and meaning."

John Danielson

2015 Developed during her time at VCCA in 2010, Bart's eleventh editioned artist's book, *Ghost Maps*, wins her third Minnesota Book Artist Award and a subsequent exhibition of her artist's books and related ephemera at the Minnesota Center for Book Arts.

The Minnesota Museum of American Art's Project Space hosts Bart and her collaborator Yu-Wen Wu for a month-long residency. They work together in the gallery-turned-artist-studio to create an evolving site-specific multimedia installation, *Random Walks and Chance Encounters*. The installation makes reference to both artists' practice of opening their art to serendipity and engaging with the visiting public.

The Walker Art Center acquires Bart's *Enduring Afghanistan*, which is on view in the anniversary exhibition *75 Gifts for 75 Years*.

2016 Carleton College Perlman Teaching Museum in Northfield, Minnesota, presents *Crossings*, a new Bart and Wu collaboration. This installation calls attention to the global crises of forced migration. Under boundless skies and beautiful landscapes are borders and fences; a river of rocks and scrolling video make reference to the more than sixty-five million refugees.

Bart travels with several artist friends to Scotland. The group rents a home where they spend time together sharing art, stories, poems, and meals.

Strong Silent Type, which pays homage to Bart's mother and refers to the labor of sewing and the garment as armor, premieres at Driscoll Babcock in October.

2017 Bart receives the McKnight Visual Artist Fellowship, which supports the research and development of new work and archival materials for her 2020 career retrospective at the Weisman Art Museum. She begins the multi-year exhibition planning process with curator Laura Wertheim Joseph and studio assistant Heather Everhart.

2018 Bart and Yu-Wen Wu attend a month's residency at Yaddo in Saratoga Springs, New York. Based on their research for *Crossings*, they work on a new collaboration about the special circumstances of women and children refugees. *Out of Silence* is comprised of multiple elements; they focus on one of the elements, *Leavings/ Belongings*, to premiere at Site Santa Fe, New Mexico, in 2020.

Bart's dear friend Leslie Gillette dies unexpectedly.

Bart gifts a segment of her work to the Weisman Art Museum, which will eventually hold her archive.

2020 Celebrating her career of more than forty-five years as a feminist conceptual artist, Harriet Bart is the subject of a Weisman Art Museum retrospective curated by Laura Wertheim Joseph, *Harriet Bart: Abracadabra and Other Forms of Protection*.

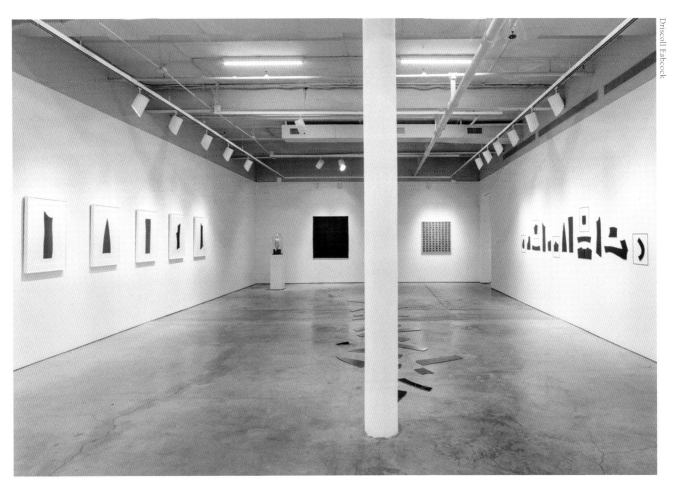

Driscoll Babcock

LEFT:
Harriet Bart and
Yu-Wen Wu with their
installation **Random
Walks and Chance
Encounters,** 2015

ABOVE:
Installation view
of **Strong Silent Type,**
Driscoll Babcock,
New York, 2016

NEAR RIGHT:
Harriet Bart and John
Driscoll of Driscoll
Babcock, New York,
2016

FAR RIGHT:
Traffic Zone Center for
Visual Art open studio
announcement, 2012

Steve Ozone, edited by Isaac Everhart

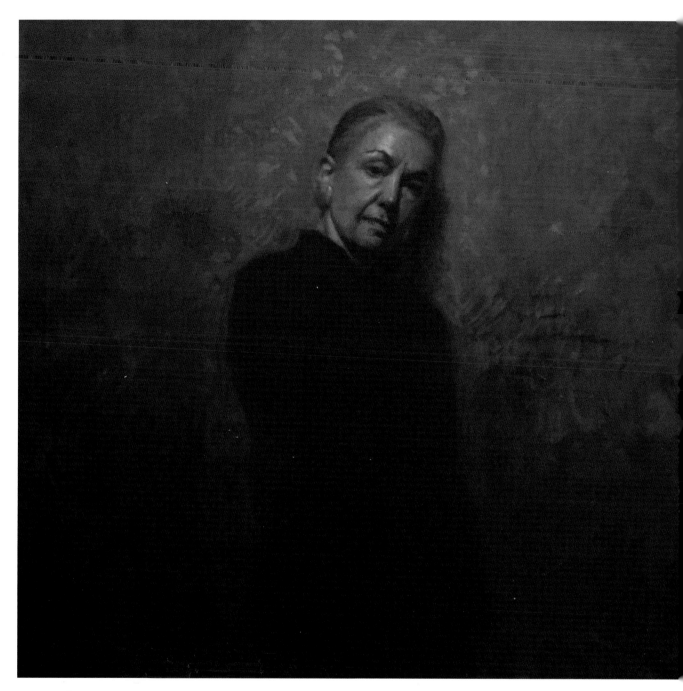

Kristie Bretzke,
Harriet Bart, 2016.
Oil on linen,
36 x 60 inches.

Notes

[1] Kathryn C. Johnson,"Lights and Shadows, *Bart/Belvo*," Women's Art Registry of Minnesota (April 15, 1978): 8.

[2] Grant Alison, "Three-dimensional Art," *Minnesota Daily* (October 26, 1979).

[3] Philip S. Gutis, "Turning Superheroes into Super Sales," *The New York Times*, January 6, 1985.

[4] Patricia McCormack, "Wonder Woman Foundation Honors Women's Achievements," UPI Archives, December 3, 1982.

[5] Ronny Cohen, "Structure and Metaphor: Six Contemporary Visions," Women's Art Registry of Minnesota (January 18, 1986): 4.

6 Bart quoted in ibid., 7.

7 Joanna Inglot, *WARM: A Feminist Art Collective in Minnesota* (Minneapolis: Weisman Art Museum and the University of Minnesota Press, 2007). See also Amber Schadewald, "A WARM Body of Work," *Minnesota Women's Press* (May 31, 2006).

SELECTED EXHIBITIONS

Solo and Two-Person Exhibitions

1978 *Bart/Belvo*, WARM Gallery, Minneapolis, Minnesota

1980 *Harriet Bart and Mary Walker*, WARM Gallery, Minneapolis, Minnesota

1981 *Harriet Bart*, Michigan Technological University, Houghton, Michigan

1982 *Inscriptions*, Peter M. David Gallery, Minneapolis, Minnesota

1983 *Two Artists* (with Mary Walker), University of Nebraska Sheldon Memorial Gallery, Lincoln, Nebraska

1986 *Harriet Bart: Paintings and Drawings*, Tweed Museum of Art, Duluth, Minnesota

1987 *Harriet Bart: Paintings and Sculpture*, Carleton College Boliou Gallery, Northfield, Minnesota

1987 *Harriet Bart: Woven Works of the 70s*, Textile Arts International, Minneapolis, Minnesota

1990 *Fading Memories / Timeless Truths*, curated by Jim Conaway, Hamline University, St. Paul, Minnesota

1993 *Harriet Bart*, University of Minnesota School of Architecture, Minneapolis, Minnesota

1993 *Dialogue: Alchemy of the Word* (with Helmut Löhr), Dolly Fiterman Fine Arts, Minneapolis, Minnesota

1994 *Dialogue: Alchemy of the Word II* (with Helmut Löhr), Galerie Schüppenhauer, Cologne, Germany

1995 *Locus: Reflections on a Time and Place by Harriet Bart*, Iowa State University Brunnier Art Museum, Ames, Iowa

1995 *Dialogue: Alchemy of the Word III* (with Helmut Löhr), Galerie Henn, Maastricht, Netherlands

1995 *Dialogue: Alchemy of the Word IV* (with Helmut Löhr), Galerie Horst Dietrich, Berlin, Germany

1996 *Harvest*, Weisman Art Museum, Minneapolis, Minnesota

1998 *WITHOUT WORDS: A Reading Room*, Laumeier Sculpture Park and Museum, St. Louis, Missouri

2003 *Dialogue: In the Presence of Absence* (with Helmut Löhr), curated by Cynde Conn, Center for Contemporary Art, Santa Fe, New Mexico

2003 *Dialogue: In the Presence of Absence* (with Helmut Löhr), Evo Gallery, Santa Fe, New Mexico

2003 *The Art of the Book*, Babcock Galleries, New York, New York

2004 *Object ≤ Book*, Indianapolis Art Center, Indianapolis, Indiana

2005 *Punica Granatum*, Bethel University Olson Gallery, St. Paul, Minnesota

2007 Frederick W. Goudy Lecture and Exhibition, curated by Kitty Maryatt, Scripps College, Claremont, California

2010 *Winter Projects,* curated by Rosemary Furtak, Walker Art Center Library, Minneapolis, Minnesota

2011 *Drawn in Smoke,* Babcock Galleries, New York, New York

2012 *In Association,* Minnesota Center for Book Arts, Minneapolis, Minnesota

2012 *Between Echo and Silence,* curated by Joanna Inglot, Macalester College Law Warschaw Gallery, St. Paul, Minnesota

2013 *Locus,* Driscoll Babcock, New York, New York

2015 *Minnesota Book Artist Award Exhibition,* Minnesota Center for Book Arts, Minneapolis, Minnesota, and George Latimer Central Library, St. Paul, Minnesota

2015 *Random Walks and Chance Encounters* (with Yu-Wen Wu), Minnesota Museum of American Art, St. Paul, Minnesota

2016 *Crossings* (with Yu-Wen Wu), Carleton College Perlman Teaching Museum, Northfield, Minnesota

2016 *Strong Silent Type,* Driscoll Babcock, New York, New York

2020 *Harriet Bart: Books + Works on Paper,* Minneapolis Institute of Art, Minneapolis, Minnesota

2020 *Harriet Bart: Abracadabra and Other Forms of Protection,* Weisman Art Museum, Minneapolis, Minnesota

Group Exhibitions

1975 Macalester College, St. Paul, Minnesota

1975 Rochester Art Center, Rochester, Minnesota

1975 John Michael Kohler Art Center, Sheboygan, Wisconsin

1976 University of Minnesota Goldstein Gallery, St. Paul, Minnesota

1976 California State University, Costa Mesa, California

1977 *Self-Images,* WARM: A Women's Collective Art Space, Minneapolis, Minnesota

1977 *Women's Art Across the USA,* Soho 20, New York, New York

1977 *Personal Icons,* WARM: A Women's Collective Art Space, Minneapolis, Minnesota

1978 *Minnesota Artists,* curated by Bonnie Sussman, Peter M. David Gallery, Minneapolis, Minnesota

1978 Augsburg College, Minneapolis, Minnesota

1979 *Warm Exchange,* ARC Gallery, Chicago, Illinois

1979 *Contents/Structures,* Minnesota Artists Exhibition Program (MAEP), Minneapolis Institute of Arts, Minneapolis, Minnesota

1982 *The Dark Core,* curated by Cherie Doyle, Macalester College, St. Paul, Minnesota

1984 *Character Reference,* Minnesota Artists Exhibition Program (MAEP) at the Minneapolis Institute of Arts, Minneapolis, Minnesota

1985 *A Landmark Exhibition,* WARM Gallery, Minneapolis, Minnesota

1986 *Structure and Metaphor: Six Contemporary Visions,* WARM Gallery, Minneapolis, Minnesota

1988 *Visions of Fate,* curated by Julie Yanson, Minneapolis College of Art and Design, Minneapolis, Minnesota

1989 *Fifteenth Anniversary Exhibition,* Center for Book Arts, New York, New York

1989 *Coda,* WARM Gallery, Minneapolis, Minnesota

1989 *Volumes,* Minnesota Artists Exhibition Program (MAEP), Minneapolis Institute of Arts, Minneapolis, Minnesota

1990 *The Book as Art / The Book in Art,* Barbara Fendrick Gallery, New York, New York

1990 *Intricate Narratives,* curated by Catherine Tedford, St. Lawrence University Brush Gallery, Canton, New York

1991 *Outspoken Women,* Intermedia Arts, Minneapolis, Minnesota

1991 *Boundless Vision,* curated by Judith Hoffberg, San Antonio Art Institute, San Antonio, Texas

1992 *Volumination: The Book as Art Object,* Edwin A. Ulrich Museum of Art, Wichita, Kansas

1993 *Books as Objects,* organized by Donald Vogler, Comus Gallery, Portland, Oregon

1993 *Artists' Books and Art About Books,* Pratt Institute, New York, New York

1993 *Visuelle Poesie,* curated by Uwe Warnke, Kunsthalle Ostseebad, Kühlungsborn, Germany

1994 *The Book as Art,* Edith Lambert Gallery, Santa Fe, New Mexico

1994 *Re-Reading the Boundless Book,* curated by Anne Ward Burton, Minnesota Center for Book Arts, Minneapolis, Minnesota

1995 *Bibliovertigo,* curated by Brock Lueck and Michael Piazza, Northern Illinois University Art Museum, DeKalb, Illinois

1995 *In So Many Words,* curated by Clarissa Sligh, Minnesota Museum of American Art, St. Paul, Minnesota

1996 *Culture and Continuity: The Jewish Journey,* The Jewish Museum, New York, New York

1997 *Visuelle Poesie,* Kurt Tucholsky Memorial Castle, Rheinsberg, Germany

1998 *Women in the Weisman Collection: The Spirit of Seneca Falls,* curated by Diane Mullin, Weisman Art Museum, Minneapolis, Minnesota

1999 *Legible Forms: Contemporary Sculptural Books,* curated by Carla Hanzal, Contemporary Art Center, Virginia Beach, Virginia

1999 *Open and Closed: Artists Contemporary Books as Sculpture,* Fullerton College, Fullerton, California

2000 *New Work: McKnight Fellows Exhibition,* curated by Brian Szott, Minneapolis College of Art and Design, Minneapolis, Minnesota

2002 *Third National Book and Paper Arts Biennial,* juried by Lynn Amlie, Tracy Honn, and Rox Leax, Columbia College, Chicago, Illinois

2002 *Bildsprache,* Volker Marschall Gallery, Düsseldorf, Germany

2003 *Altered Books: Spine Bending Thrillers,* curated by Karen McDermott, Rider University Art Gallery, Lawrenceville, New Jersey

2003 *Corporal Identity Body Language,* Klingspor Museum, Offenbach, Germany

2003 *Corporal Identity Body Language,* curated by David McFadden and Stefan Soltek, Museum of Arts and Design, New York, New York

2006 *Fourth International Artist's Book Exhibition,* King Saint Stephen Museum, Székesfehérvár, Hungary

2006 *Found in Translation,* curated by Marshall Weber, New York Center for Book Arts, New York, New York

2006 *Found in Translation,* curated by Marshall Weber, San Francisco Center for the Book, San Francisco, California

2006 *WARM: 12 Artists of the Women's Art Registry of Minnesota,* curated by Joanna Inglot, Weisman Art Museum, Minneapolis, Minnesota

2006 *Works with Paper: Artists' Books,* curated by Ruth Rogers, University of the South, Sewanee, Tennessee

2007 *Books and Death: Constructions of Death, Mourning, and Memory,* curated by Maria Pisano, University of Wisconsin, Milwaukee, Wisconsin

2007 *The Exquisite Book,* curated by Diane Mullin, Weisman Art Museum, Minneapolis, Minnesota

2008 *Party Party in a Tweety Land b/w This Republic of Suffering,* curated by Colleen Sheehy and Camille Gage, Form + Content Gallery, Minneapolis, Minnesota

2008 *Altered Books,* curated by Betty Bright, Minneapolis Central Library Cargill Gallery, Minneapolis, Minnesota

2008 *Performing the Book,* curated by Kitty Maryatt, Scripps College Williamson Gallery, Claremont, California

2009 *Type Bound: Books as Sculpture from Florida Collections,* curated by Theo Lotz and Craig Saper, University of Central Florida Art Gallery, Orlando, Florida

2009 *Text / Messages: Books by Artists,* curated by Rosemary Furtak and Siri Engberg, Walker Art Center, Minneapolis, Minnesota

2009 *X LIBRIS: The Re-Purposed Book,* curated by Harriet Bart, Dennis Jon, and Lisa Nankivil, Traffic Zone Center for Visual Art, Minneapolis, Minnesota

2010 *Special Choice Book Arts I + II,* curated by Yuko Nii, Williamsburg Art + Historical Center, Brooklyn, New York

2010 *Speaking Volumes: The Language of Artists Books,* John Michael Kohler Art Center, Sheboygan, Wisconsin

2011 *From Press to Page: Book Arts in Minnesota,* curated by Dennis Jon, Minneapolis Institute of Arts, Minneapolis, Minnesota

2011 *Artists' Books: Books by Artists,* curated by Stanley Cushing, Boston Athenæum, Boston, Massachusetts

2011 *Object Poems,* curated by David Abel, 23 Sandy Gallery, Portland, Oregon

2011 *Deceptive Distance,* curated by Christina Schmid, College of Visual Arts, St. Paul, Minnesota

2011 *Fine & Dirty: Contemporary Letterpress Art,* curated by Betty Bright, Minnesota Center for Book Arts, Minneapolis, Minnesota

2012 *Tenuous Though Real,* Weisman Art Museum, Minneapolis, Minnesota

2012 *Diamond Leaves,* The Central Academy of Fine Arts Museum (CAFA), Beijing, China

2013 *The Studio Sessions: Minnesota Artists in the 1970s: Photos by Victor Bloomfield,* curated by Christina Chang, Minnesota Museum of American Art Project Space, St. Paul, Minnesota

2013 *Seductive Alchemy: Books by Artists,* curated by Ruth Rogers, Texas Woman's University, Denton, Texas

2013 *The House We Built: Feminist Art Then and Now,* curated by Joyce Lyon and Howard Oransky, University of Minnesota Katherine Nash Gallery, Minneapolis, Minnesota

2014 *Logical Guesses,* curated by House of the Noblemen, Driscoll Babcock, New York, New York

2014 *Lists,* curated by Harriet Bart, Scott Helmes, and Eric Lorberer, Traffic Zone Gallery 308, Minneapolis, Minnesota

2015 *Unhinged: Book Art on the Cutting Edge,* curated by Barbara Matilsky, Whatcom Museum, Bellingham, Washington

2015 *75 Gifts for 75 Years,* curated by Siri Engberg, Walker Art Center, Minneapolis, Minnesota

2015 *Medium of Exchange,* curated by Tess Sol Schwab, SPRING/BREAK Art Show, New York, New York

2016 *Just One Look,* curated by Lauren Dudley, University of Washington Special Collections Library, Seattle, Washington

2016 *Reading with the Senses,* curated by Ruth Rogers, Lesley University College of Art and Design, Cambridge, Massachusetts

2016 *Warm Guerillas: Feminist Visions,* organized by Jo-Anne Reske Kirkman and Laura Mayo, Bottling House, Minneapolis, Minnesota

2017 *I am you, you are too,* curated by Vincenzo de Bellis, Adrienne Edwards, and Pavel Pyś, Walker Art Center, Minneapolis, Minnesota

2018 *Books/Bodies,* Yale University Library, New Haven, Connecticut

Awards and Commissions

1980 Minnesota State Arts Board, Artist Grant, St. Paul, Minnesota

1990 MacDowell Colony, Artist Residency, Peterborough, New Hampshire

1992 *Helicon Volumes,* Ibaraki Municipal Library, Ibaraki, Osaka, Japan

1993 Arts Midwest / NEA Regional Visual Arts Fellowship, Minneapolis, Minnesota

1993 Minnesota State Arts Board, Career Opportunity Grant, St. Paul, Minnesota

1994 *Double Ode,* Doubleday Book and Music Clubs, Garden City, New Jersey

1995 *Alcove,* Iowa State University Carrie Chapman Catt Hall and Anderson Sculpture Garden, Ames, Iowa

1996 *Harvest,* Sculpture Plaza Commission, Weisman Art Museum / Jerome Foundation, Minneapolis, Minnesota

1998 *Foundations and Elements,* University of St. Thomas Science and Technology Center, St. Paul, Minnesota

1999 MCAD/McKnight Foundation, Artist Fellowship, Minneapolis, Minnesota

1999 *Demeter's Table,* Franconia Sculpture Park, Shafer, Minnesota

2000 Bush Foundation, Visual Arts Fellowship, Minneapolis, Minnesota

2001 Partnership 2000: A Cultural Exchange Encounter, Poriya Tiberias, Israel

2002 *Garment Register,* Minnesota Book Artist Award, Minneapolis, Minnesota

2003 *Cento,* University of Minnesota Walter Library, Minneapolis, Minnesota

2005 *13 ÷ 14: Reflections on Thirteen Ways of Looking at a Blackbird,* Minnesota Book Award, Minneapolis, Minnesota

2007 *Riversong Anthology,* Fort Dodge Library, Fort Dodge, Iowa

2007 *Rondo: Miscellany of Visual Poetry,* Rondo Community Outreach Library, St. Paul, Minnesota

2010 Virginia Center for Creative Arts, Artist Residency, Amherst, Virginia

2011 *Winter Projects* with Hopkins/Baumann, Minnesota AIGA winner, Minneapolis, Minnesota

2012 Forecast / McKnight Foundation, Mid-Career Public Artist Professional Development Grant, St. Paul, Minnesota

2012 *X LIBRIS: Cadence,* Ramsey County Library, New Brighton, Minnesota

2013 Minnesota State Arts Board, Artist Initiative Grant, St. Paul, Minnesota

2015 *Ghost Maps,* Minnesota Book Artist Award, St. Paul, Minnesota

2017 McKnight Visual Artist Fellowship, Minneapolis, Minnesota

2017 Yaddo, Artist Residency, Saratoga Springs, New York

Selected Collections

Boston Athenæum, Boston, Massachusetts
Brown University, Providence, Rhode Island
Burns Hotel, Düsseldorf, Germany
Carleton College, Northfield, Minnesota
Columbia University, New York, New York
Dartmouth College, Hanover, New Hampshire
Duke University Perkins Library, Durham, North Carolina
Federal Reserve Bank, Minneapolis, Minnesota
Hofstra University, Hempstead, New York
Iowa State University, Ames, Iowa
The Jewish Museum, New York, New York
Lafayette College, Easton, Pennsylvania
Laumeier Sculpture Park and Museum, St. Louis, Missouri
Library of Congress, Washington, D.C.
Long Island University, Brooklyn, New York
Louisiana State University, Baton Rouge, Louisiana
Metropolitan Museum of Art, New York, New York
Milwaukee Public Library, Milwaukee, Wisconsin
Minneapolis Institute of Art, Minneapolis, Minnesota
Minnesota Historical Society and History Center, St. Paul, Minnesota
Minnesota Humanities Education Center, St. Paul, Minnesota
Muller–Schwann Zerlag, Nuremberg, Germany
National Gallery of Art, Washington, D.C.
National Museum of Women in the Arts, Washington, D.C.
New York Public Library, New York, New York
Rondo Community Library, St. Paul, Minnesota
Sackner Archive of Visual and Concrete Poetry, Miami, Florida
Scripps College Denison Library, Claremont, California
Skidmore College, Saratoga Springs, New York
Smith College, Northampton, Massachusetts
Stanford University, Palo Alto, California
University of California San Diego, La Jolla, California
University of Chicago, Chicago, Illinois
University of Connecticut, Storrs, Connecticut
University of Kentucky, Lexington, Kentucky
University of Louisville Eckstrom Library, Louisville, Kentucky
University of Minnesota Andersen Library, Minneapolis, Minnesota

University of St. Thomas, St. Paul, Minnesota
University of Virginia Art Museum,
 Charlottesville, Virginia
University of Washington, Seattle, Washington
University of Wisconsin Kohler Art Library,
 Madison, Wisconsin
Walker Art Center, Minneapolis, Minnesota
Weisman Art Museum, University of Minnesota,
 Minneapolis, Minnesota
Wesleyan University, Middletown, Connecticut
Yale University, New Haven, Connecticut

Editioned Artist's Books

1990 *Gatherings*
1994 *Quire Music*
2000 *Garment Register*
2002 *In the Presence of Absence*
2003 *The Poetry of Chance Encounters*
2004 *13 ÷ 14*
2005 *Punica Granatum*
2006 *Rondo: A Miscellany of Visual Poetry*
2009 *Plumb Bob*
2011 *Drawn in Smoke*
2013 *Act V, Midsummer Night's Dream*
2013 *The Things They Carried* (World Book Night altered
 edition; original by Tim O'Brien)
2015 *Ghost Maps*
2016 *Patterns*

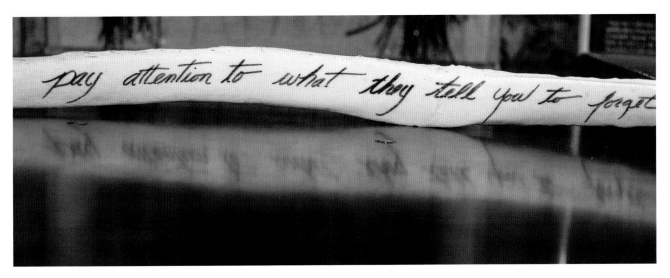

Valérie Jardin,
Untitled (detail of
artwork in Harriet
Bart's studio), 2018

ACKNOWLEDGMENTS

Harriet Bart often begins her artist talks by explaining that she came of age as an artist in the turbulent seventies, when people were getting organized to form change-making coalitions that gave rise to the civil rights, antiwar, and women's liberation movements. The Women's Art Registry of Minnesota (WARM) drew Bart from the isolation of her basement studio (where she was working to develop her practice between times spent fulfilling her responsibilities as a wife and mother) into a vibrant network of feminist artistic exchange and consciousness raising.

When she visited the newly established gallery for the first time in 1976, she met Elizabeth Erickson, who immediately informed her that WARM was a feminist project. Bart joined shortly thereafter. In keeping with the heterogeneity of feminist activity around the country at that time, the group did not agree about how to define or prioritize feminist artistic goals.

Yet still the collective project remained viable because decision-making was governed by compromise and consensus rather than individualism. In her landmark history of the WARM collective, *WARM: A Feminist Art Collective in Minnesota* (Minneapolis: Weisman Art Museum with the University of Minnesota Press, 2007), Joanna Inglot cites Bart as giving this explanation for the spirit of cooperation: in "coming together, having power, taking control, making another world, making a new path" the members created "opportunities that were stronger than the differences we had over how we should get there" (33).

Bart describes her experience in WARM as "inspiring years of growth" that transformed her practice to one rooted in collaboration. Her collaborative artistic spirit has been the guiding force of this project, which is the result of the sharing of knowledge and power across generations of women and of the generosity and support of many.

Elizabeth Erickson and Joanna Inglot are two of the eighteen writers whose intelligence and creativity have helped create the world held within this book. Thanks also to contributors Betty Bright, Stephen Brown, Robert Cozzolino, Heather Everhart, Nor Hall, Matthea Harvey, Eric Lorberer, Jim Moore, Diane Mullin, Samantha Rippner, Joan Rothfuss, John Schott, Sun Yung Shin, and Susan Stewart for embracing an unconventional approach and bringing their unique, insightful voices to this project.

Thanks to the dedicated graphic design work of Mary K. Baumann and Will Hopkins of Hopkins/Baumann this book is a beautiful object. Through their attention to detail and many hours of hard work, they designed a book reflective of Bart's high aesthetic standards. Over the course of many hours, the talented Rik Sferra took or retouched most of the photographs you see featured here; we are grateful to Rik for his patience, humor, and excellent work. Laura Westlund has been a tireless and thoughtful editor, sensitively revising texts with wide-ranging voices and approaches. In her generous, kind, and smart way, Jane Blocker read this catalogue's introductory essay and provided helpful feedback. Jim Bindas, our knowledgeable production manager, ensured the book was made to exacting specifications while always remaining calm, collegial, and responsive. We appreciate the partnership of the University of Minnesota Press and its commitment to reaching a wide audience for this book's insights.

I'm personally grateful to have had so many meaningful opportunities to discuss with Harriet Bart the ideas, processes, and histories that inform her work, and I am grateful that WAM is providing a public point of access for this material. I have often found myself in the position of trying to recuperate the histories of women artists whose achievements and contributions were not recognized during their lifetimes. One of the many things I've learned from having to make such curatorial correctives is the importance of written records and scholarship. A catalogue ensures that the insights gained through an exhibition are not lost to the future. In recognition, many individuals provided critical funding that made the realization

of this publication possible. We are thankful to these people, who are listed in this book, for their meaningful support and confidence in WAM's vision. Karen Kaler hosted a lovely event that made it possible for us to share information about the project and its importance with a supportive community.

We are especially grateful to Karen Desnick for her key role in our fundraising efforts and for her tireless commitment to advancing recognition for women in the arts. We extend special thanks to Dianne Fenyk for being important to our fundraising team. We thankfully acknowledge the support of Howard Oransky, who shared ideas about securing funding for the project.

We are deeply grateful to the Andy Warhol Foundation for the Visual Arts for awarding leadership funding for the exhibition and this publication, and to the National Endowment for the Arts for its support.

Several institutions and individuals loaned artwork to the exhibition, including Jennie Dick and Nick Swenson, the Jewish Museum, Michael Shea, and the Walker Art Center: thank you. I enjoyed and appreciated the informing conversations I had with Beth Bergman and Charlene Burningham about this show.

This exhibition has been made possible by the leadership of the Weisman Art Museum. Recognition of WARM as a platform for aesthetic, conceptual, and social innovation has increased thanks to WAM's 2007 exhibition that explored WARM's creative contributions. With *Harriet Bart: Abracadabra and Other Forms of Protection,* WAM furthers its commitment to creating a more complex story of American art, one that acknowledges the significant impact the women artists in WARM have had in their communities and on the trajectory of American art.

My thanks to WAM's director, Lyndel King, for her belief in the project and in my ability to realize it. I'm grateful to WAM's senior curator Diane Mullin for first suggesting the idea of organizing a retrospective devoted to Harriet Bart. As the show's coordinating curator, Diane supported its development in countless ways beyond her contribution as an author. This exhibition and publication are made possible by WAM's dedicated staff. Katie Covey, Matthew Engelstad, William Haugen, Patti Phillips, Reggie Spanier, Annette Van Aken, Christopher Williams, and Jamee Yung deserve special thanks for their talents and support. We appreciate the installation ideas and insights Lynn Barnhouse shared.

I have had the pleasure of working closely with Harriet Bart's longtime studio assistant, Heather Everhart, on all aspects of the exhibition and publication. Her organizational skills, dedication, intelligence, generosity, and warm friendship have been instrumental to our success. She oversaw the work of two great interns: Laurel Darling carefully digitized the Bart archive, and Brittany Kieler meticulously recreated one of the artist's large-scale sculptures, as well as completing important archival work. As my colleague at Interact Center for the Visual and Performing Arts, Brittany has also provided immeasurable support to me during this project's development.

This publication and exhibition seek to honor the artistic contributions of Harriet Bart. She is a feminist artist who has been prominent in shaping the cultural life of Minnesota, while creating a substantial, distinct, and mature body of work that is as visually captivating as it is conceptually powerful. I'm honored to have worked closely with her over the past three years, and I'm grateful for her warm kindness and creative vision. I also wish to recognize some of the people who have helped sustain her in her work: her parents, Mort and Natalie Levine; her husband, Bruce Bart; her family; her collaborators past and present (David Cole, Nor Hall, Helmut Löhr, Yu-Wen Wu); her fabricators (especially Philip Gallo, Jill Jevne, Tom Oliphant); and friends (Carol Daly, Leslie Gillette, and many others).

My endless gratitude and love go to my own tireless supporters: my parents, Terri and Glenn Wertheim, and my sister and brother-in-law, Katie and Jeremy Iacarella. Deepest thanks to my husband, Taylor Joseph, who is my Abracadabra in a precarious world. *~Laura Wertheim Joseph*

CONTRIBUTORS

Betty Bright is a writer, curator, and historian. She helped start Minnesota Center for Book Arts in 1985 and authored *No Longer Innocent: Book Art in America, 1960–1980*. She specializes in contemporary letterpress printing, craft's evolving identity, the physiology of the book, and the intersecting realms of art and the body. Her recent publications include an article on Claire Van Vliet's work in *American Craft* magazine and "Lines of Force: The Hand, the Book, and the Body Electric" in the monograph series CODE(X) + 1.

Stephen Brown is the Neubauer Family Foundation Associate Curator at the Jewish Museum in New York City, where he has organized award-winning exhibitions and catalogs, including *Florine Stettheimer: Painting Poetry, Lee Krasner: From the Margins,* and *Chaim Soutine: Flesh.* His research on art in its historical, literary, and social contexts focuses on the modern period, and his writing has been published in journals and anthologies such as the *Bulletin for Research in the Humanities* and *Burlington Magazine.*

Robert Cozzolino is Patrick and Aimee Butler Curator of Paintings at the Minneapolis Institute of Art. He has been called the "curator of the dispossessed" for championing underrepresented artists and uncommon perspectives on well-known artists. As curator at the Pennsylvania Academy of the Fine Arts in Philadelphia from 2004 to 2016, he oversaw more than thirty exhibitions, including retrospectives of George Tooker and Peter Blume, as well as the largest American museum exhibition of David Lynch's visual art. He is curating a major survey of the paranormal in American art, from the Salem witch trials to UFOs.

Elizabeth Erickson, a painter and poet, is a founding member of the feminist art collective WARM (the Women's Art Registry of Minnesota) and a former faculty member at the Minneapolis College of Art and Design. Her art is informed by feminist studies in archaeology, anthropology, religion, and history. She has been recognized, with fellow feminist artist and educator Patricia Olson, as a Changemaker by the Minnesota Women's Press for her role in founding the Women's Art Institute, a summer intensive studio course for women artists.

Heather Everhart supports curatorial programs, cross-departmental engagement, and equity initiatives via the Painting Department at the Minneapolis Institute of Art. She has been assistant to conceptual artist Harriet Bart since 2008. A visual artist and descendant of Łíídlı̨ Kų́ę́ First Nation, her interests are abstraction, conceptualism, feminisms, twentieth-century women painters, Indigenous Canadian contemporary art, and Dené art/history. She is a contributor to the landmark catalogue and exhibition *Hearts of Our People: Native Women Artists.*

Nor Hall is a theatre artist, psychoanalyst, and author of numerous books, including *Irons in the Fire, Those Women,* and *The Moon and the Virgin.* She writes on a variety of topics inspired by art and artists. Dramaturg for the award-winning Archipelago Company in Chapel Hill since 1996, she also collaborates on performance research projects with artistic directors and has been a longtime advisor of Pantheatre's Myth and Theatre festival in France and the Gymnasium Tink Tank in Minnesota. From 2012 to 2016, she co-chaired the Walker Art Center's Performing Arts Producers' Council.

Matthea Harvey is the author of five books of poetry, including *If the Tabloids Are True, What Are You?*, *Modern Life* (winner of the Kingsley Tufts Poetry Award and a *New York Times* Notable Book), and *Of Lamb*, an erased biography of Charles and Mary Lamb created in collaboration with visual artist Amy Jean Porter. She has received many awards and fellowships, including the Guggenheim Fellowship in creative arts, and has been contributing editor to *jubilat* and *BOMB*. She teaches at Sarah Lawrence College.

Hopkins/Baumann is a firm in Minneapolis specializing in publication design. Partners Will Hopkins and Mary K. Baumann have lectured internationally on visual trends and presently are creative directors of *American Craft* magazine. Hopkins/Baumann has designed and redesigned such magazines as *Life, Look, People, Money, GEO, Kids Discover, Architectural Digest, L'Express* (France), and *Claudia* (Brazil). Among their many book projects, they have authored and produced the best-selling *What's Out There: Images from Here to the Edge of the Universe*, and produced *The Dictionary of Love, King: The Photobiography of Martin Luther King, Jr.*, and *Sinatra: Intimate Portrait of a Very Good Year*.

Joanna Inglot is Edith M. Kelso Associate Professor of Art History at Macalester College. Among her writings on modern and contemporary art are *The Figurative Sculpture of Magdalena Abakanowicz: Bodies, Environments, and Myths* and *WARM: A Feminist Art Collective in Minnesota*, which accompanied an exhibition she curated for the Weisman Art Museum. She has received national grants, including a Fulbright Fellowship and International Exchanges Commission Grant (IREX), and awards from American Council of Learned Societies and the National Endowment of the Humanities.

Laura Wertheim Joseph is curator of exhibitions at the Minnesota Museum of American Art. She specializes in modern and contemporary art, focusing on gender studies, performance, and shadow feminisms, as well as theories of affect and empathy in art. Her curatorial projects include *A Feast of Astonishments: Charlotte Moorman and the Avant-Garde* and *Heart/Land: Sandra Menefee Taylor's Vital Matters*. She contributed to *Covered in Time and History: The Films of Ana Mendieta*, which was longlisted for Best Moving Image Book Award by the *British Journal of Photography*.

Lyndel King is director and chief curator of the Weisman Art Museum at the University of Minnesota in Minneapolis. She has been curator of numerous international exhibitions and is interested in exploring the relationship between art and science. She is a contributor to *The Innovative Museum: It's Up to You . . .* and recently collaborated with scientists on an exhibition and book of the early twentieth-century drawings of Spanish neuroscientist Santiago Ramón Cajal, *The Beautiful Brain*.

Eric Lorberer is the author of numerous poems, essays, and works of criticism; he was awarded an SASE/Jerome Fellowship for his writing. As the editor of *Rain Taxi Review of Books*, he is responsible for the voice and style that has brought the magazine widespread acclaim. He is the director of the Twin Cities Book Festival, has served as a panelist for the National Endowment for the Arts, and speaks at conferences and literary festivals around the country as an advocate for independent publishing and literary culture.

Jim Moore has written several poetry collections, including his most recent book, *Underground: New and Selected Poems*. He has won four Minnesota Book Awards and the 2002 Loft–McKnight Award in poetry, and he has received grants from the Bush Foundation, John Simon Guggenheim Foundation, and the Minnesota State Arts Board. He has twice served as the Edelstein–Keller Distinguished Visiting Professor in Creative Writing at the University of Minnesota and is a teacher in the MFA program at Hamline University.

Diane Mullin is senior curator at the Weisman Art Museum, where she has organized many exhibitions, including *Paul Shambroom: Picturing Power, Common Sense: Art and the Quotidian,* and *Piotr Szyhalski: We Are Working All the Time!* From 1998 to 2004 she was a member of the faculty at Minneapolis College of Art and Design; she was director of MCAD Gallery from 2002 to 2004. Her writings have been published in *ArtReview, Public Art Review, Art South Africa, Flash Art, New Art Examiner,* and *caareviews*.

Samantha Rippner is an independent writer and curator. From 1999 to 2014 she was a curator in the Department of Prints and Drawings at the Metropolitan Museum of Art, where she was responsible for its collection of modern and contemporary American and European prints. She has organized numerous exhibitions, including *Rhythms of Modern Life: British Prints, 1914–1939* and *The Prints of Vija Celmins* for the Met and *Word as Image: Highlights from the Marmor Collection* for the Cantor Arts Center at Stanford University.

Joan Rothfuss is an independent writer and curator. From 1988 to 2006 she was a curator at the Walker Art Center in Minneapolis, where she organized exhibitions on Joseph Beuys, Bruce Conner, and Jasper Johns, among many others. A leading scholar of Fluxus and intermedia art, she has published widely on modern and contemporary art. She has been awarded grants from the Creative Capital/Andy Warhol

Foundation Arts Writers Program, the Dedalus Foundation, and the Getty Grant Program. Her publications include *Time Is Not Even, Space Is Not Empty: Eiko & Koma* and *Topless Cellist: The Improbable Life of Charlotte Moorman*.

John Schott is a photographer, filmmaker, and educator. His photographic work has been featured in many publications, including *Rethinking Mythogeography in Northfield, Minnesota*; *John Schott: Mobile Homes, 1973–1976*; and *John Schott: Route 66 Motels, 1973–1974*. His work has been widely exhibited and was in the landmark exhibition *New Topographics* at the George Eastman House in 1977. He has directed and produced many films and television series including *America's Pop Collector*, a documentary he codirected with E. J. Vaughn. From 1979 to 2017 he was a professor of cinema and media studies at Carleton College.

신 선 영 **Sun Yung Shin** is the author of three books of poetry, including *Unbearable Splendor*, winner of the Minnesota Book Award and finalist for the PEN USA Literary Award for Poetry, and *Skirt Full of Black,* winner of the Asian American Literary Award for poetry. She has edited numerous anthologies, including the bestselling *A Good Time for Truth: Race in Minnesota*, and has received artist grants and fellowships from the Archibald Bush Foundation and the Jerome Foundation. She codirects the community organization Poetry Asylum with poet Su Hwang.

Susan Stewart is the author of five books of poetry, including *Columbarium,* winner of the National Book Critics Circle Award, and *Cinder,* her most recent collection. She has written several books of literary criticism, including *Poetry and the Fate of the Senses*, which received the Christian Gauss and Truman Capote awards. She has received fellowships and awards from the Pew Charitable Trusts and the Guggenheim Foundation. A former MacArthur Fellow and a chancellor of the Academy of American Poets, she teaches at Princeton University.

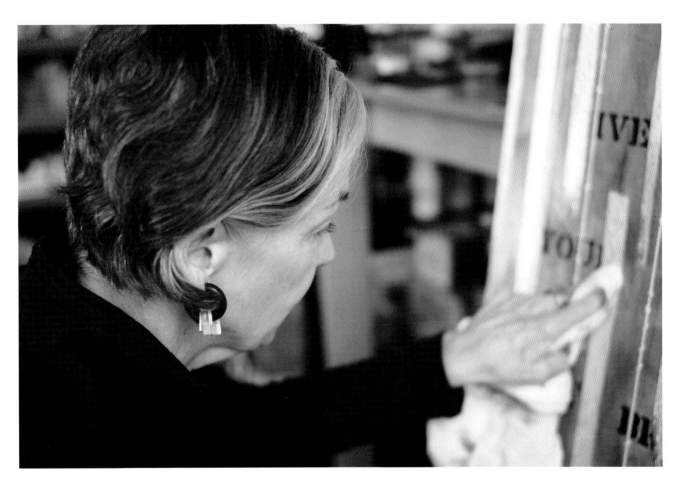

Valérie Jardin,
Untitled (Harriet
Bart at work on **Here
Shall Stand**), 2018

GRATITUDE

Many generous donors made this catalogue possible. We extend our deep gratitude to the following individuals, foundations, and agencies.

The Andy Warhol Foundation
 for the Visual Arts, Inc.

Nina M. Archabal

Lynn Barnhouse and Thomas A. Oliphant

Bruce J. Bart

Caprice and Gavin B. Bart

Eden Bart

Hazel Belvo

Mitchell E. Bender and Perci Chester

Beth E. Bergman

Scott R. Berry and Kathryn C. Johnson

Kristie A. and Carl Bretzke

Pam and Michael Burger

Marilyn Chiat

Laura and John Crosby

Diane and Kevin Daly

Linda T. and John R. Danielson

Shirley J. Davis

Karen and Leslie Desnick

Susan J. Diem and Bradley A. Bart

Noah and Susan Eisenberg

Elizabeth Erickson

Jil Evans and Charles C. Taliaferro

Dianne and John Fenyk

Donald and Patricia Fradkin

Lynn S. and Jeffery H. Fradkin

Emily Galusha and Don McNeil

Elinor D. Hands

Scott Helmes

Diane Robinson Hunt

Matthew and Heather Hunt,
 in honor of Nancy Fisher and Alice Tiano

Marlene M. Johnson

Sarah P. Johnson and Patrick K. Coleman

Catherine V. Jordan, in honor of the artists
 of WARM Gallery

President Eric W. and Karen F. Kaler

James P. Lenfestey

Edith D. Leyasmeyer

The Honorable Peggy Lucas and David Lucas

Joyce S. Lyon

Marguerite and Donald L. Harvey Family Fund
 of The Minneapolis Foundation

Daniel L. McFadden and Beverlee T. Simboli

Kathleen M. McLaughlin

National Endowment for the Arts

Patricia L. Olson

Howard L. Oransky

Patricia L. Phillips

Rehael Fund – Roger Hale/Nor Hall
 of The Minneapolis Foundation

Rockler Jackson Family Foundation

Philip M. and Tammie S. Rosenbloom

James W. Rustad and Kay A. Thomas

Marvin Sackner, in honor of Ruth Sackner

Beej and Jim Smith

Wendy A. and Mark D. Stansbury-O'Donnell

Robin Torgerson

Marcia K. Townley

Leslie K. Van Duzer

Jantje Visscher

Deborah D. Weiss

The William and Susan Sands Fund

Yu-Wen and Julian Wu

Sharon R. Zweigbaum

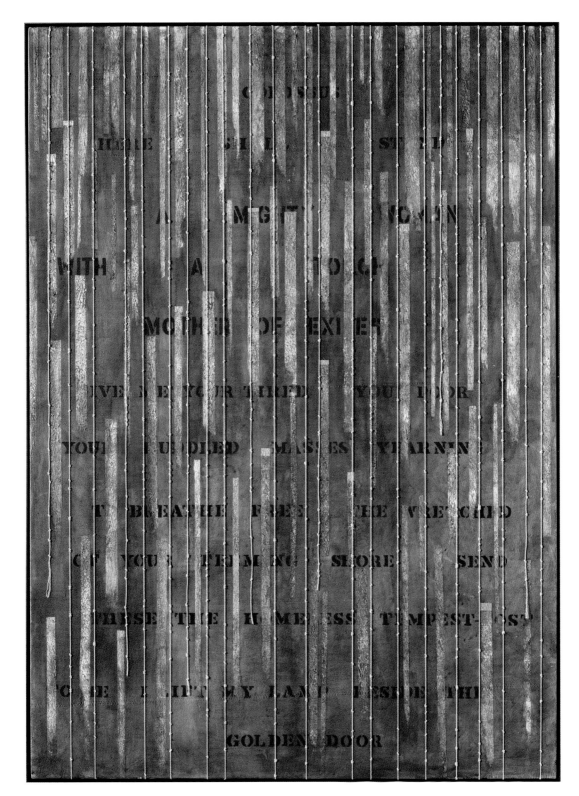

Here Shall Stand, 2018
mixed media on canvas
65 x 46 inches

Text from *The New Colossus*
by Emma Lazarus

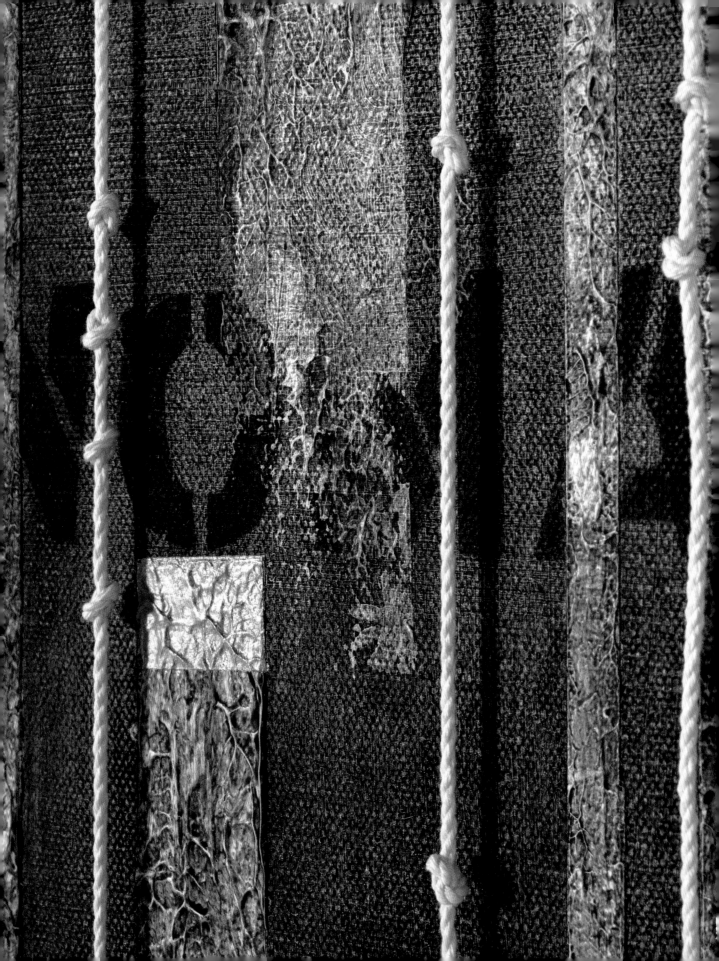